CITY

SKETCHING

REIMAGINED

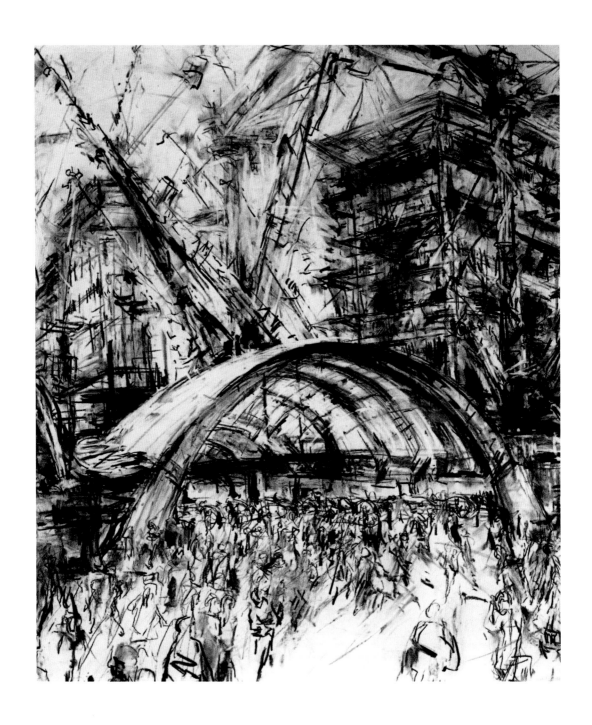

CITY

JEANETTE
BARNES
& PAUL
BRANDFORD

SKETCHING

REIMAGINED

BATSFORD

CONTENTS

INTRODUCTION

This book comes from our love of cities – their architecture and their people. It aims to serve a number of purposes; for the beginner it hopefully provides an encouraging introduction to drawing in general and urban sketching in particular. In this regard it introduces many types of art materials and their uses, and a number of insights and exercises to build confidence in a range of approaches to drawing. For the more experienced sketcher looking to develop their practice we examine the processes behind drawing and strategies to inject more creativity and open-mindedness about how to take a drawing forward.

Finally, it will give you a window into the experiences of Jeanette, who has travelled to many cities worldwide in search of inspiring subjects and a half-decent cocktail. Full of tips and ideas about working on location and back in the studio, this book is filled with the scribbles, sketches and preparatory drawings that feed into the larger works for which she is known.

As a whole, the book is a multipurpose tool that can be used to unlock the potential of drawing both technically and creatively, so that the reader can be the architect of their own drawing experience rather than the recipient of someone else's. Drawing is so much more of a journey than a destination – it's important to own the mode of transport and to know how to enjoy the ride.

We met as students at the Royal Academy Schools; Jeanette's love of urban activity was very much part of her work even then. We live together and share a studio although we are never

Canary Wharf, Docklands Light Railway Station Compressed charcoal (J)

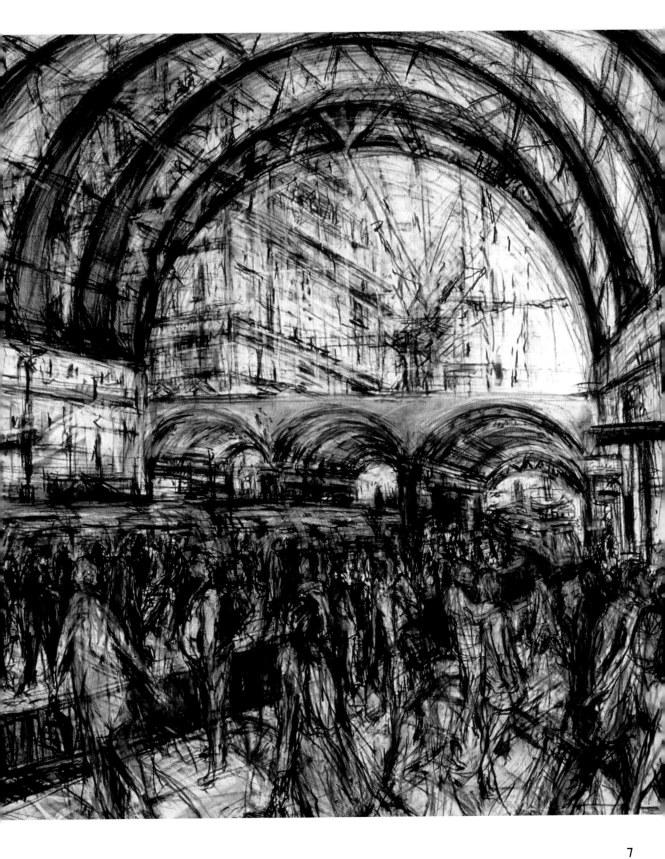

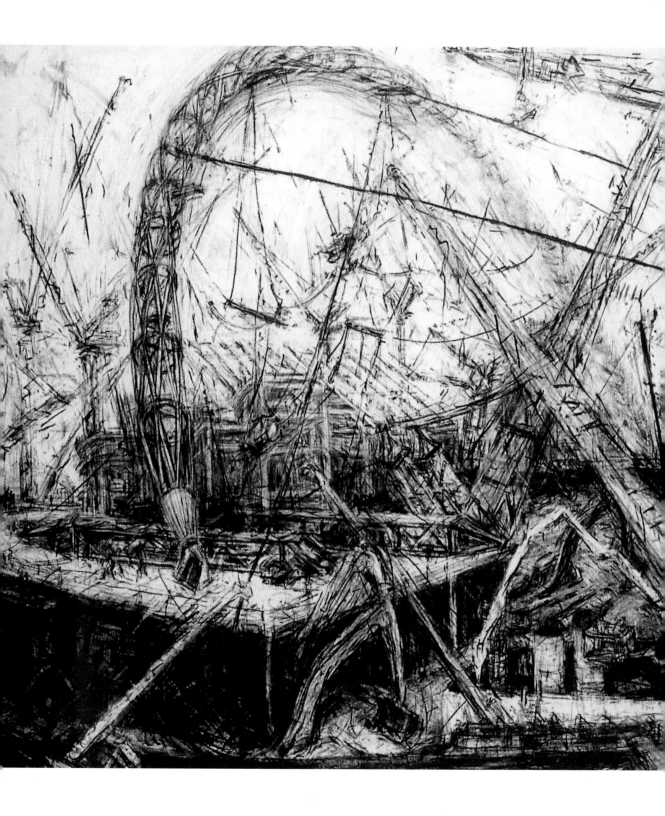

there at the same time so that territorial disputes don't arise. Jeanette loves the adventure of exploring new cities and developing her location studies into large finished works. Paul's collage-based works explore the colour and texture within a range of media, resulting in large-scale oil paintings.

After 30 years of drawing, both of us still feel an sense of excitement when picking up a pencil or some charcoal; the chance of bringing an image to life is a challenge met with enthusiasm and optimism. As much as we view drawing as a contemporary practice, we also have a love of visiting galleries and museums, often taking trips to draw from the works we discover there. We've always worked in education, aiming to communicate our love for the subject and pass on the practical know-how that we've built up over the years. Our teaching partnership We Explore Drawing runs a range of workshops for schools and colleges, both in person and online.

Here we've opted for an A-to-Z format so that the book is user-friendly and can be read from beginning to end or just dipped into more randomly; either way we hope it encourages and informs. *weexploredrawing.co.uk*

Constructing the Wembley Arch
Compressed charcoal (J)

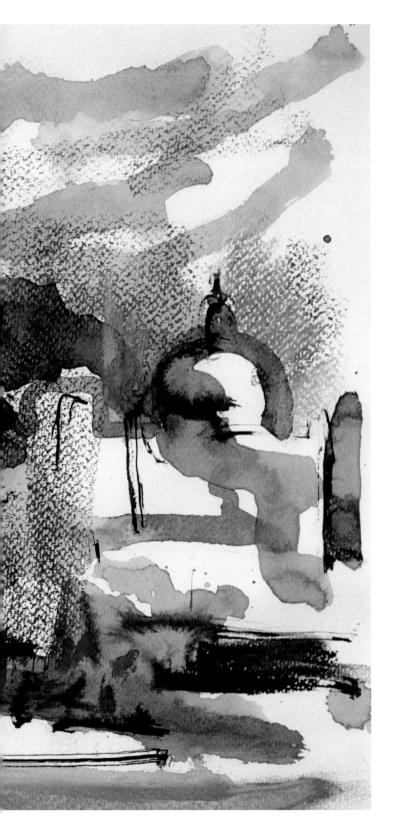

ACCIDENT

The world around us is not entirely ordered, structured or controlled – things happen. The car crash, the lost wallet, the dropped ice cream. Spontaneous incidents – something surprising or unplanned – bring a certain kind of disorderly drama. In drawing this can be very useful; the key is to know which accidents might be helpful and which are distinctly not. It seems odd but this more or less started with a spillage of coffee – I just allowed the brush to travel through it in places, mopping up other more unhelpful areas. There was no weight of expectation, just dealing with the situation and literally messing around until something began to emerge. Why not try it? Then, when it's dry enough, add some pastel or other drawing materials until the balance between definition and suggestion works for you.

Liverpool Skyline (detail)
Mixed media (P)

TOP AND ABOVE *Liverpool Skyline*
(stages 1 and 2) Mixed media (P)

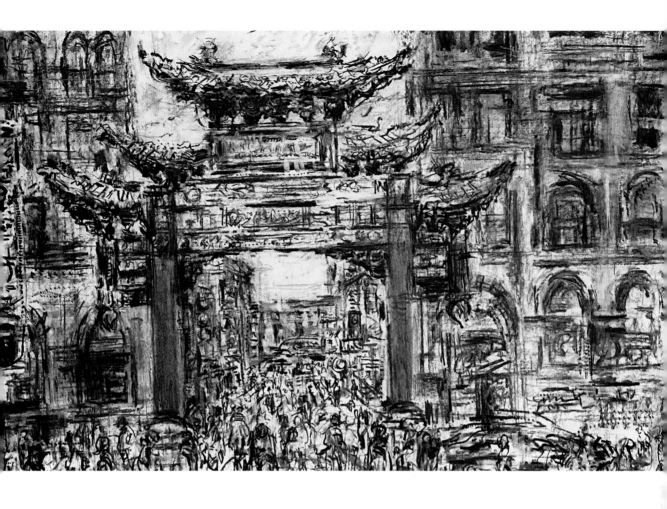

AMBITION

This should be at the heart of everything you attempt, whether it comes off or not. Desire and enthusiasm count for far more than any single artwork. Ask yourself what kind of ambition you have for your drawing so you can be specific about what it is you're trying to achieve. If you can pin this down, then you have a better chance of improvement. Think about the qualities you're trying to attain: does your work need more energy, atmosphere or structure? Choose the art materials best suited to your goals and discover ways of using them accordingly.

Manchester Chinatown (detail)
Charcoal (J)

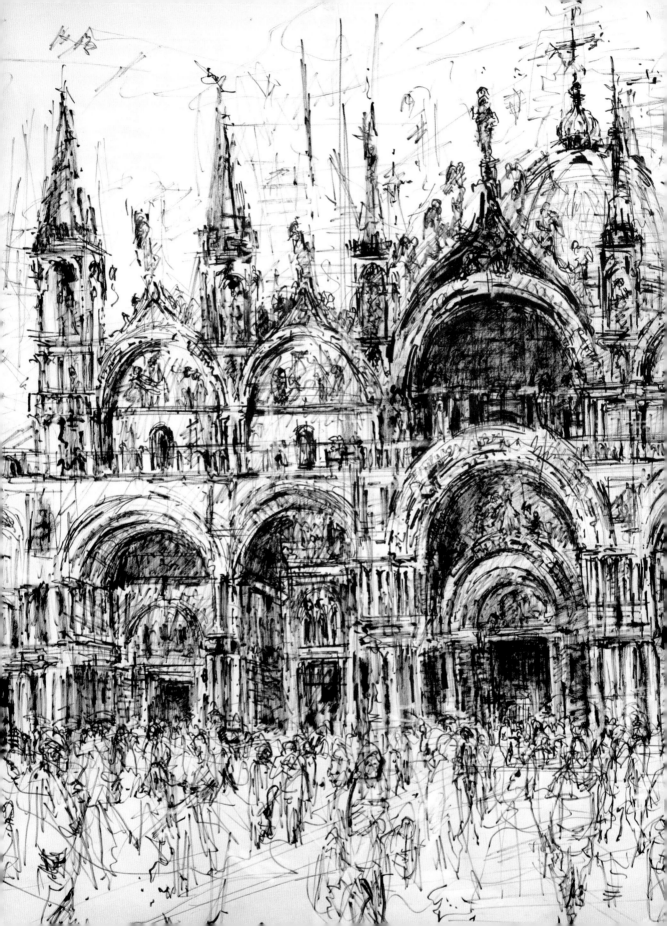

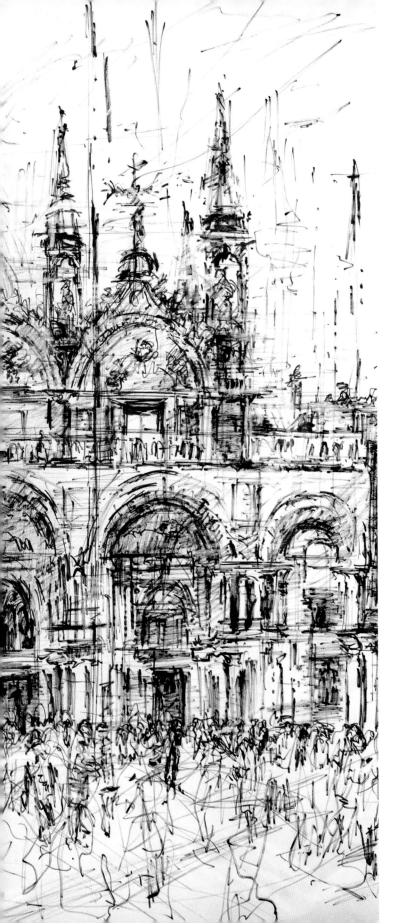

ARCHITECTURE

Architecture has long been my inspiration, the majestic buildings on Liverpool's waterfront, the city's twin cathedrals and busy shopping districts shaping my working practices when I was an undergraduate.

All these years later I travel around the world in search of new architecture and environments to experience and draw. Cities are symbolic of who we are, who we once were and who we desire to be. They are an expression of human ingenuity, imagination and desire.

St Mark's Basilica, Venice (detail)
Brush pen, white paint (J)

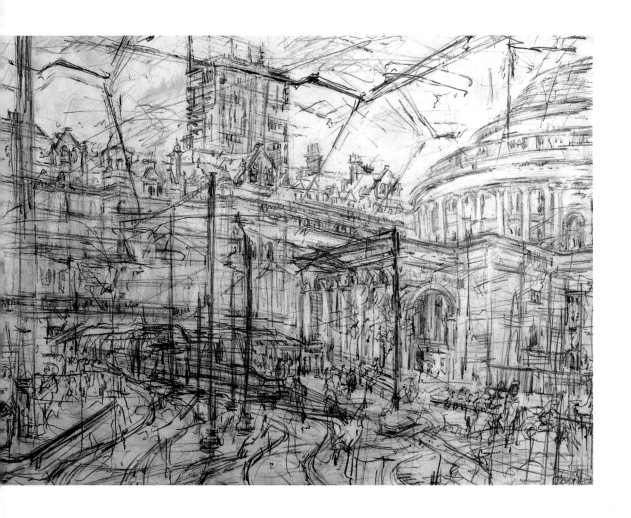

ARTIST'S EYES

This is an easy phrase to help you remember this very simple exercise. If you half-close your eyes, especially when outside looking at a scene, everything will be simplified, quite tonal. Open them again and you get all the details. It's such a good way to start off. Simplify, then

be particular. You can go in and out of this whenever you find it necessary.

ABOVE *Trams at St Peter's Square, Manchester* Pencil (J)
OPPOSITE *Shard From Outside London Bridge Underground* Compressed charcoal
223 × 150cm (88 × 59in) (J)

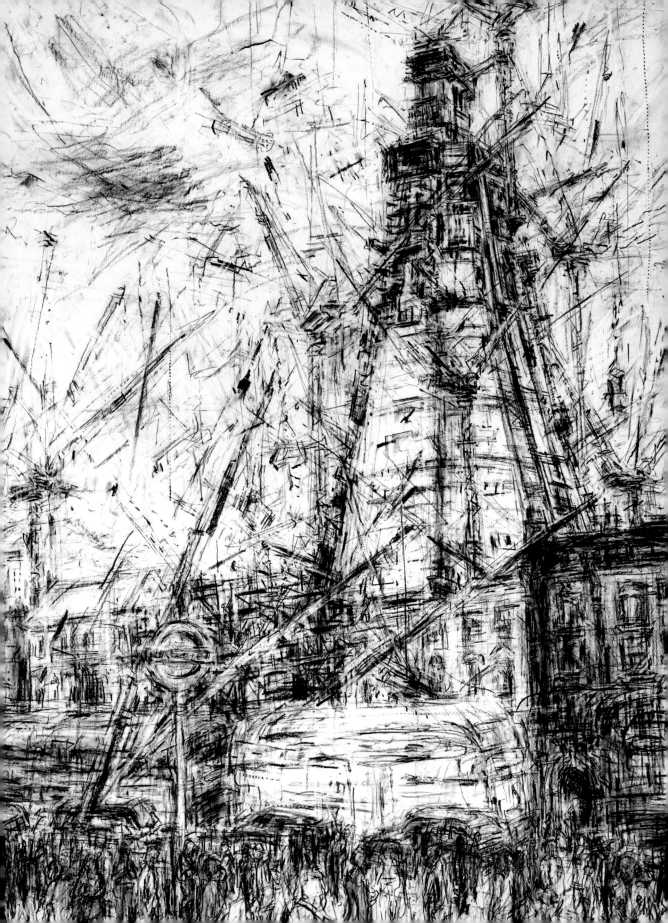

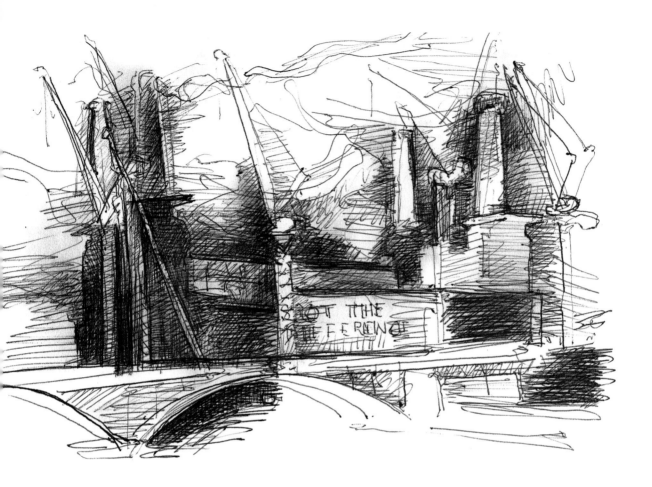

BIRO

Everyone has a pen on them. If you're caught without art materials but find something that you really want to capture, a biro is the easy answer. Along with convenience does come limitation; being almost entirely linear, biros will begin to struggle on larger sizes of paper, but they can capture an idea with ease and intensity. They'll glide across paper pretty smoothly

TOP *Atmospheric Battersea* Biro (P)
ABOVE *Battersea Power Station sketch* Biro (P)
OPPOSITE *St Paul's Cathedral* Biro on photo paper (P)

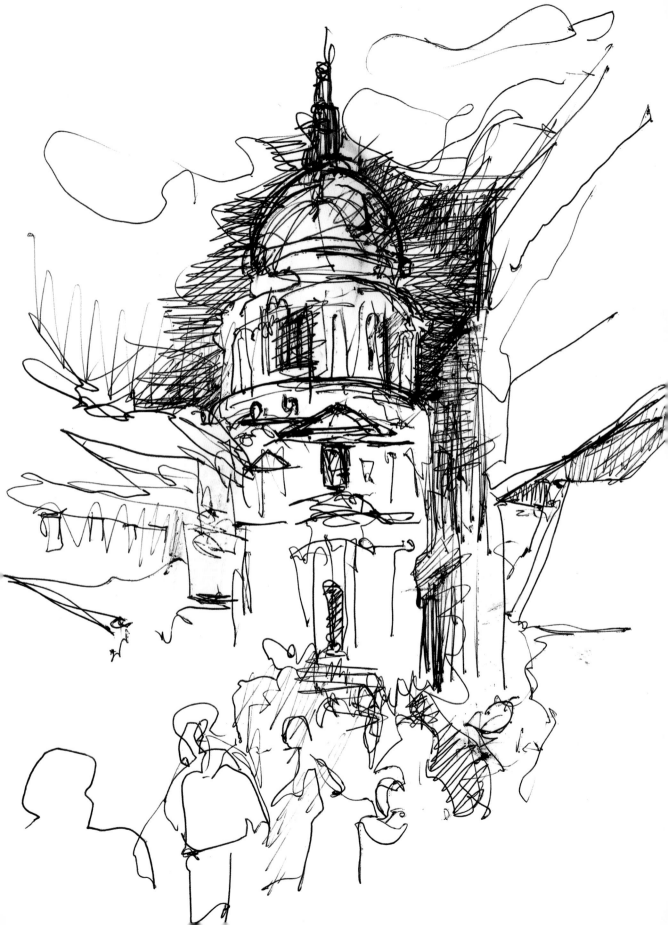

(try them on photographic paper and this sense of flow will be increased). Because a biro sketch is never a big deal there's rarely any pressure to perform – without thinking, you'll correct or redraw until the thing that you're after begins to emerge. This is a great attitude to bring to more 'important' situations.

Begin with a two-minute sketch and allow it to develop for a further ten minutes, or as long as you feel it's heading in the right direction.

BLACK AND WHITE

This isn't as clear-cut as it sounds! If you take colour out of the equation you're still left with something that's full of nuance, variety and contradiction. Black-and-white artworks often emphasize how they've been made and the types of materials used. It's a world in itself, which if you are at the beginning of your artistic journey is a useful start, as it's as simple or as complex as you want to make it.

Sheikh Zayed Road, Dubai Biro (J)

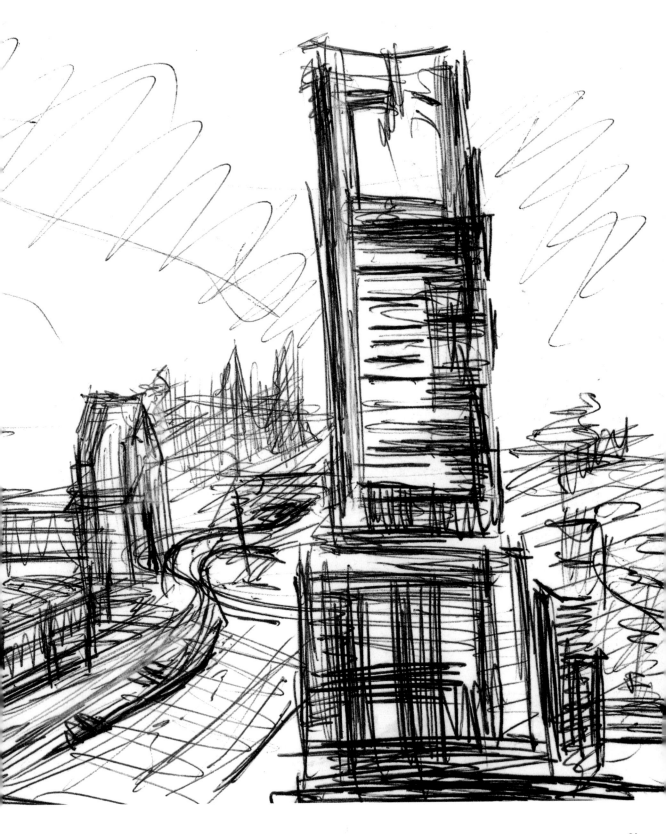

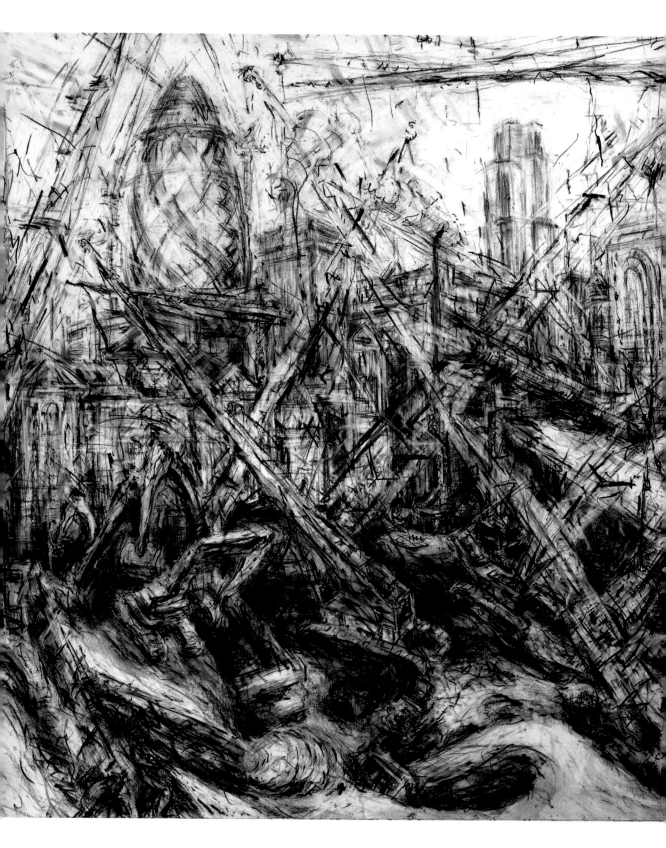

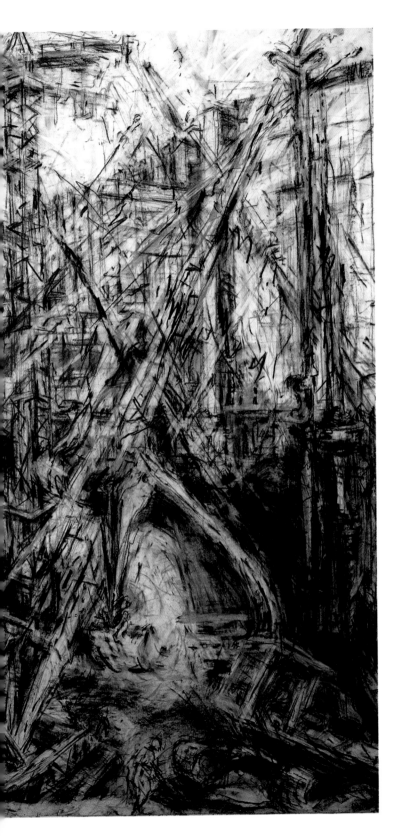

BUILDING SITES

I have drawn many, many building sites over the years. I love how cities reinvent themselves through their evolving architecture; whole areas can be revitalized. Change isn't always progress but building sites tend to be a place of optimism and visual dynamism regardless of outcome. It's a bit like making a drawing – there's endless activity, unexpected events and extremes of space and scale; for me, it's the ideal subject, as results don't have to be constrained or tidy to reflect that reality.

Bishops Square, Spitalfields
Compressed charcoal
150 × 215cm (59 × 85in) (J)

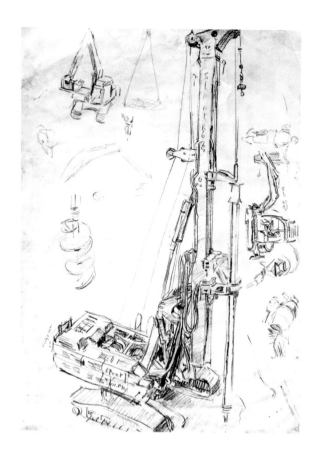

LEFT *Drill* Pencil (J)
BELOW *Digger* Pencil (J)
OPPOSITE *Shard of Glass
from London Bridge*
Compressed charcoal
150 × 223cm (59 × 88in) (J)

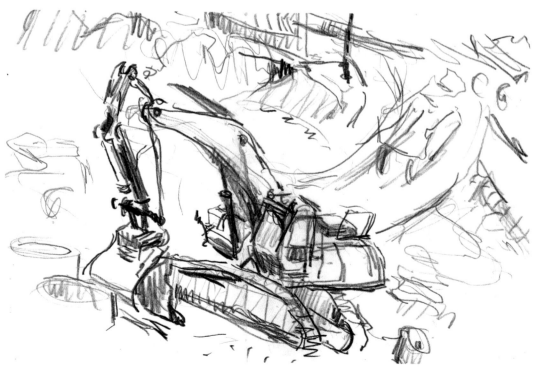

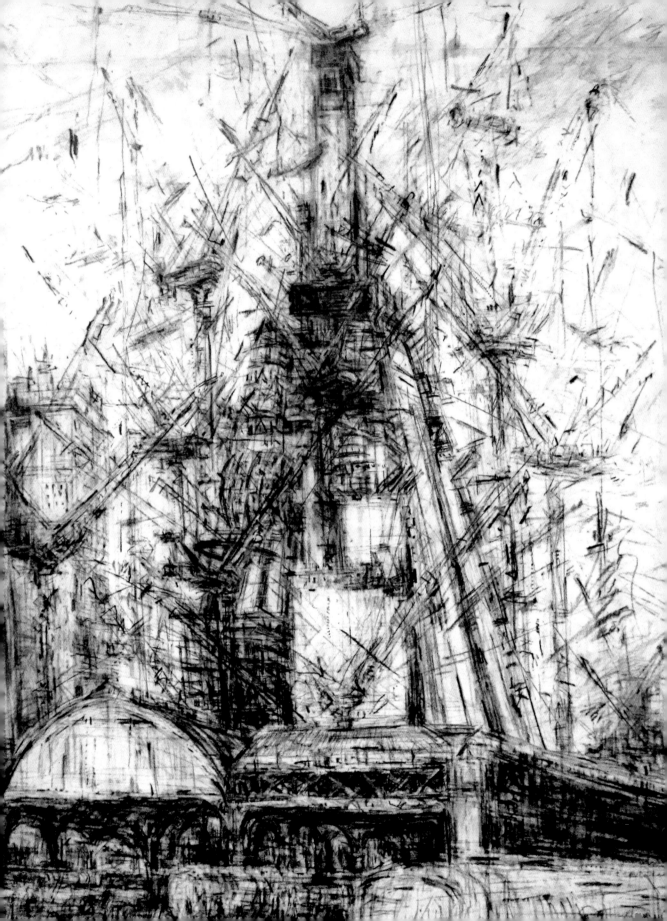

CABLE CARS

I really enjoy drawing the
continuous movement of cable
cars; they will always return,
so you can keep on drawing
them in the positions that
best suit your design. The
change of scale helps make an
interesting composition. They
can seem huge as they come
towards you, then minute as
they move away into space.
Drawing the view from
inside a moving cable car is
also a uniquely challenging
experience.

*Cable Cars over Greenwich
Peninsula* Pencil (J)

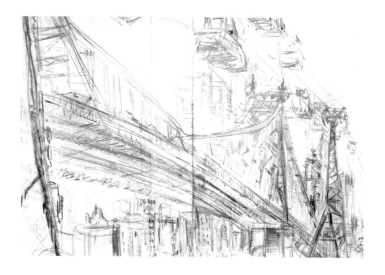

ABOVE
*Roosevelt Island
Cars* Pencil (J)

RIGHT *Cable Car Towards
Manhattan* Charcoal
105 × 150cm (41 × 59in) (J)

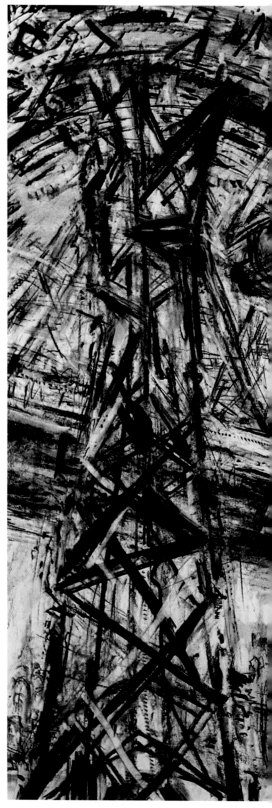

Exercise

When I am sketching something moving, I'm happy to leave out parts, implying the motif rather than capturing it too much. If you are lucky to be able to sketch cable cars or anything that moves repeatedly, stay in one place and honestly draw everything you see in, say, a 15-minute period. You might start with pencil for the first half of the time and then, if it's a repeated subject, use something darker like a thin marker pen, allowing marks to overlap some of the first drawing without cancelling out previous marks. I often think it's the marks outside the main subject that help show movement and speed; it's also about where objects have been and anticipating where they will go. I sometimes draw on tracing paper and then overlay drawings – it gives a feel of energy to the combined work.

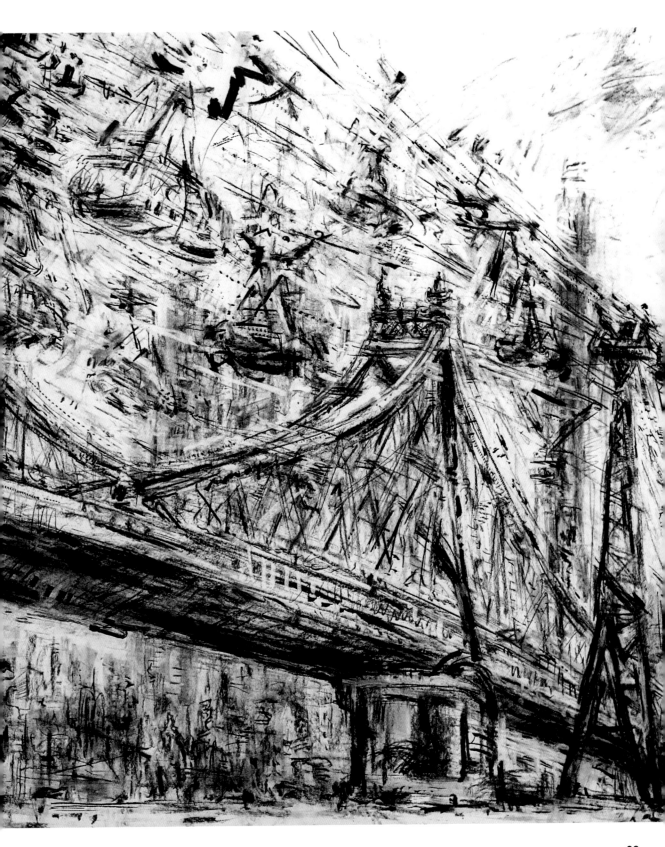

CHARCOAL

This is a wonderfully versatile
material that rewards bravery.
If you think of it just as a
messy pencil you won't get
the best out of it. It comes in
a whole range of thicknesses
from ridiculously thin to tree
trunk. Medium and thick
are the most useful in our
opinion. Charcoal rewards
instinctive use and can build
light and shadow quickly; it
responds well to lightness
and heaviness of touch as
well as speed of drawing,
so is great for capturing
movement. When used on
its side it can block in large
areas quite quickly and is
extremely sensitive to the
texture of the paper you're
using. You might try adding
texture before you start with
an acrylic paint or gesso (let it
dry thoroughly). Any charcoal
drawing will, however, need to
be fixed either with hairspray
or artists' fixative to keep it
stable in the long term.

Salford Quays, Manchester
Charcoal over acrylic gesso (P)

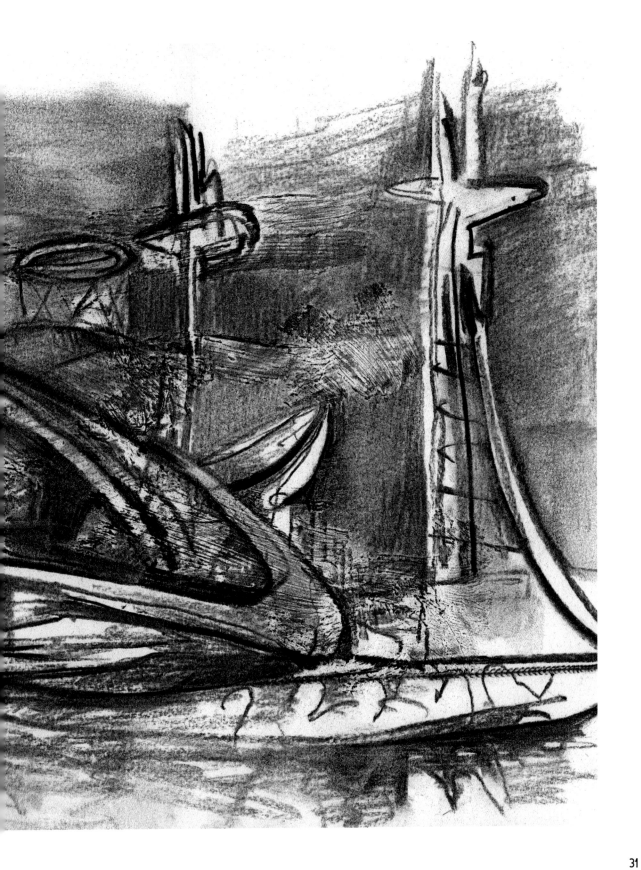

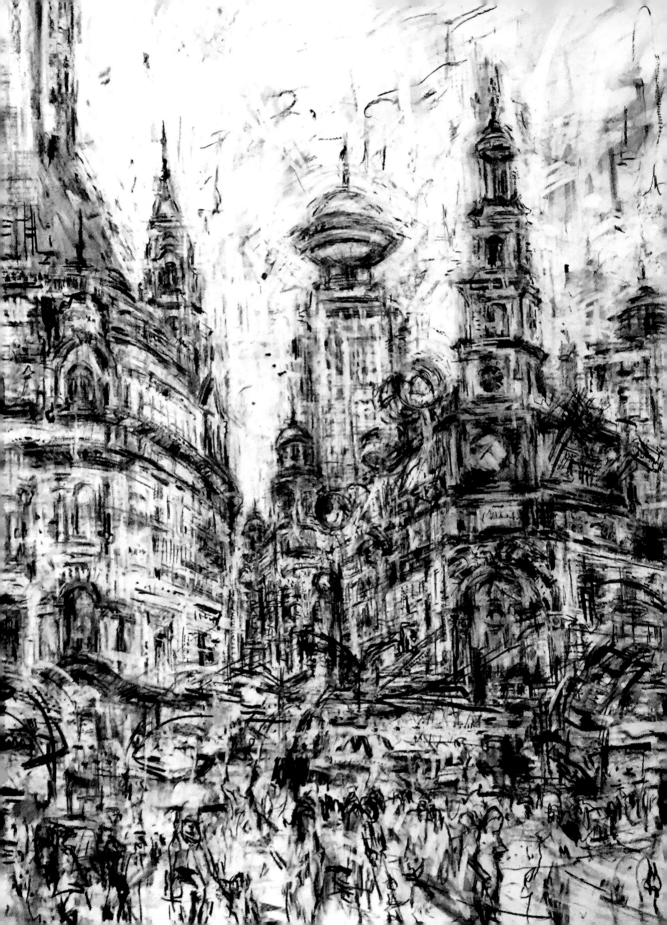

Exercise

Test the flexibility of your responses and the charcoal's potential by making a range of sketches of the same subject. Give yourself eight minutes to make a charcoal drawing on an A5 sheet, six minutes on an A4 sheet and only three minutes on an A3 sheet. The time you've spent observing your subject will make your decision-making sharpen up by the time you get to the last sheet. That knowledge of the subject will also allow you to become more instinctive and even playful with the material.

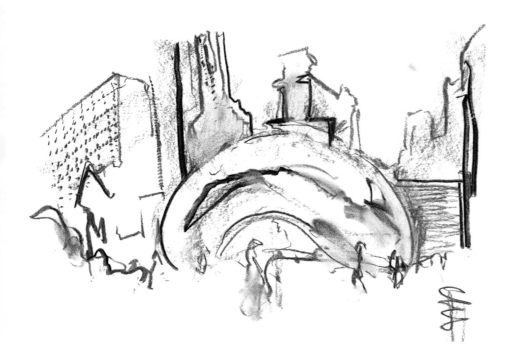

TOP, ABOVE AND LEFT *The Coffee Bean, Chicago* Charcoal (P)

OPPOSITE *Nanjing Road, First of May* Charcoal 162 × 140cm (64 × 55in) (J)

CLASSES

There's a lot you can achieve on your own through patience and practice. What might be harder to do on your own is explore new ideas with the confidence of knowing results are achievable. We always love looking at what others have produced in a class; you can learn so much from seeing a range of different outcomes, their use of materials, compositions, ways of interpreting the same instructions or source material.

We have always taught drawing for a number of art institutions. During lockdown we took our workshops online, from figure and portrait to urban drawing. It was the first time we had used photography and film with students, discovering how we could get them to produce drawings that were inventive, confident and personal. If you want to find out about our classes, especially city sketching both online and on location in London, then take a look at our dedicated teaching website that covers workshops for both school students and adults: weexploredrawing. co.uk. Even if you don't take our classes, there is a class out there that will make you a better practitioner. Artists are always learners. Always.

COCKTAILS

If you've been working hard, it's important to treat yourself. When I'm drawing abroad my mission in life is to find the best Cosmopolitan in a bar with the greatest view after the long hours spent with a drawing board. I can't always afford dinner in the posh hotels with the best views from on high, but will happily splash out on a cocktail, look out on the scene and plan the next day or, if it's still light, get in a bit of sketching overlooking the city.

When I was in Shanghai I found that a cocktail cost about as much as a pot of tea, so there was no competition there whatsoever.

Two Towers Charcoal
195 × 150cm (77 × 59in) (J)

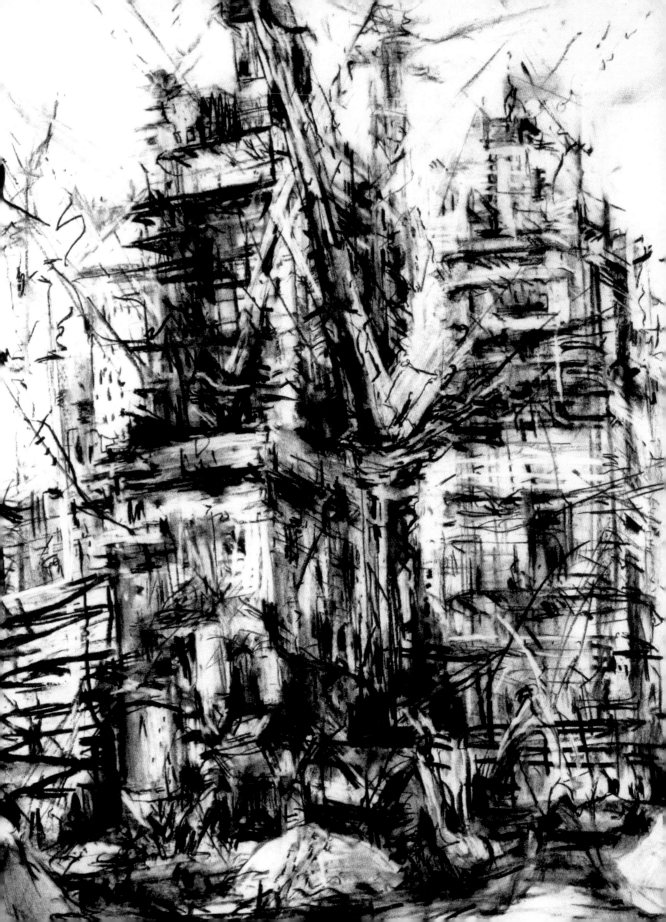

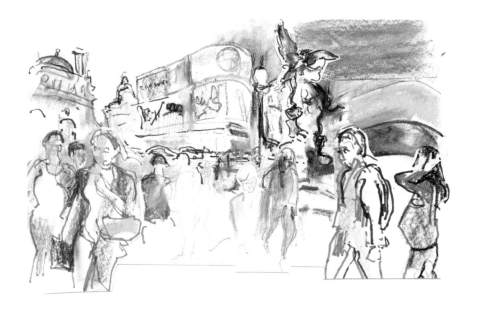

COLLAGE

Collage is a great way of experimenting with composition and design. You might take some photos yourself of a place or collect some images of cities and, in the old-fashioned way with scissors and glue, create new cityscapes to draw from. On the other hand, you might have a drawing where some parts are letting the picture down and can't be altered. You might decide to collage a fresh piece of paper onto that area and have another try. The sense of fracture will also 'speed up' your image. You might also like to combine your sketches with other visual information such as maps or photographs to create a wider sense of place.

ABOVE *Piccadilly Cubism*
Pencil, pastel, pen (P)
OPPOSITE *Past and Present*
Maps, pencil (P)

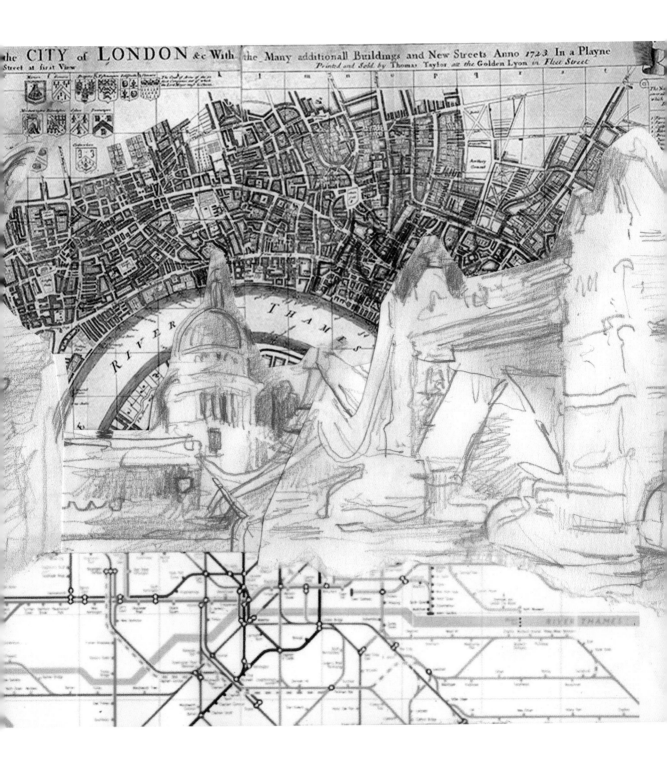

the CITY of LONDON &c With the Many additionall Buildings and New Streets Anno 1723. In a Playne
Street at first View
Printed and Sold by Thomas Taylor at the Golden Lyon in Fleet Street

RIVER THAMES

RIVER THAMES

COLOUR

Colour can be used to give
life to an image as it creates
drama or harmony that we
instantly react to. I'm not a
fan of 'filling in', either with
colour or shaded tone; a filled
shape will largely remain
flat and inert. Think about
applying it more freely so
that the application itself
imparts some kind of energy
– if colour comes before line
it won't feel as constrained,
so try drawing by quickly
building suggestive blocks and
then adding linear focus only
where necessary. You don't
have to reproduce the colours
that you see in front of you for
your drawing to make sense.

ABOVE RIGHT, RIGHT
AND OPPOSITE *The Shard
from the Street* (stages 1–3)
Pastel and charcoal (P)

38

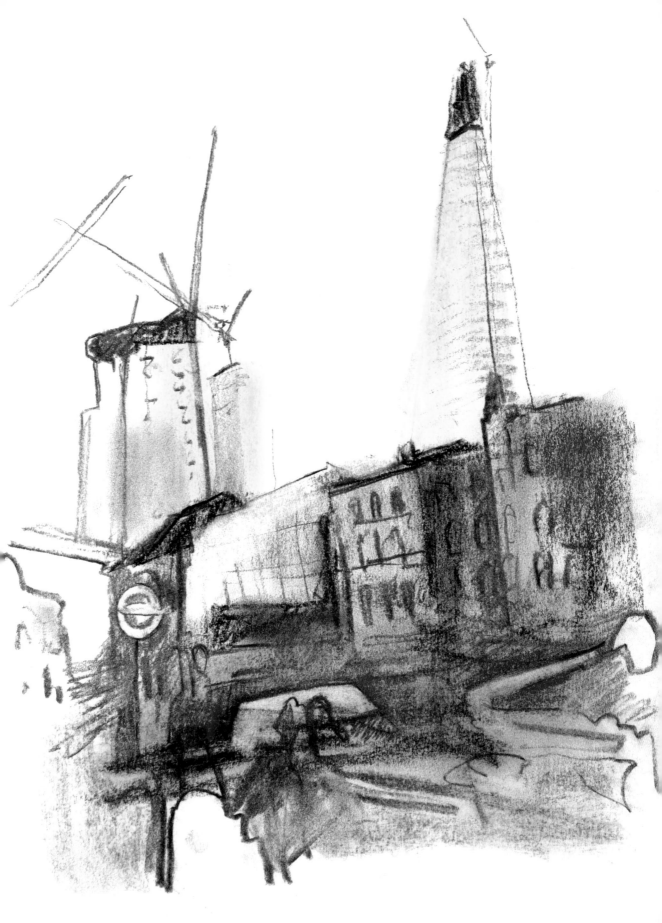

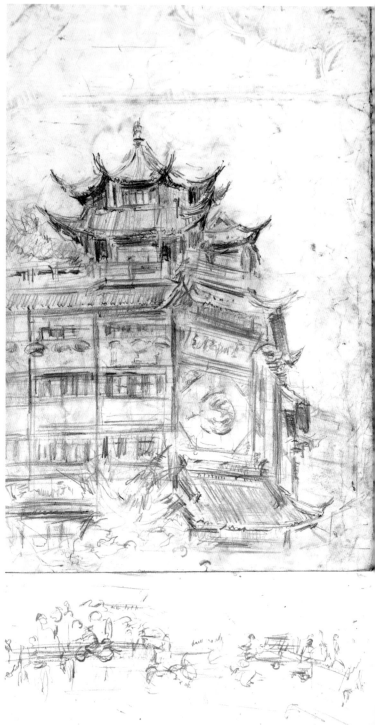

COMPOSITION

It's often useful to create alternatives. I take the sketches I make on location and combine them back at the studio to create a number of options. The key thing is not to spend too long on them but to play around without feeling any pressure; a quickly drawn idea will help with the energy of the final work. On location it's a bit different; I'm not really looking for a perfect composition but a set of ideas that I can work into something finished later. I start from the part of the scene that interests me the most, then move on to connected areas, moving out in all directions. A quick

Shanghai Studies Pencil (J)

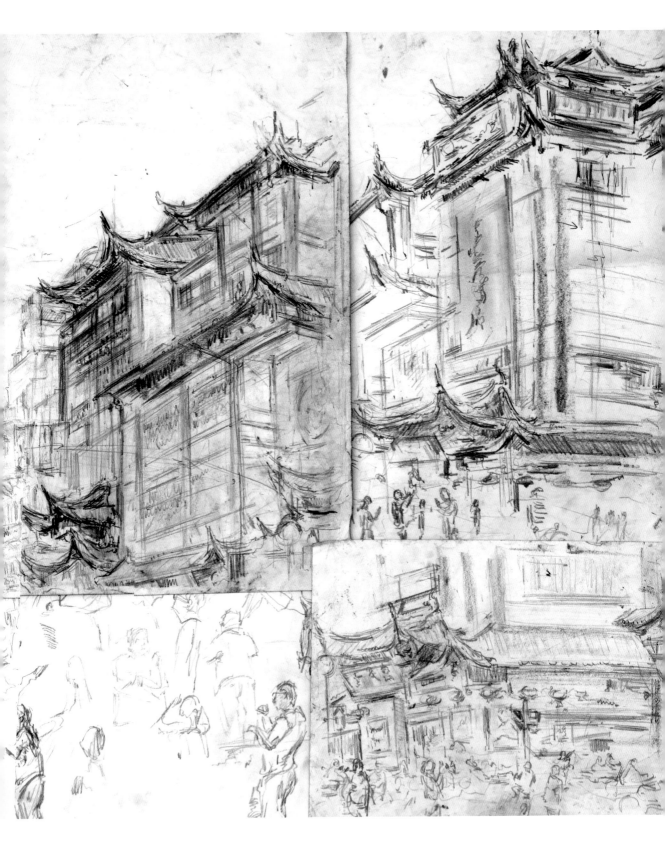

41

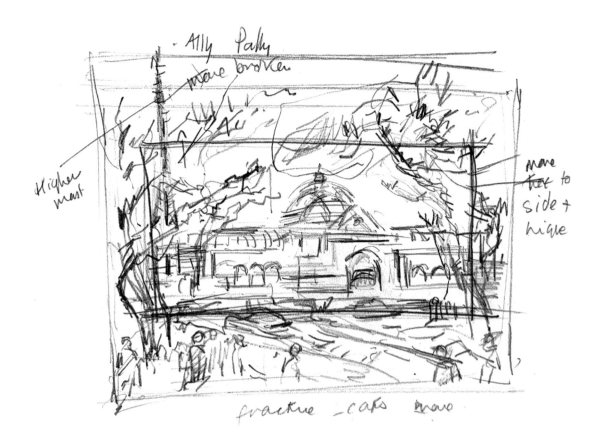

plan will help you decide if
it should be landscape or
portrait, bigger or smaller –
how might it all fit together?

Always be prepared
to use extra paper; being
precious doesn't come into my
working practice very often.
If you have a sketchbook, be
prepared to use the double
page if and when it becomes
necessary. Your sketchbook is
a tool, not a display case!

ABOVE *Alexandra Palace* Pencil (J)
OPPOSITE *Construction Site,*
London Felt-tip pen (J)

too high.

Light grey

8 Bishops gate

More sky

sky

Dark traffic light?

More traffic

More are ground

From diff angles

COMPRESSED
CHARCOAL

Despite its name, this isn't
wood; it's a manufactured stick
that comes in different grades
of hardness and softness like
a pencil. It's heavier in the
hand than ordinary charcoal
and you'll notice even before
you've drawn anything that
it's dirtier and blacker too. On
the paper it's more permanent
– it won't fully rub out – so
it's good for leaving traces,
building a drawing in layers,
leaving signs of its history.
It has a similar versatility to
charcoal (it's good for energy
and mood) without being quite
as smudgy when you work
back on top of what you've
already drawn. If you don't
mind getting stuck in, then
this is the material for you.

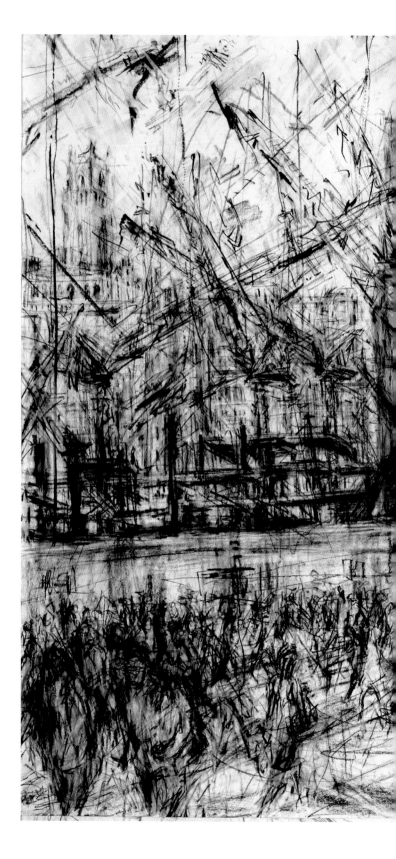

*Rebuilding Ground Zero From PATH
Station Entrance* Compressed
charcoal 150 × 214cm (59 × 84in) (J)

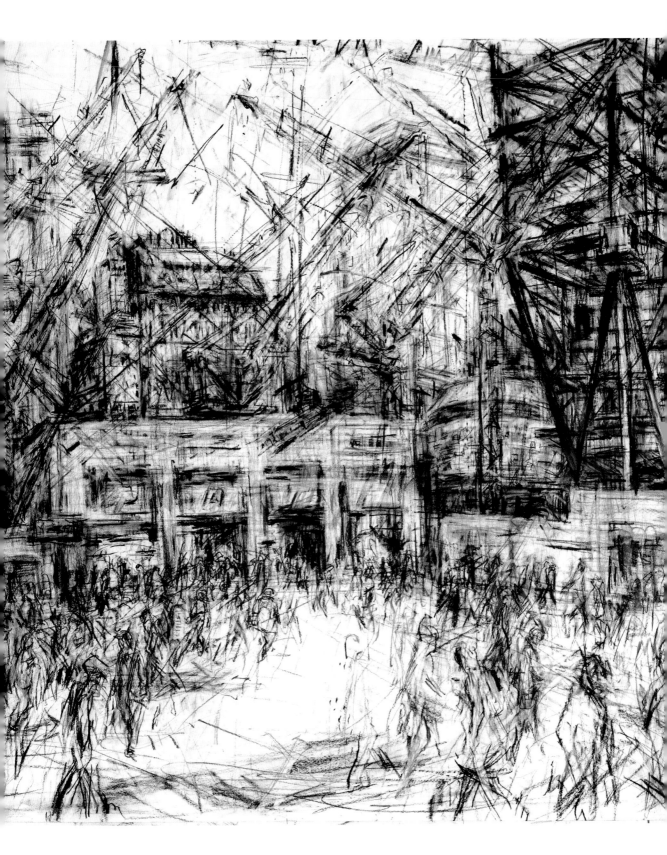

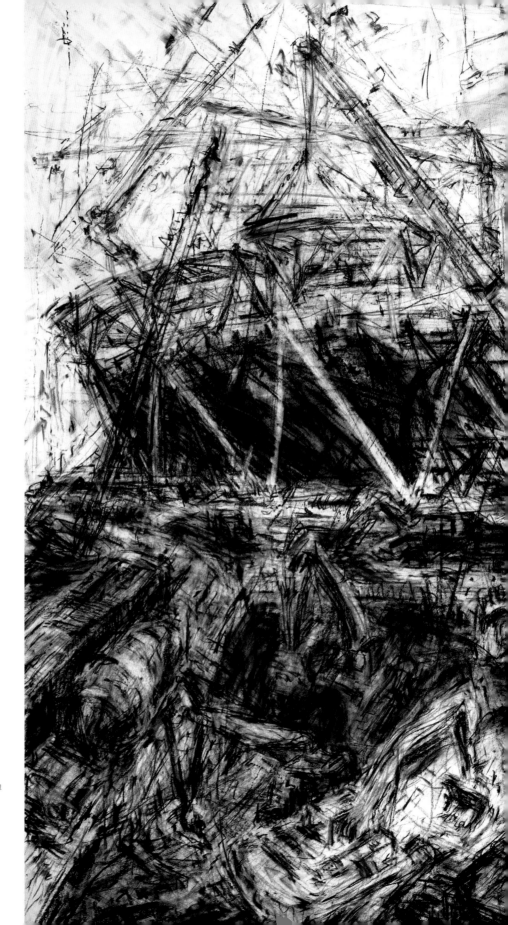

Building the Olympic Stadium Compressed charcoal 150 × 190cm (59 × 75in) (J)

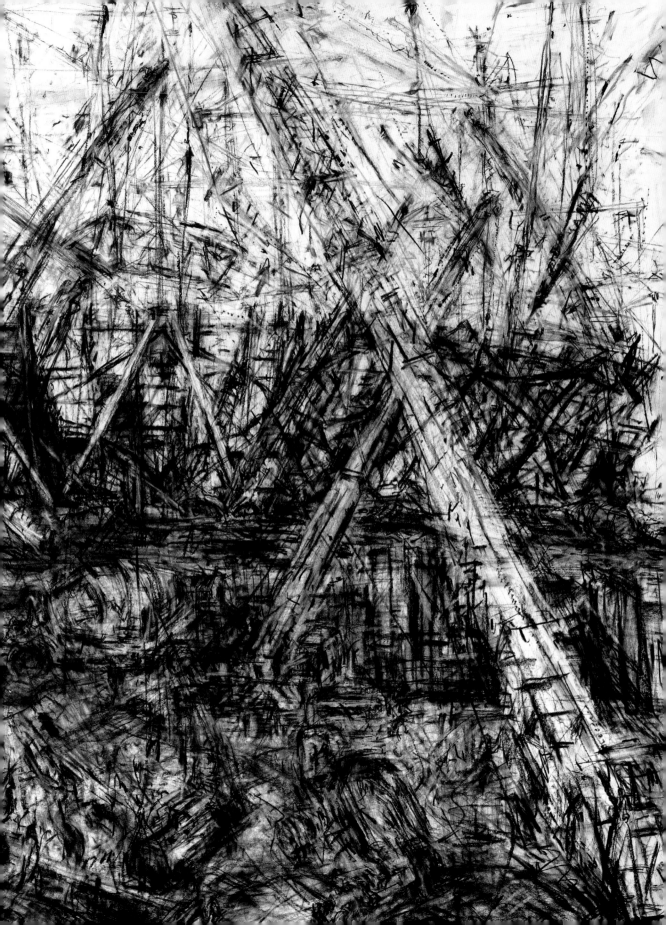

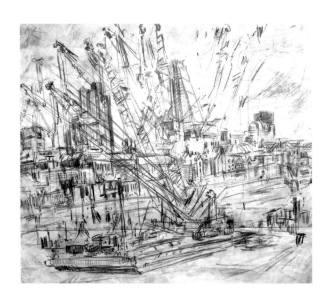

CRANES

Cranes are so slight and slender next to the larger buildings that they are connected to. Their movement is lovely; if you get a few operating together it's almost like a ballet. One of the main advantages is that they are in the sky where there is often nothing but a few clouds, so add helpful information in empty areas of your composition. You don't have to illustrate their structure – even a few loose marks tracing their journey, showing several aspects of their movement, can help bring a city scene to life.

ABOVE *Floating Crane, Blackfriars* Pencil (J)

RIGHT *Limehouse Tunnel Link* Compressed charcoal 150 × 190cm (59 × 75in) (J)

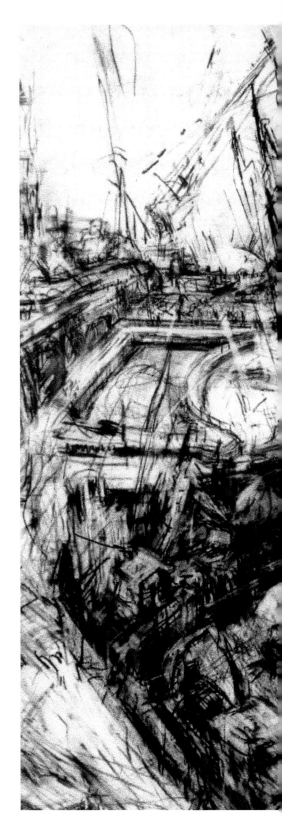

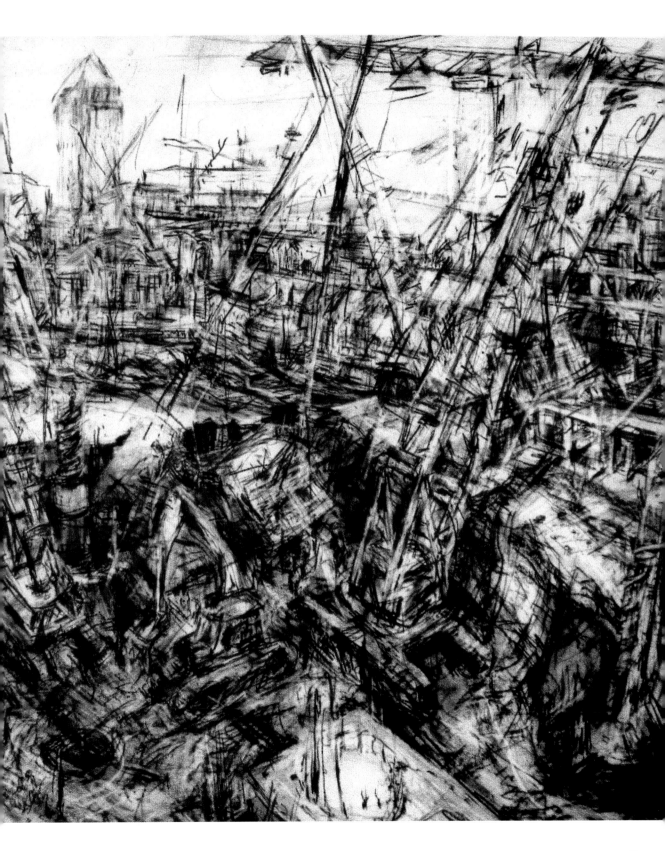

49

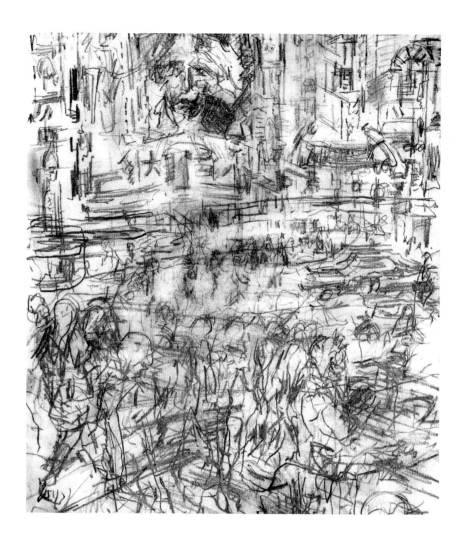

DIRTY

Well, that's me – clean of mind,
obviously, but filthy of hand,
I can't help it. I actively choose
art materials that you have to
work with in a physical way.
I often smudge in graphite
or charcoal to get a simple
impression of the composition
I intend to create, then I can
work into it with a material
I can be more particular with.

Chances are, if you really get
involved with your subject you
won't even notice the dirt and
the mess until afterwards –
carry a few wet wipes with you
and you'll clean up pretty well.

ABOVE *Shibuya Crossing Study*
Pencil (J)
OPPOSITE *Construction Site with
Gherkin* Compressed charcoal (J)

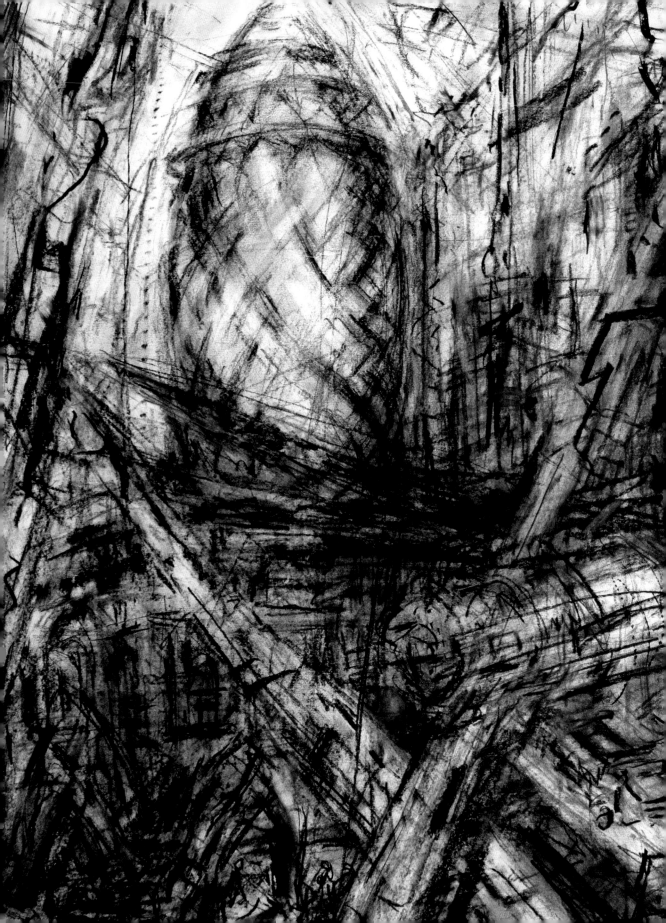

DOCKLANDS

When I first started drawing in London's Docklands I had to sit in the small Docklands Light Railway stations as there was so much site traffic it was unsafe to be on the ground. I have sketched and drawn in Docklands for 30 years, charting its changes and history. This has given me a firm connection to the place; I've never lived there but feel a sense of belonging that drawing there has created. Filthy holes in the ground in a windswept wilderness transformed into glass and steel by work and ingenuity – love or hate what the place stands for, the metamorphosis has been breathtaking.

Crossrail Station, Canary Wharf
Compressed charcoal
150 × 215cm (59 × 85in) (J)

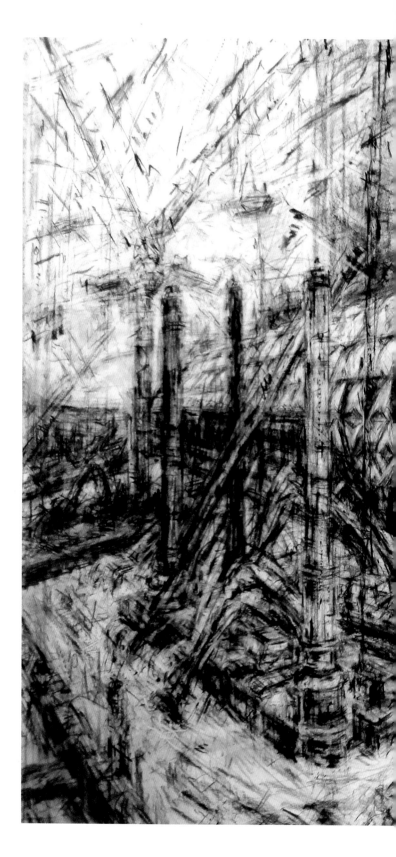

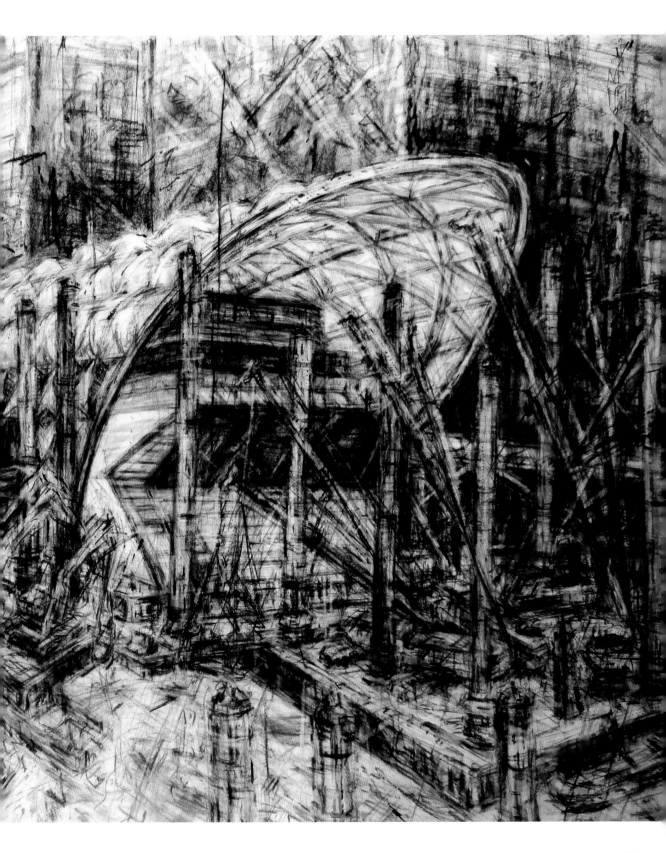

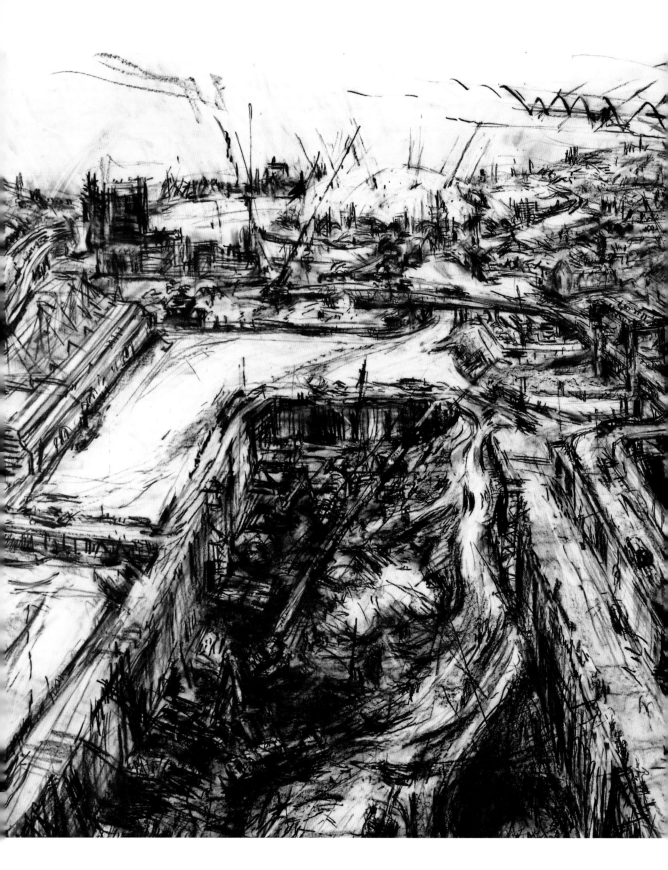

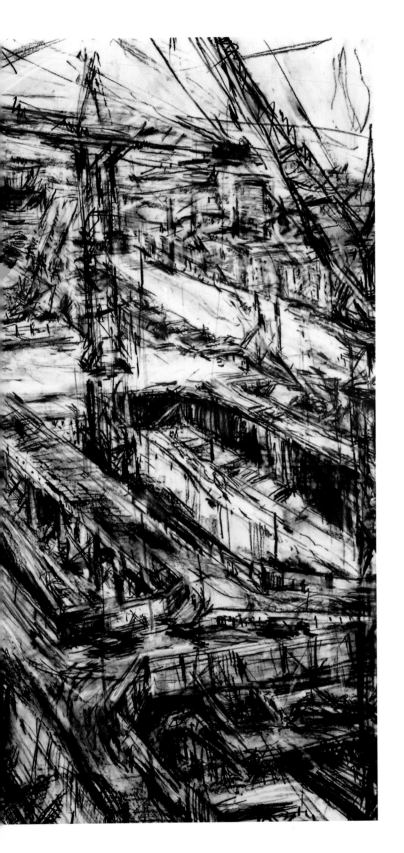

DISTRACTION

In everyday reality, things surprise us, distract us or catch our attention; it's a normal part of how we experience the world. If such things – the passing car, the stray dog, the shop window – can be built into our drawings in a way that recreates that sense of how we saw them, this will bring the drawing to life. These things may not be the main focus of what you're doing but there's a truthfulness to life in distracting the viewer.

Towards the Dome Compressed charcoal 150 × 190cm (59 × 75in) (J)

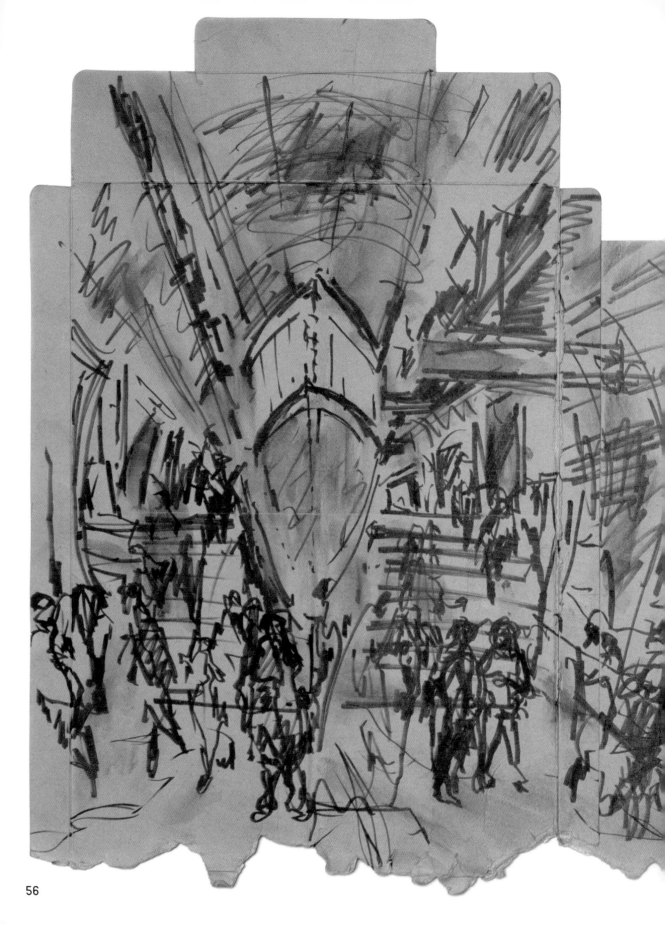

56

DOG ENDS

It sounds ridiculous but
they are very useful and, no,
they're not cigarette butts.
When I say dog ends I mean
some paper that's not that
great, either cheap or a bit
damaged, and some old type
of material I haven't used
for ages. Something right at
the bottom of my bag, an old
crayon, a cheap bit of chalk,
an almost-running-out felt-
tip pen. The fact that it isn't
precious allows you to play
around, working in a very
different way and often with
surprising results. I might
not even keep the sketch,
but it might provide new
information, which then
allows me to experiment a bit
more on subsequent pieces.

Southwark Underground Station
Pen on cardboard box (J)

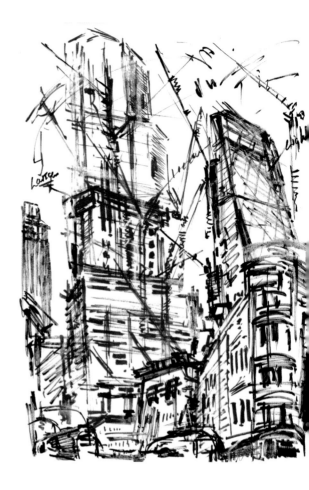

DUPLICATE

If you want to use a number of sketches from a sketchbook to make a larger drawing it's no good just flicking through them, because this is how details are missed. The sketches have to be taken out of the book and used in conjunction with one another. If you don't want to pull your sketchbook apart, photocopying or scanning is the answer. You might at times wish to work over a sketch – playing with alternative ideas without destroying the original. Duplicate it to create a starting point that can be experimented with practically risk-free.

ABOVE AND OPPOSITE
Site near Leadenhall
Pen (J)

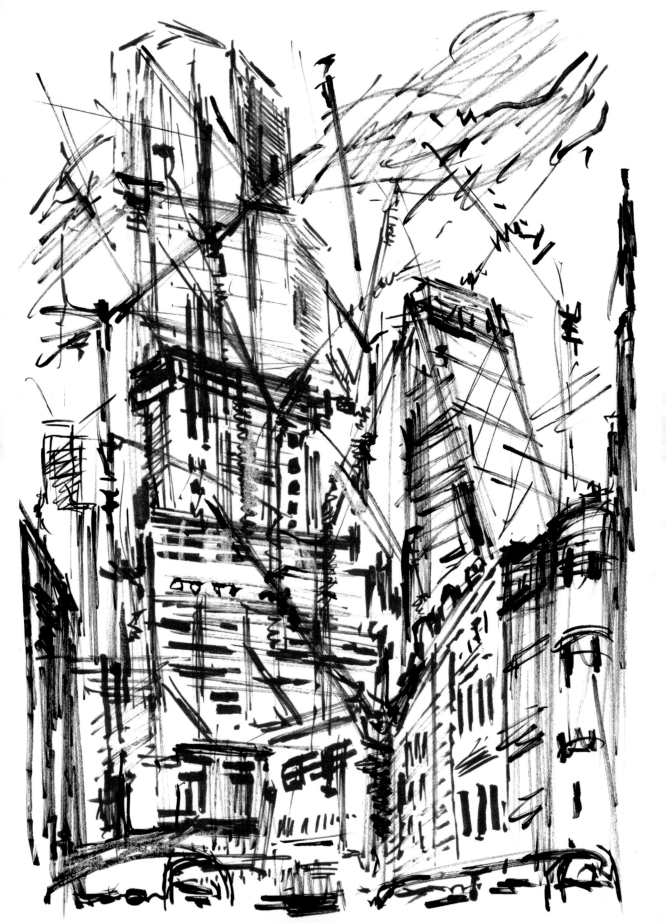

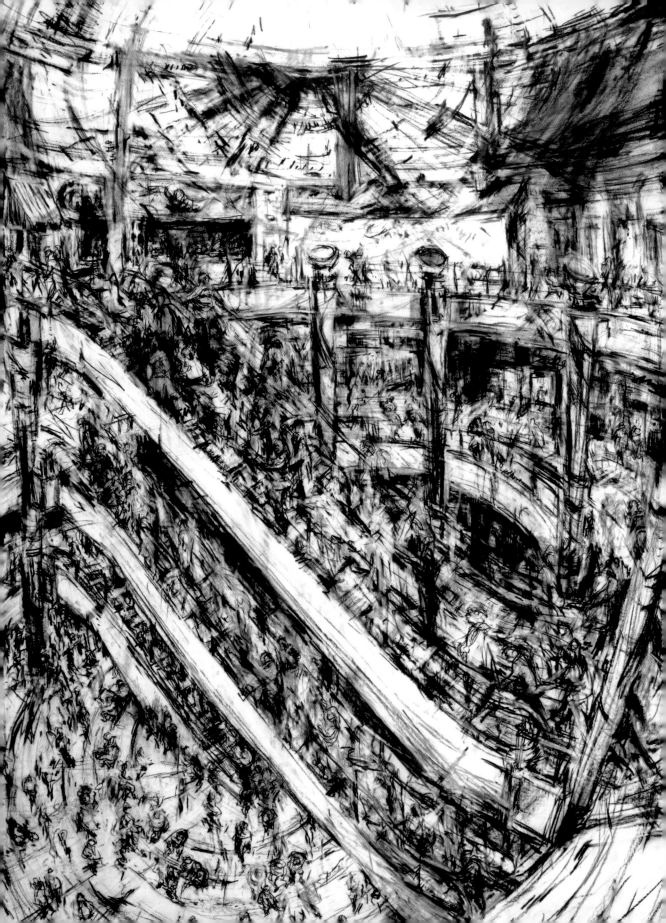

ESCALATORS

I once worked out percentage-wise how many of my pictures had escalators in and, as it was a time when I was drawing in stations, it was well over 50 per cent. I adore them. I come from a little town where there weren't any and I remember one of my treats on holiday was to ride an escalator. What's not to like? Shiny, smooth, effortlessly taking you upwards and onwards. The great thing is, people keep pretty still on them – it's easier than trying to draw figures walking upstairs. Even if there are only a few individuals on them you can draw them several times as they disappear into the distance, making the scene feel like it's a lot busier than it actually is. I was commissioned to draw the escalators inside Canary Wharf shopping mall for the Financial Services Authority. I made a 2-metre (6½ft) drawing of the three sets of escalators from different levels, very enjoyable but very difficult – all of that looking up and down was really hard on my neck!

Escalators, Canary Wharf
Compressed charcoal
213 × 150cm (84 × 59in) (J)

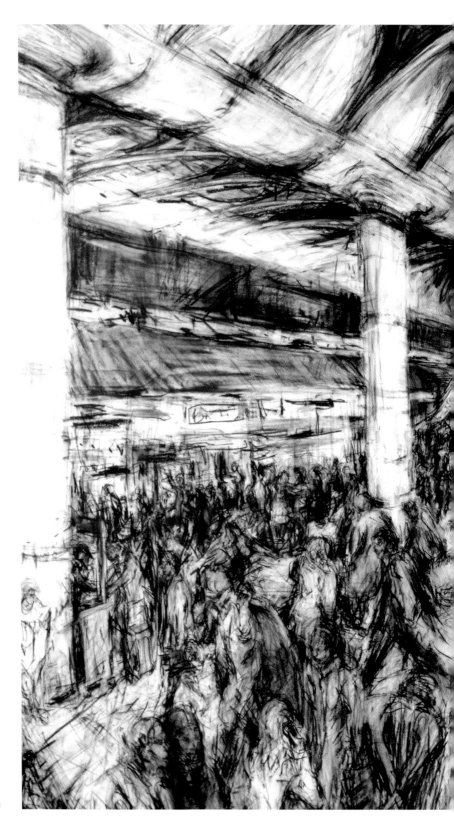

Inside Canary Wharf
Underground Station
Compressed charcoal
150 × 190cm (59 × 75in) (J)

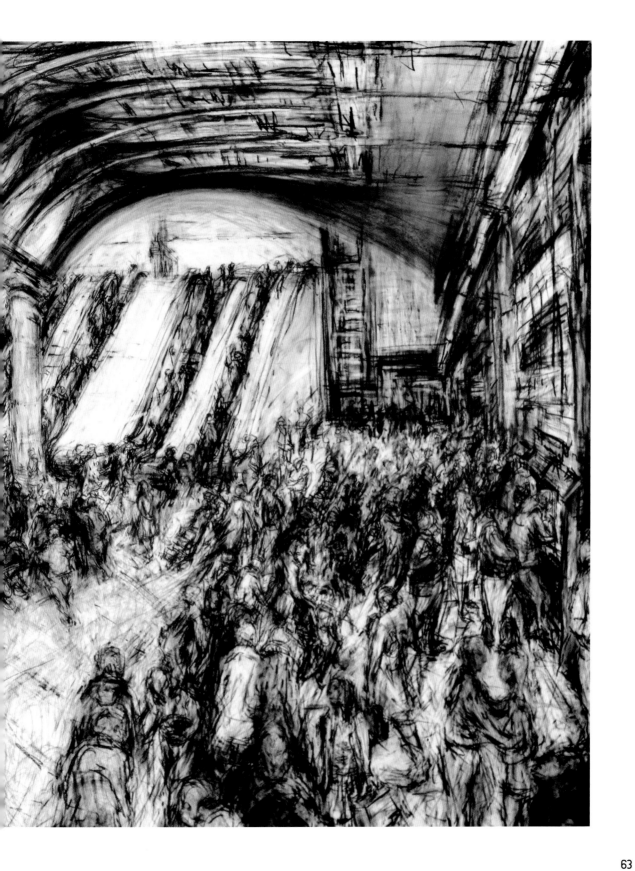

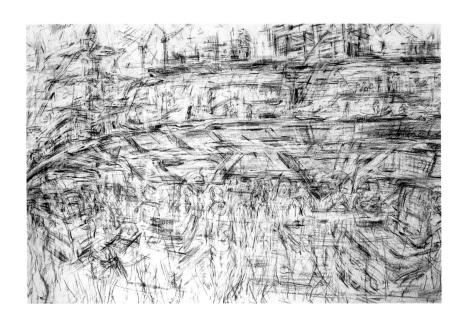

EVOLUTION

It's not always the case that your drawing will develop predictably from start to finish. You might change your mind about what you're trying to capture as your drawing progresses or as new information becomes available. You might rub an element out in the hope of replacing it with something more appropriate at the next attempt, you might draw over something, burying that initial statement beneath its successor. All these things deflect and divert the picture's journey. It pays to keep an open mind about how your drawing might progress, making the most of opportunities as they appear and being prepared to edit out what is no longer useful.

It isn't helpful to think of rubbing out as a negative thing. It provides the space to allow for change as well as altering the lighting and weight within an image. As drawings progress over time they often evolve, going through periods of construction, then destruction, then construction again – layers being put down and accumulating,

ABOVE AND RIGHT
Canning Town Station (details)
Compressed charcoal (J)

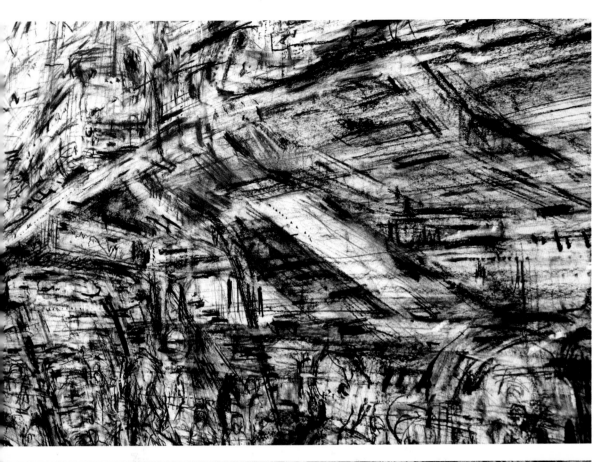

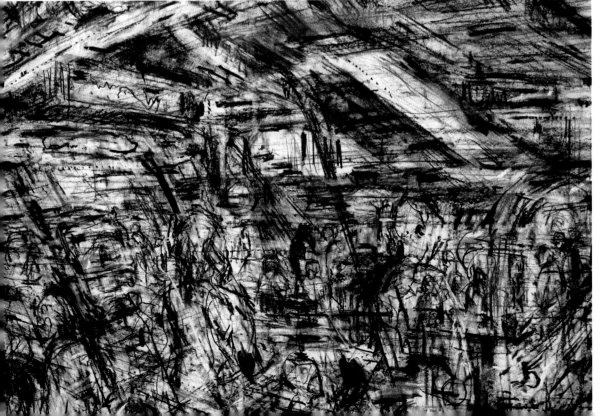

creating a network of information that rewards closer inspection.

This kind of visual density assumes its own reality but at the same time is specific to the initial experience of place.

EXHIBITIONS

Exhibitions – should you go to them? Yes, if you can; they're a great way of seeing what is going on and broadening your horizons. You are not obliged to like everything you see, but that doesn't mean that what you don't like can't be informative in some way. Should you yourself exhibit? Only if you feel like it – it can become expensive and time-consuming, but it does give you the chance to compare your work to that of others and get it out of the studio and onto a clean white wall. Don't tell yourself that you'll get rich on art sales, though. If exhibiting in reality isn't for you, then social media platforms and virtual galleries are a good digital alternative, with the advantage of keeping costs to an absolute minimum.

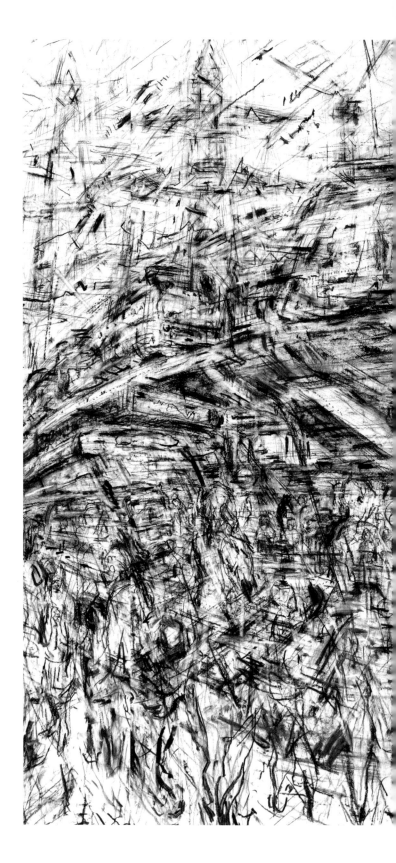

Canning Town Station
Compressed charcoal (J)

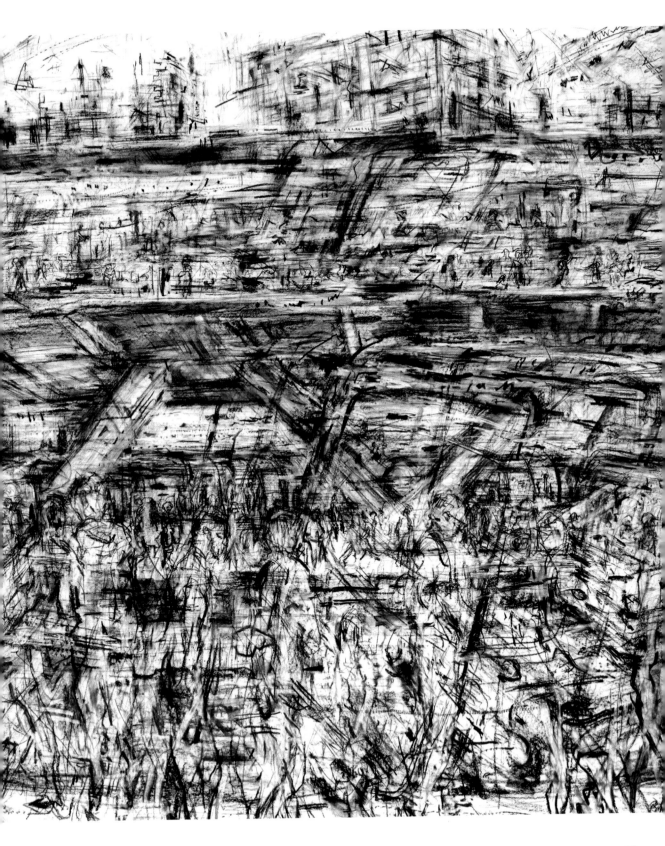

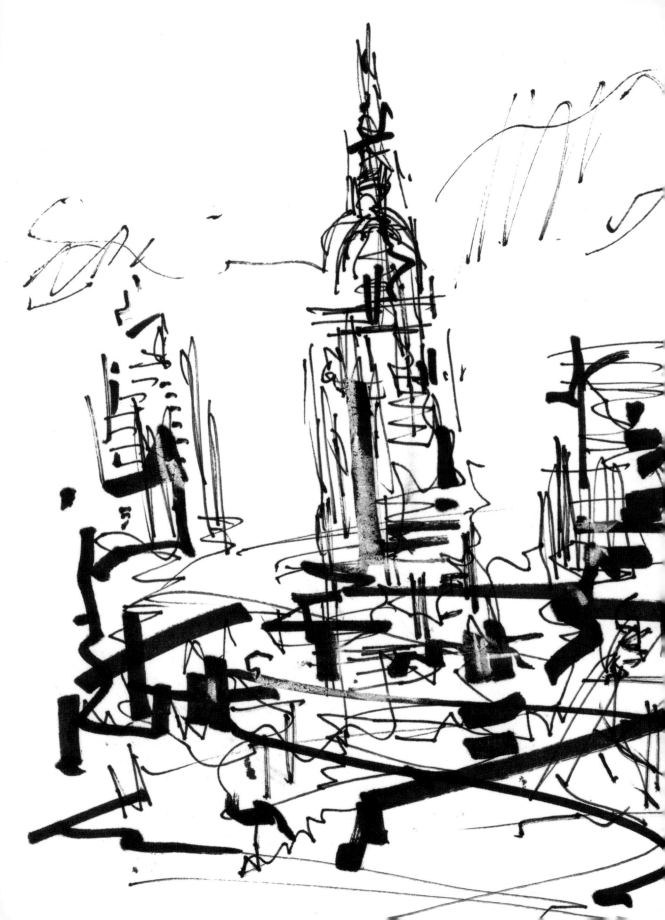

EXPERIMENT

This should be at the heart of what you're doing, not in a mad-scientist way, necessarily, but you should always be thinking, 'What happens to the drawing if I try this, what happens if I try that?' Experimentation does come with a big slice of trial and error, luck even, but you can learn just as much from a drawing that didn't quite turn out as you can from one that did. Development always involves some sort of step into the unknown. You might try experimenting with combinations of materials, the amount of time you allow yourself for a drawing, or the size of paper you might use. Some people like the idea of using their weaker hand to create something more unexpected. If you don't feel comfortable experimenting on location, work from photographs at home or in the studio. (Remember that any source or subject matter is the beginning of your journey rather than its destination.)

Architecture Study
Pen, permanent marker, white paint (J)

EXPERTISE

Being an expert isn't always an advantage. If you know too much about what you are doing your approach might easily become a fixed method, resulting in endlessly repetitive outcomes. Sometimes it pays to sabotage your own expertise – use materials that are new to you, put yourself in unfamiliar surroundings or do the opposite of what your common sense tells you when putting a drawing together. In creating new problems to solve, you have to look elsewhere for solutions, invent new answers and allow your expertise to expand.

EXPRESSION

What are you expressing? Probably not some sort of big dramatic emotion; more likely you want to express your sense of 'being there' and the experience of whatever is happening before your eyes. Drawing can never be purely objective, dealing with optical data only, so in that sense it will be expressive without you having to overdo it. If you'd like your drawings to explore the kind of energy or vitality that the city has to offer, the answer lies within how you use your chosen art materials. Working quickly and instinctively will mean that your work gains more of these qualities.

South Bank of the Thames
Acrylic gesso, felt-tip pen, pastel (P)

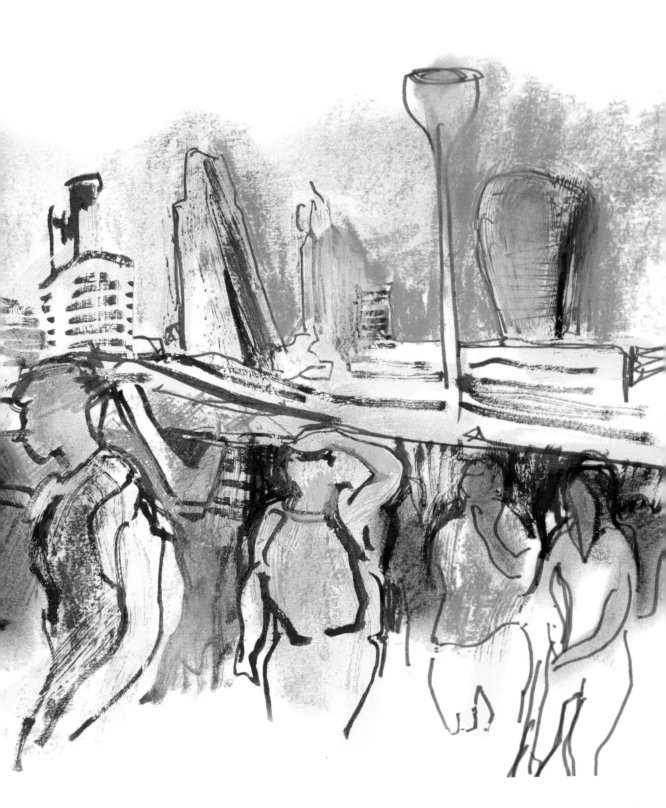

FIGURES IN MOVEMENT

I love drawing anything that moves, especially people when they can be seen in space connected visually to architecture, or to each other. If the ground is flat, the rule of thumb is that no matter how near or far away a person is in the space, the adult heads will, more or less, be on the same level. I do, however, break this rule quite a lot when I'm making my large compositions to help the overall design or create something unexpected.

When you are drawing something moving, you can't keep the edges rigid; you have to allow them to dissolve and break up in some way, whether by rubbing parts out or using more fluid or broken marks.

Some people get a bit nervous when adding people to their cityscapes, but

Figures in Movement
Charcoal (J)

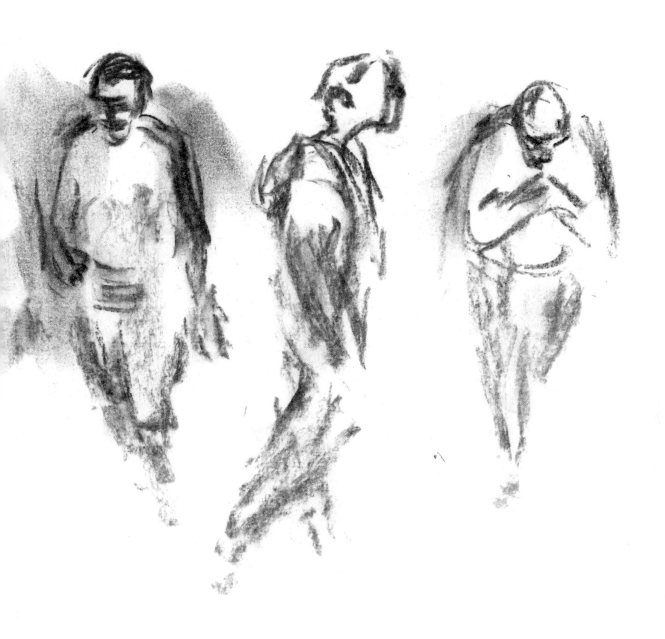

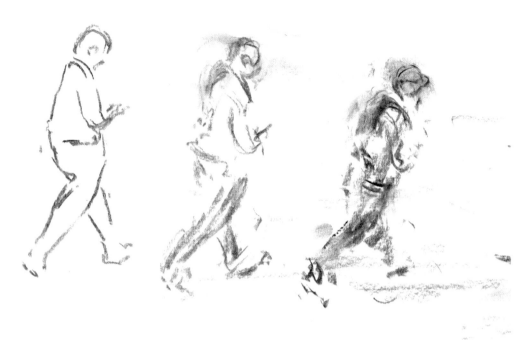

I always say you have so much
knowledge in your head about
figures, their scale, the way
they move – you see people all
the time and that impression
stays in your visual memory.
As much as you might be
tempted to draw with shapes,
you have to think of volume,
think of a suit coming towards
you. Notice where the head is
in relation to the shoulders and
if the chin is below or above
the shoulders. If you place
figures next to something,
you can see how far down the
arms come or how high the
head is relative to this.

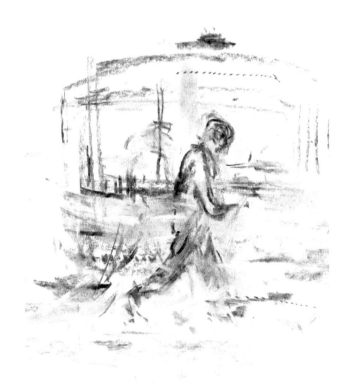

ABOVE, RIGHT AND OPPOSITE
Figures in Movement Charcoal (J)

Exercise

This will help you think of volume and scale.
Draw the three figures below, taking no longer
than five minutes for the whole exercise.
Using the side of the charcoal, loosely draw
the first figure; try to get the shape correct,
you may have to rub bits out with your fingers
if necessary. With the second, press harder,
looking for a little more definition. With the
third, try smudging out some of the edges
and create marks that flow out of the body,
implying speed and movement. You may want
to draw your figures in a more linear way
afterwards; that's OK but the idea of form
and volume should be in your mind.

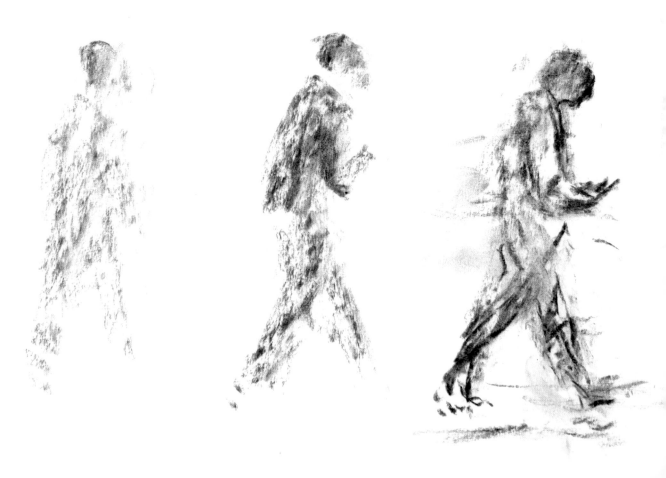

FILM

I have begun to really enjoy working from the short films I make. I have an iPad Mini and sometimes take time-lapse videos of cities. I might then use the videos for reference when I'm working on a large drawing of a subject back in the studio; it's much better than looking at a photo, as with that you'd just get a split-second view and not the overall feel of a place.

I have started encouraging students to draw from film. I play a video, pause it, and they capture what they see on screen, producing a multi-layered sketch that encourages them to draw using a variety of scale, creating an energy almost akin to the film itself.

OPPOSITE *Rush Hour, Bank*
Felt-tip pen, pencil (J)
BELOW *Nanjing Road, Shanghai*
Felt-tip pen (J)

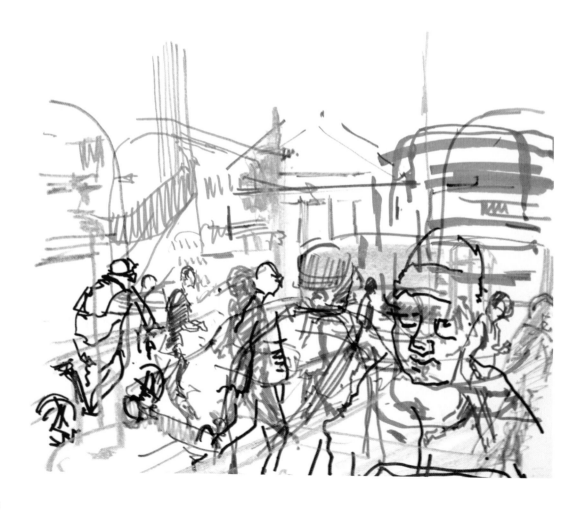

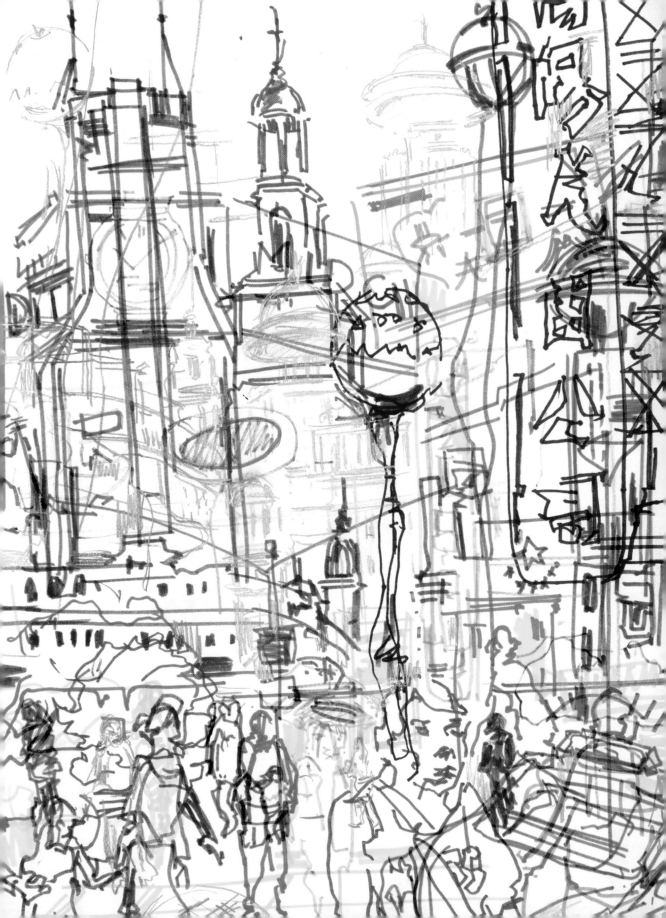

Exercise

Use a couple of different materials such as pencils and felt-tip pens in various colours. Start and stop the film quite quickly and draw one or two elements each time, overlapping previous views, a person overlapping a car, which overlaps architecture etc. If it becomes too dense you can always use a couple of pieces of tracing paper and overlay these.

 You can also try something similar in real life, on a bus journey. Sometimes, especially if it's raining, I will go to the top of a double-decker bus – I try to get a front seat – and draw whatever comes up. It's fun, there's no pressure as the circumstances mean you can't be precious; it's extreme sketching!

Buses at Bank Felt-tip pen (J)

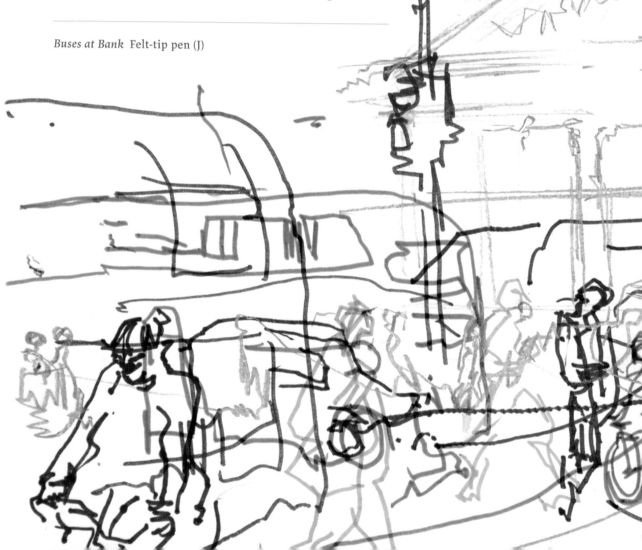

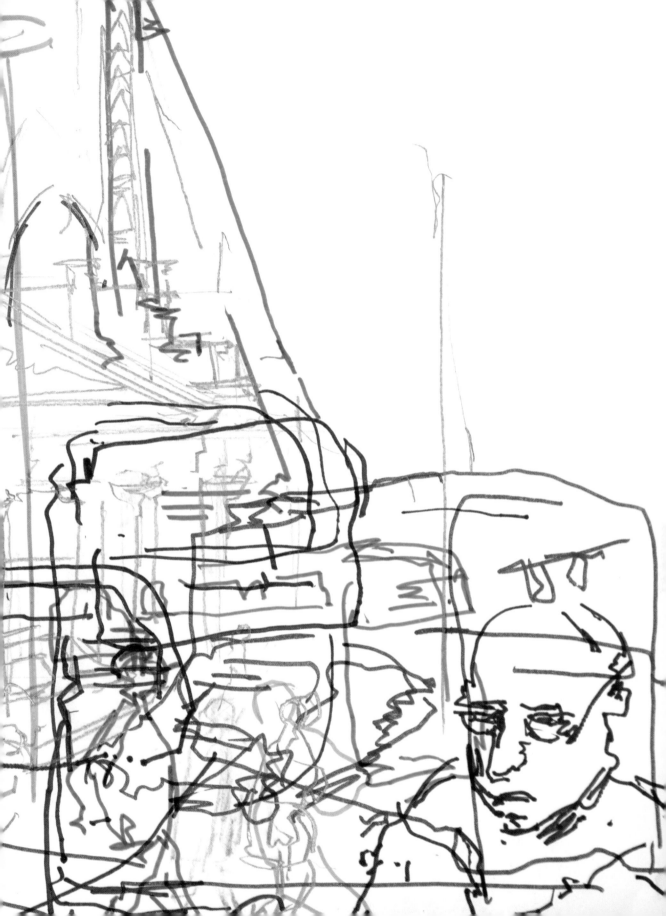

FINISHED?

How do we know if something is finished or not? The short answer is that we probably don't. You might be working under constraints – not quite enough time, not quite the materials you wish you had. It's common to look back and think, 'If only I'd done more to this part,' or that more work would have created a better drawing. While you're working you can only do your best: strive towards a drawing that, regardless of time spent on it or the circumstances you are in, is *complete* as opposed to finished. This means a drawing that is at its most efficient, most effective, in terms of what has been put down and what has been left to the imagination. More work will not improve this drawing, in fact it might get in the way of what you are trying to communicate. The viewer will finish the drawing in their mind's eye, and through doing that they become more involved.

Cambridge Heath, Fractured Journey
ProMarker pen, white pen (J)

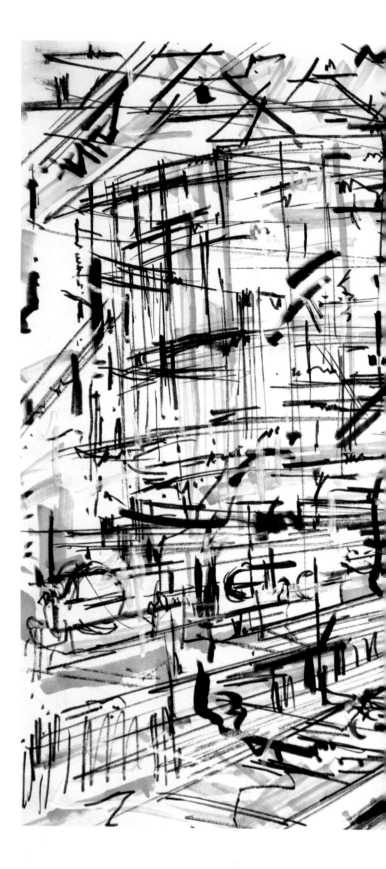

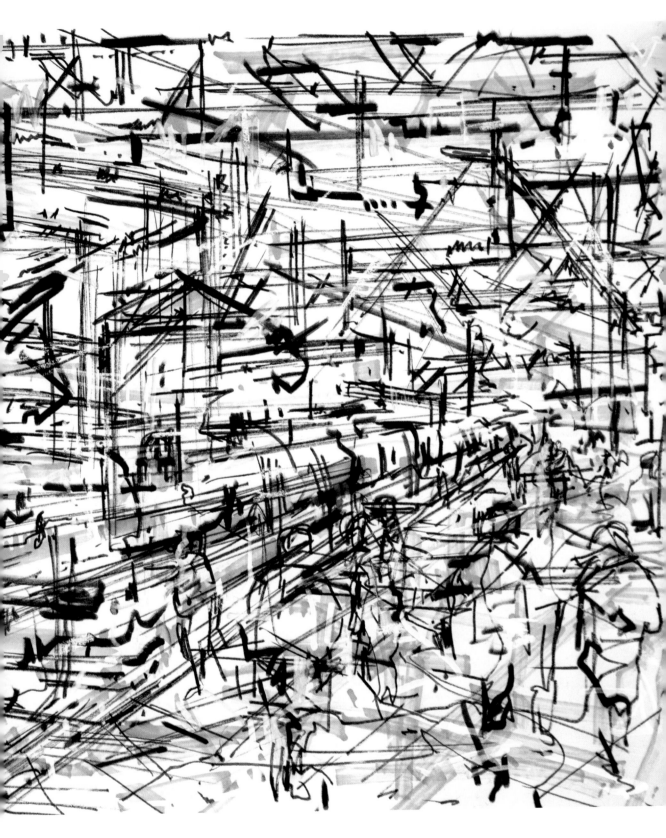

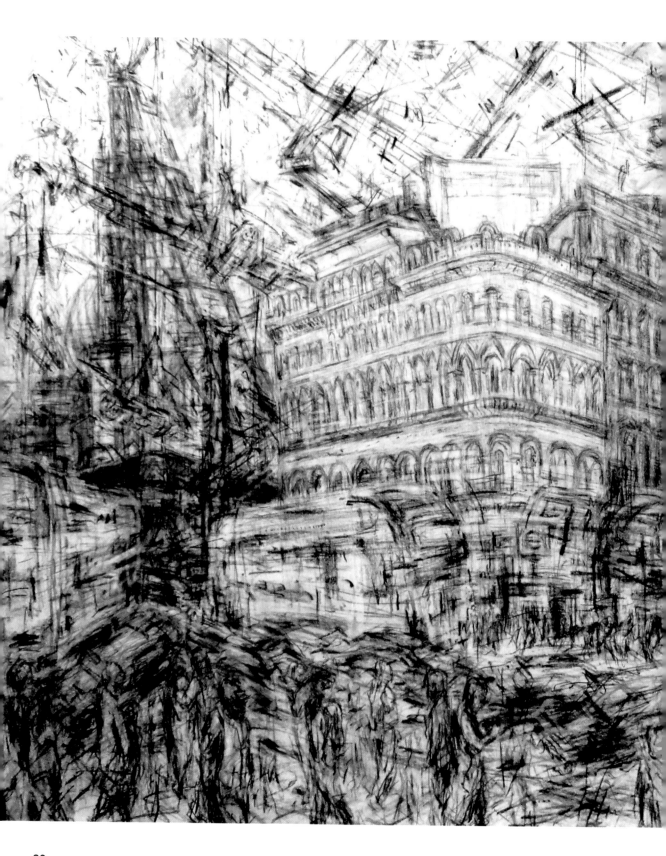

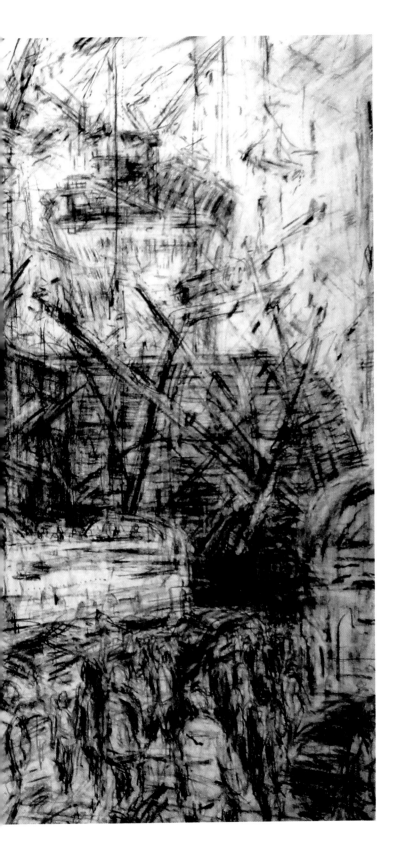

FRACTURE

I always like to break up lines or large areas in my drawings, to fracture them to create an impression of liveliness. I believe it gives a sense of the energy of the city and almost feels as though you are walking past something, so the angles and that wholeness changes in some way.

Redevelopment near
Mansion House Station
Compressed charcoal
150 × 220cm (59 × 87in) (J)

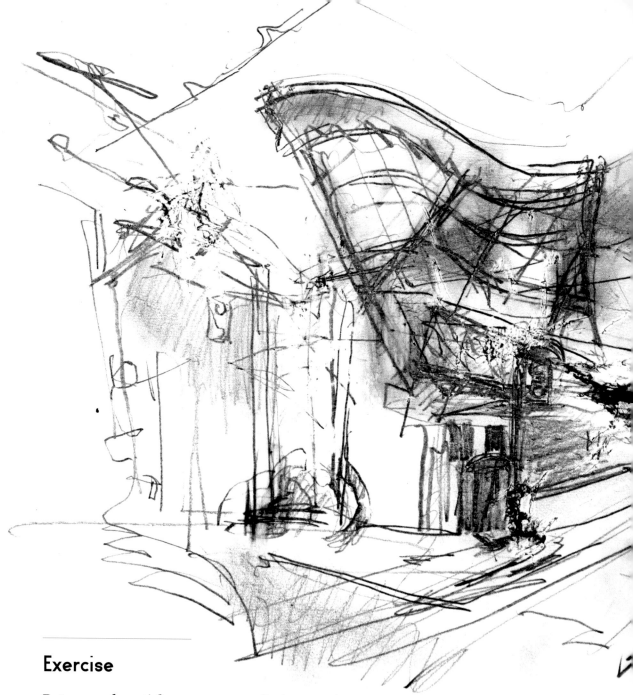

Exercise

Put some glue stick on your paper before you begin drawing – it's almost like setting a trap for yourself. Your pencil might struggle to make an impression and even slide around, creating something unplanned. You might have to fight with the picture a bit in these places, but before you know it your pencil will find unglued paper and control is restored. Your image will then be built up out of areas of relative turbulence and calm. Work quickly before the glue has a chance to dry.

GLUE STICK

These are always useful if you need to stick paper together to enlarge something or create a collage, but glue sticks can also be used in your drawing. From time to time it's good to disrupt your own know-how so that you're pushed into dealing with the unpredictable.

LEFT *Toronto Sketch*
Pencil over glue stick (P)

ABOVE *Monument and Shard*
Pastel and pencil over glue stick (P)

GRAPHITE

Graphite sticks are fantastic for when you're in a hurry and need to capture the immediacy of what's happening. Like pencils, they come in various grades of hardness or softness. They're good for creating mood and atmosphere; tonally they can build up subtleties, so you might want to think about what kind of paper goes with them – anything with a bit of texture (or tooth) will enhance this kind of drawing. When out sketching it's good to bring a graphite stick as part of your tool kit – it's great for establishing a general impression very quickly as it slides around the picture, but do play around with it to gauge its strengths and weaknesses.

OPPOSITE *Construction Site, London*
Graphite stick (J)

PAGES 88–89 *Parisian Traffic*
Graphite stick (P)

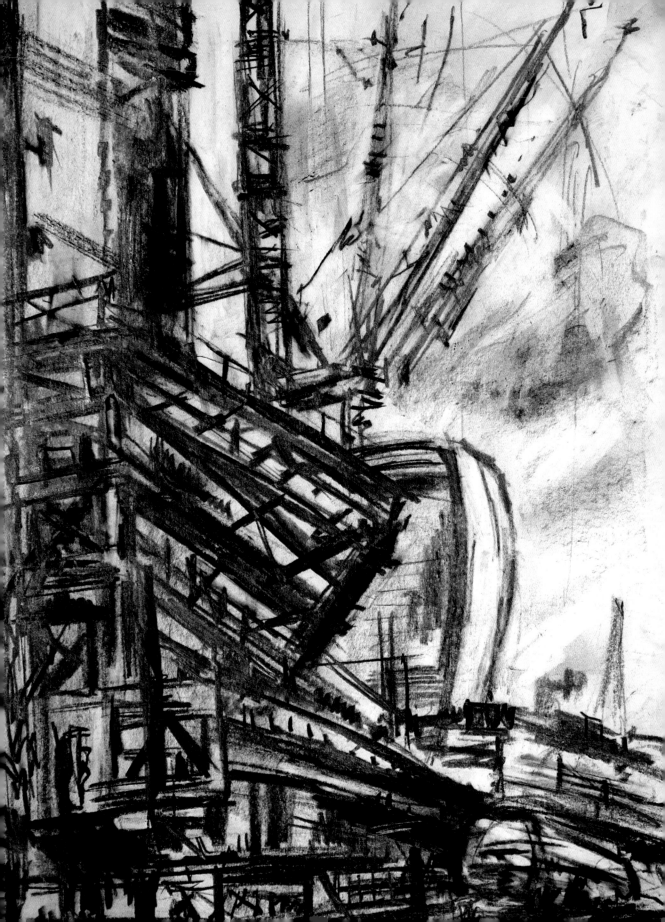

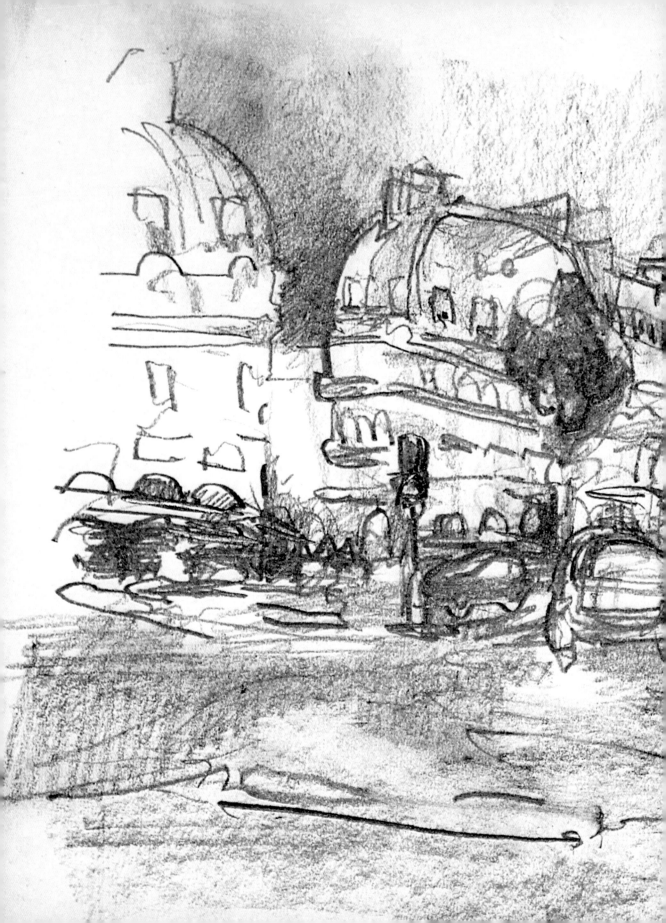

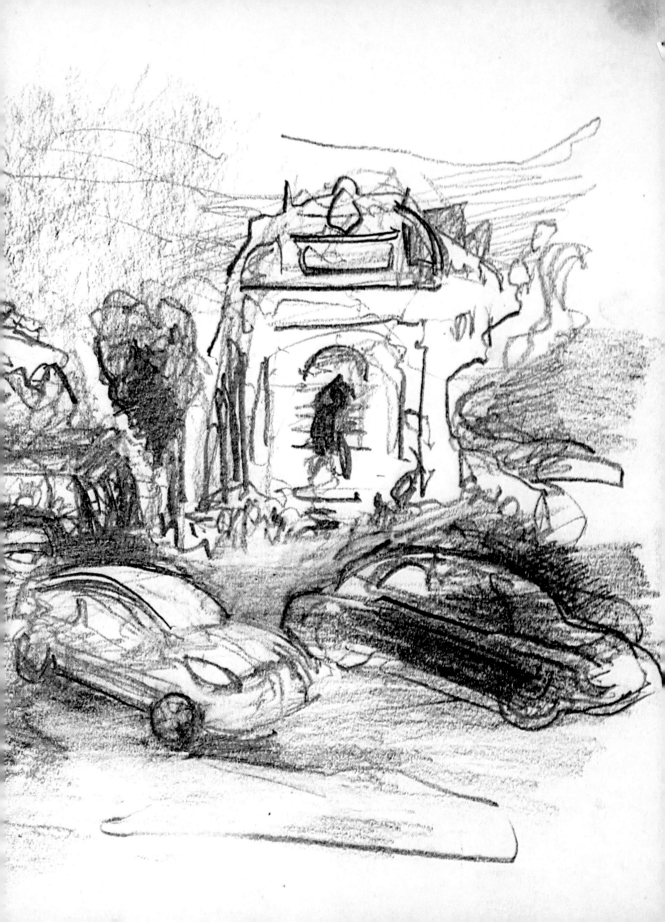

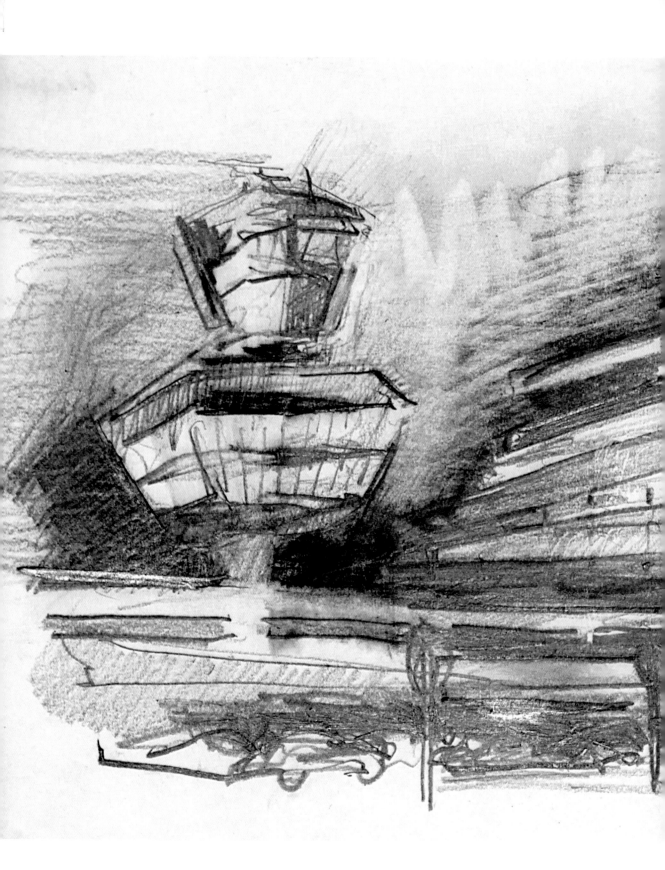

GUIDEBOOKS

I always treat myself to a new guidebook when I go on a trip, even if I've been to the place before and already have one. Who knows what's changed? I pore over them and look things up before I go, and definitely on the plane or train: a bit of history and then best views, best architecture, best galleries and especially the best bars. Ideally it should be light enough to carry around and have a fold-out map, really useful when you're wandering about (though I am really bad at folding the map back). A friend bought me one for a New York trip that was a guidebook and sketchbook combined, the best of both worlds.

Old Berlin Airport Graphite stick (P)

HAIRSPRAY

In addition to being a trashy but nonetheless entertaining musical, hairspray is also a cut-price alternative to artists' fixative. Over time it might yellow your pictures slightly, but if you're easy-going about that then it's the perfect cheap fix. If you fix your drawings between adding layers of charcoal it means that you won't smudge what you've already done and also that you can add further layers separately. Rubbing out something that's just been fixed will leave a 'ghost image', while drawing on top of what you've just fixed appears darker. All this creates a greater visual range with the material, allowing you to adapt and develop your picture without the risk of losing what you have.

Berlin Cathedral and Television Tower (stages 1–4) Charcoal (P)

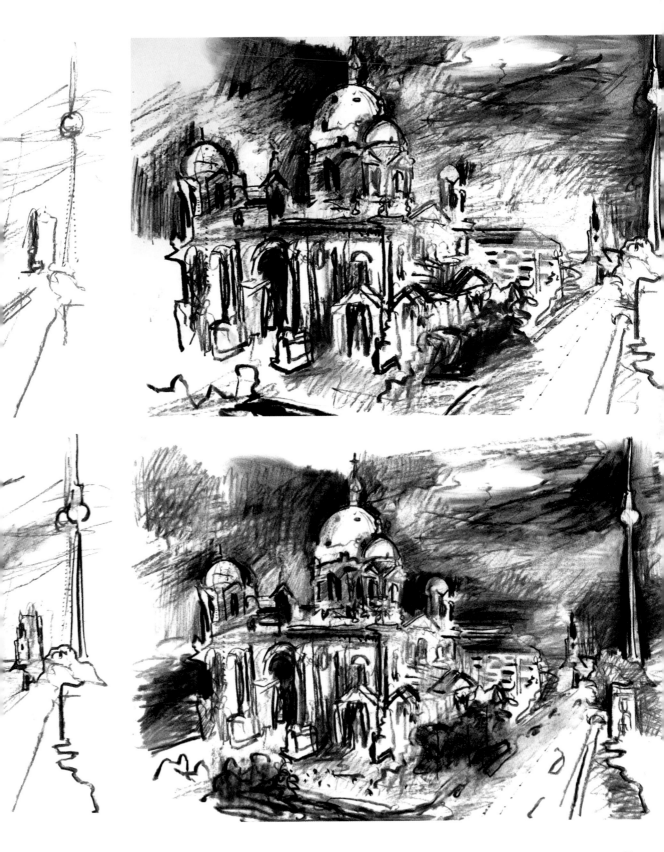

HONESTY

I do like to create a relatively honest representation of what I can see in front of me, but that doesn't mean I won't move a bit and add to the drawing from another perspective to make it both more truthful to the experience of being there, and something that functions well as a design on paper away from the subject.

Construction at Leadenhall Studies Pencil (J)

Exercise

Try working on the same drawing from a few different viewpoints. Start off from one point, then move 20 or 30 metres first to one side, then the other. This will open up the width of the drawing, and you will see things from a slightly different angle – more of the side of a building, perhaps. Draw part of it sitting down, change how near or far you are to the focal point to create a tension between how different parts of the subject are represented. I sometimes do this on separate sheets and combine them for a larger drawing back at the studio.

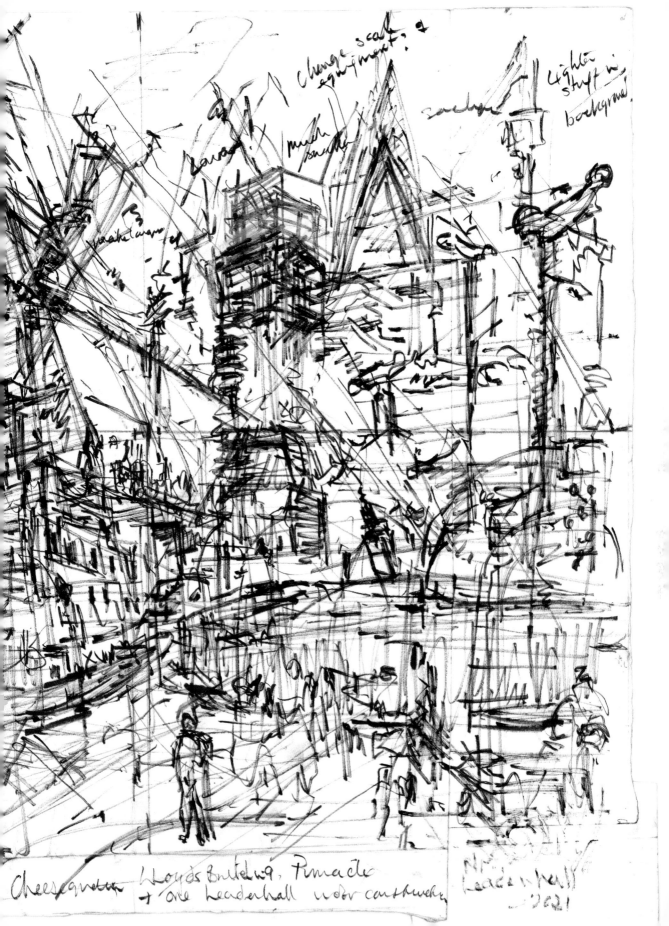

change scale
equipment. ?

much
smaller

lighter
stuff in
background

Cheesegrater Lloyds Building, Pinnacle
+ one Leadenhall under construction

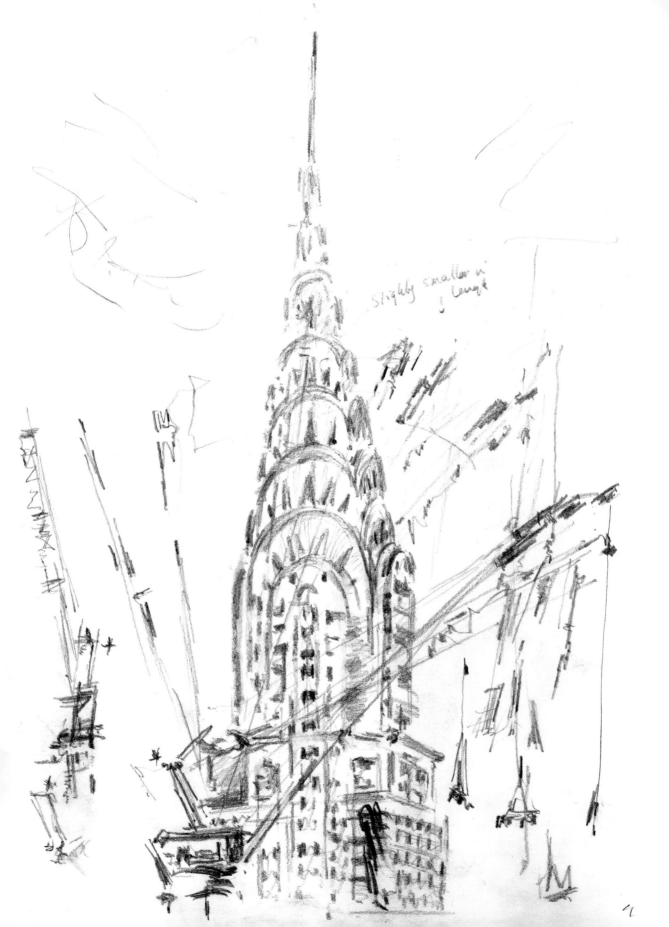

slightly smaller in
length

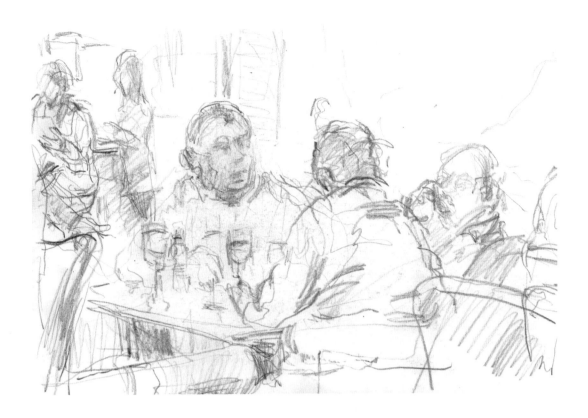

HOTELS

I love staying at a hotel with a
view; I have had some brilliant
ones. In Dubai I drew from the
roof on to Sheikh Zayed Road;
the one in Tokyo looked right
down on Shibuya Crossing,
and the Mandalay Bay in Las
Vegas looked down the Strip
with all its amazingly insane
world buildings. I read in a
guidebook about how if you
put a twenty-dollar tip in your
passport when handing it in at
Las Vegas hotels and you asked
for a view you got one – it

certainly worked for me.
Probably my favourite view
was from our room in New
York – it had the Empire State
and Chrysler buildings from
the East Side. I could literally
get out of bed, open the
curtain and start sketching.
At the end of a long day, find
the bar and relax, sketch the
view or sketch the guests if
you still have the energy.

OPPOSITE *Chrysler Study* Pencil (J)
ABOVE *In the Bar* Pencil (J)

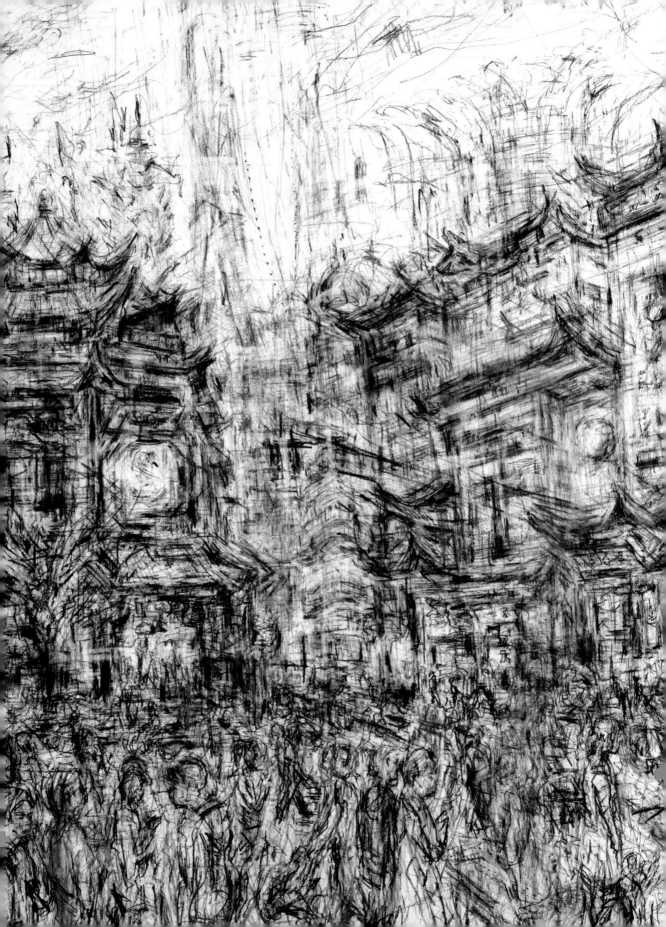

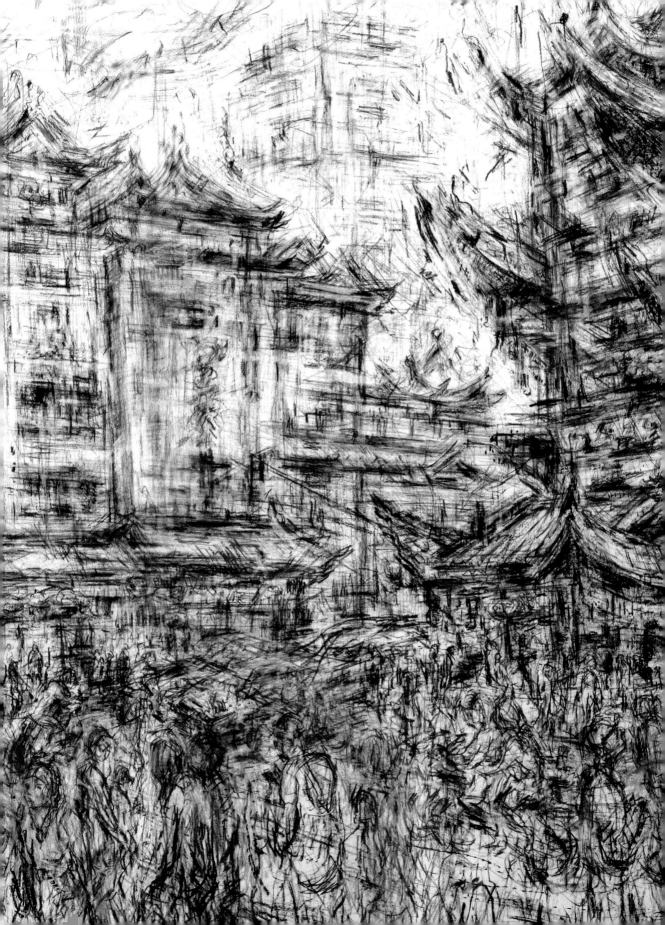

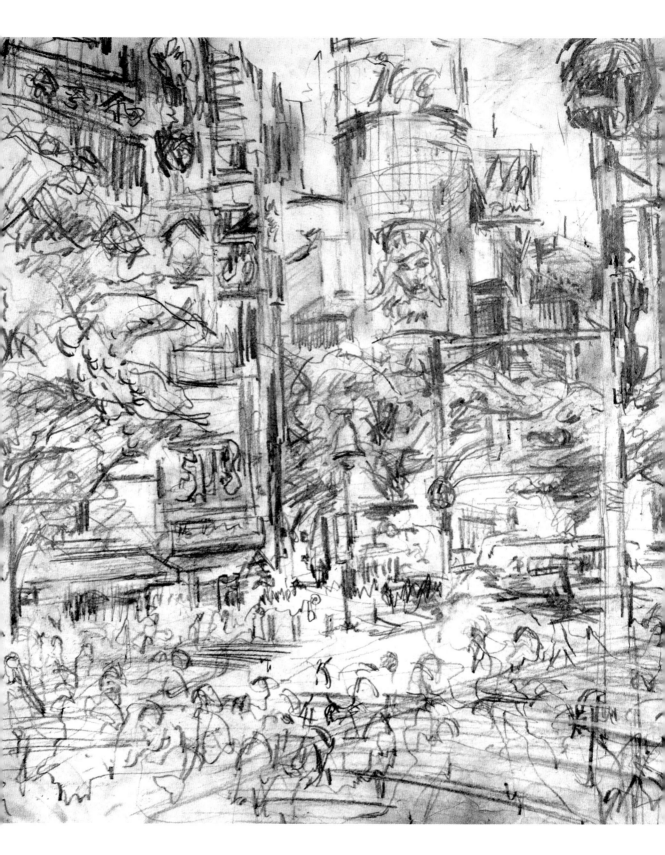

HUSTLE AND BUSTLE

I love it, the energy of the city. This is what I go to cities for, to try and capture that particular feeling on the paper. I will often park myself at the busiest intersection to sketch: Times Square, Shibuya Crossing, Piccadilly Circus, Liverpool Street Station. You have, of course, to be sensible where you stand – you don't want to be knocked down – but I do like to get into the melee. I know some people like to sit down and sketch but I mainly like to stand up to draw. I often stand behind a lamp post or pole, so I can lean my board on it and people flow by on either side. You can't capture the hustle and bustle with a tentative line. You need to draw the

PAGES 98–99 *Old Shanghai*
Compressed charcoal
150 × 203cm (59 × 80in) (J)

LEFT *Shibuya Crossing, Tokyo*
Pencil (J)

flow of the people and traffic, find the rhythm. You may use many marks together, overdrawing, or broken lines. Everything changes all the time, it's like drawing from a film but more intense, as you can't stop and start it. You may not be able to draw a specific person or car, you may only get time to do a bit of them to start with, but then another one comes along and you draw that, add it on, and it goes on and on. Sometimes it's fun to pick someone specifically and draw them as they are walking along; you may get several sketches of the same person as they become smaller and smaller. This is easier in something like a station – I love following someone's trail.

IGNORING PEOPLE

People can sometimes become interested in what you are doing and want to chat to you about your work, compliment you or talk art in general. This mostly happens in tourist areas – if you draw in the business area of a city you hardly ever get bothered because the people there have no time to interact with you, they are too busy working, making money. If someone comes up to you and starts to chat, try not to engage them very much; be polite but carry on working. If they persist and are nice, say something like, 'Thank you, but I have to carry on drawing as I'm only here for a short time.' Some of my students wear headphones, but I like being part of the city. Just keep calm and carry on; people will soon get bored if they can't have a proper conversation.

Nanjing Road, Shanghai Pencil (J)

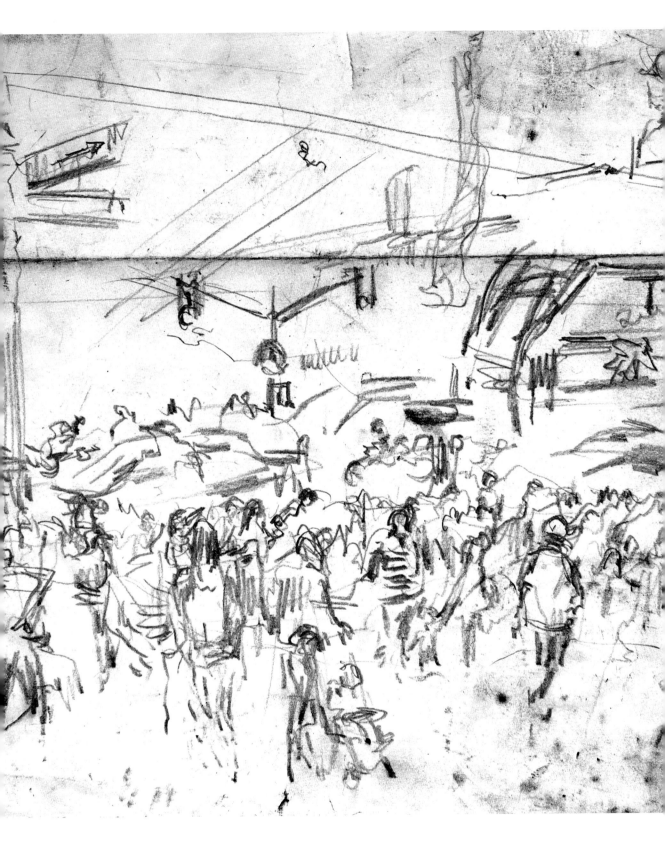

IMAGINATION

You probably use it unaware that you're doing so. We all have a visual memory that helps our brain recognize things when there's not quite enough information. This also happens on paper – a few suggestive marks will create something that is somehow believable without that information necessarily being overtly descriptive. Imagination isn't some dreamy thing; it can be how you solve problems in your picture, how you use your materials, how you create belief. When working from imagination there's less pressure to 'get it right', which means it's liberating in a very useful way. Ideas about how you might use your materials can very easily be transferred from the imaginative to the observational.

London Rain
Compressed charcoal (P)

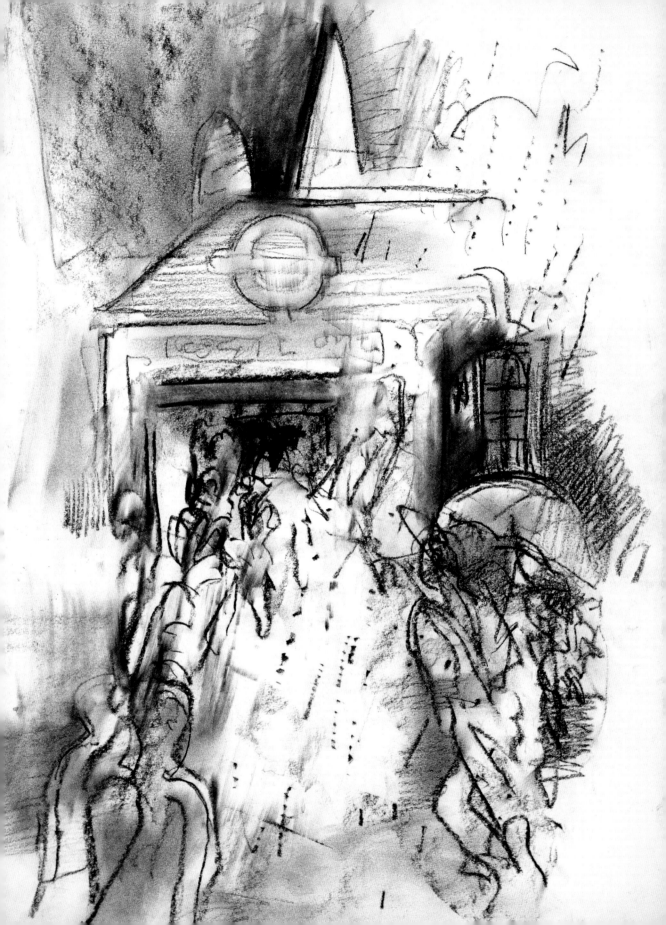

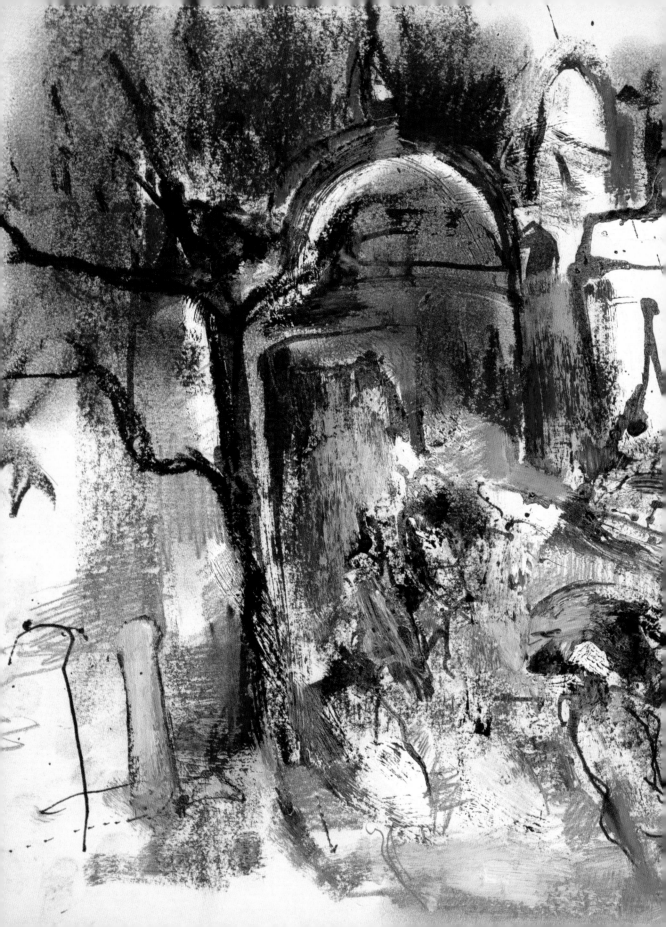

Exercise

If you want to bring something to your drawing that takes it beyond reporting or recording, try writing a few evocative sentences about a place and draw solely from those. Something like this perhaps:

A broken skyline begins to emerge from behind the government buildings,

Their white columns clean and regimentally austere.

A crowd of commuters move almost as a single mass towards the station entrance,

Surprised by a sudden downpour some speed up as others wrestle with umbrellas,

Summer's warmth disrupted by this sudden storm.

Give yourself a maximum of three minutes' drawing time per line, using anything other than pencil.

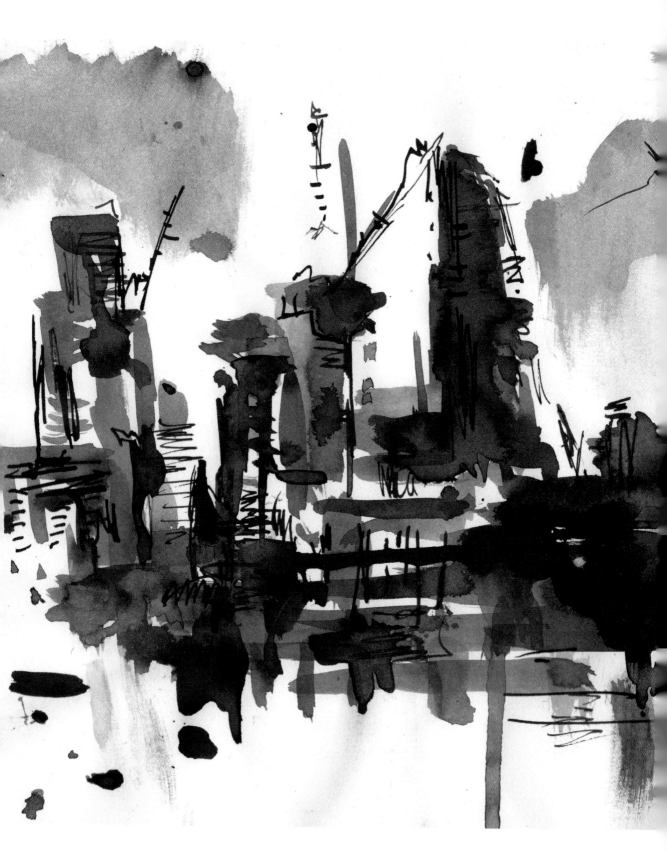

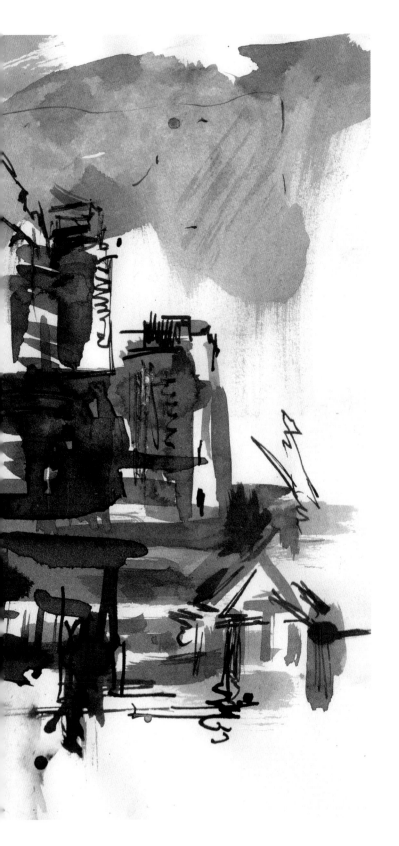

INK

The beauty of ink is that when it's not in a biro or a fineliner it can never quite be fully under control. Its innate fluidity gives any resulting picture a sense of life, movement and energy. Taking ink on location might be problematic but there is a way around this. Brush pens are widely available: developed in the Far East, the body, like an old fountain pen, holds ink while at the business end there is an incredibly versatile synthetic brush. If you fancy dipping something into a small bottle there is plenty of choice: Chinese and Japanese brushes, old-fashioned dip pens with metal nibs, or even wooden barbecue skewers or cocktail sticks from the supermarket. A large part of ink drawing is the acceptance of chance, which can be both frustrating and enjoyable in equal measure.

City Skyline Ink (J)

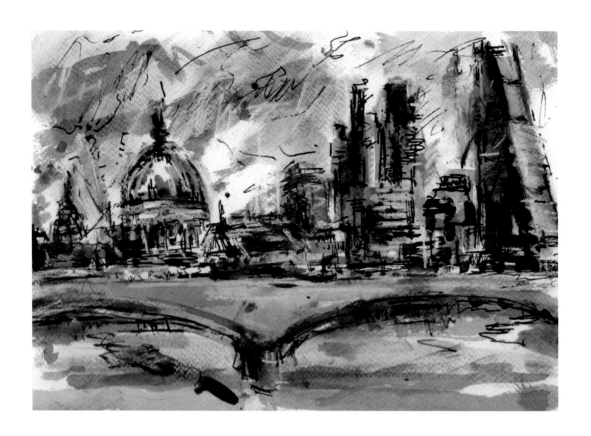

INSTINCT

Any sketch or drawing is basically the evidence of decision-making over time; as part of this process, learning to trust your instincts is hugely important. Your own instincts will lead you to make the decisions that others might not and so serve to create your own identity within a drawing.

You really don't have to know everything about drawing, it's absolutely fine to take a wild guess or just try something out because you felt like it. Instinct, however, is a tool that does benefit from sharpening.

ABOVE *Waterloo Bridge* Ink (J)
OPPOSITE *Construction Sketch* Ink (P)

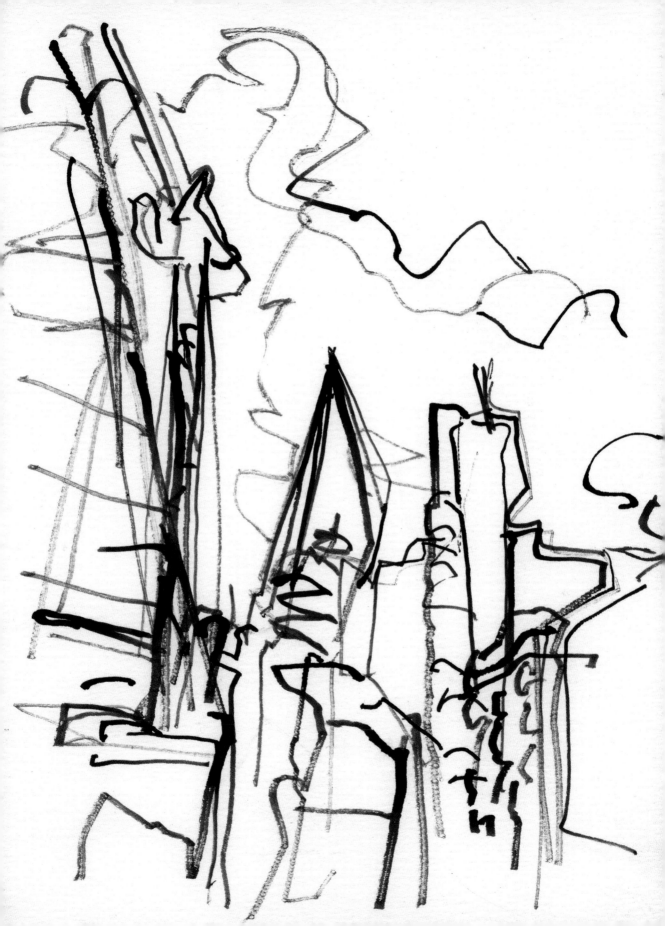

IPADS AND TABLETS

I'm not going to pretend that either of us are digital experts (instinctively we prefer the responsiveness of actual art materials), but having said that, an iPad or tablet is an amazing tool that can build confidence and enjoyment. This comes down to the fact that the technology removes fear of failure. Stages can be saved, layers of work can be made and kept separately, you can delete whatever you like. This means you can have fun with a range of tools and effects knowing that it's not a big deal. For the beginner it's like a high-tech training gym; for the more experienced artist it's a whole new realm.

Jeanette, who actually did the drawings here, says: Like most things, some people will be naturally drawn to it, others not so much. I'm surprised that I enjoyed taking time building up an image. I haven't made many iPad drawings but have signed up to an online class to find out a bit more; I think it's worth

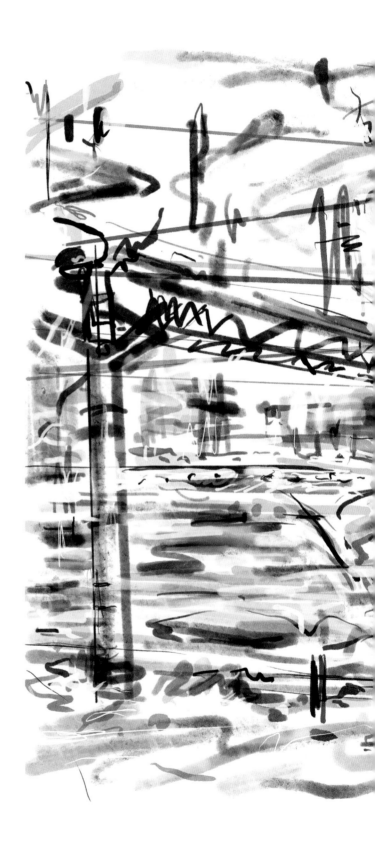

Passing Through Hornsey
Digital drawing (J)

112

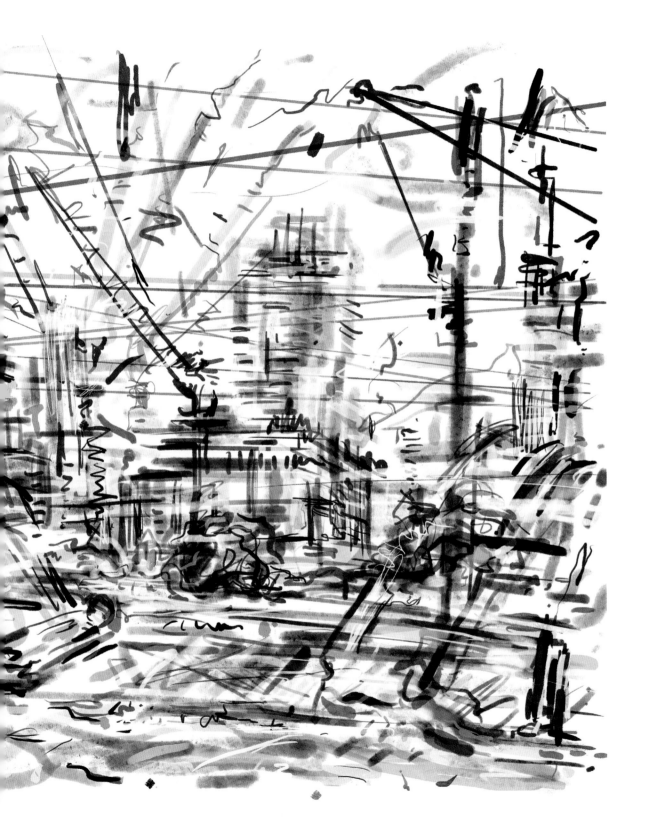

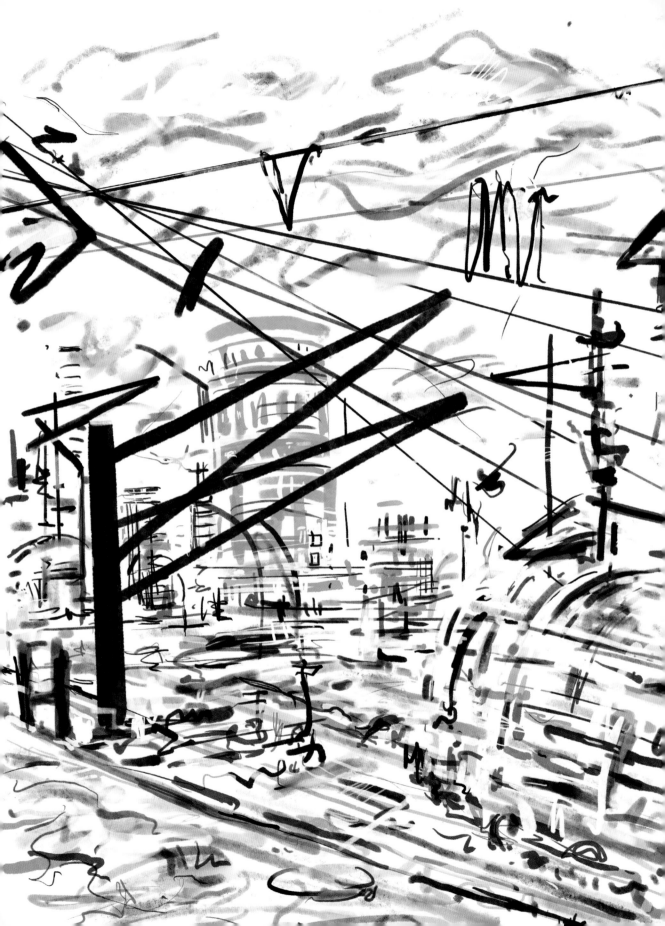

doing. I used Procreate and I love the playback feature that is a time-lapse video of your drawing showing different stages. You'll probably have to get a responsive stylus to draw with; I have an Apple Pencil (expensive but I think you can get cheaper alternatives).

I am not over-reliant on layers as I enjoy rubbing out and changing as a whole. I was originally overwhelmed by all the different brushes and textures on offer. I did go through most of them to see what effects they gave and generally keep now to about four or five. I especially liked using the Tinderbox brush, as you can use it on its tip and side to get different kinds of marks; you don't have to keep changing brushes. There's a slider to make the brushes different sizes and opacity, which is easier to get used to than you might think. The screen is affected by glare when out on a sunny day and the battery will run down.

Will it ever overtake sketching on paper for me? Definitely not, but I think it will become an intriguing addition to my regular practice.'

OPPOSITE *Train Journey, Hornsey*
BELOW *Imagined City*
Digital drawings (J)

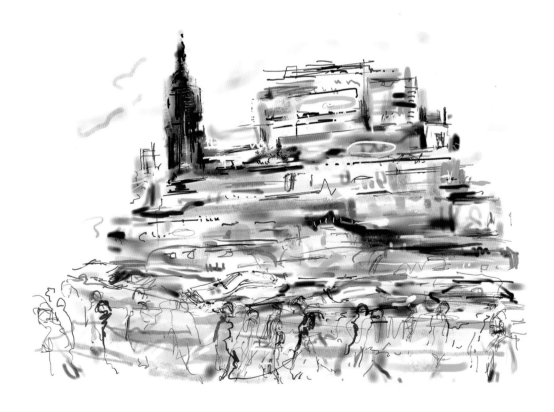

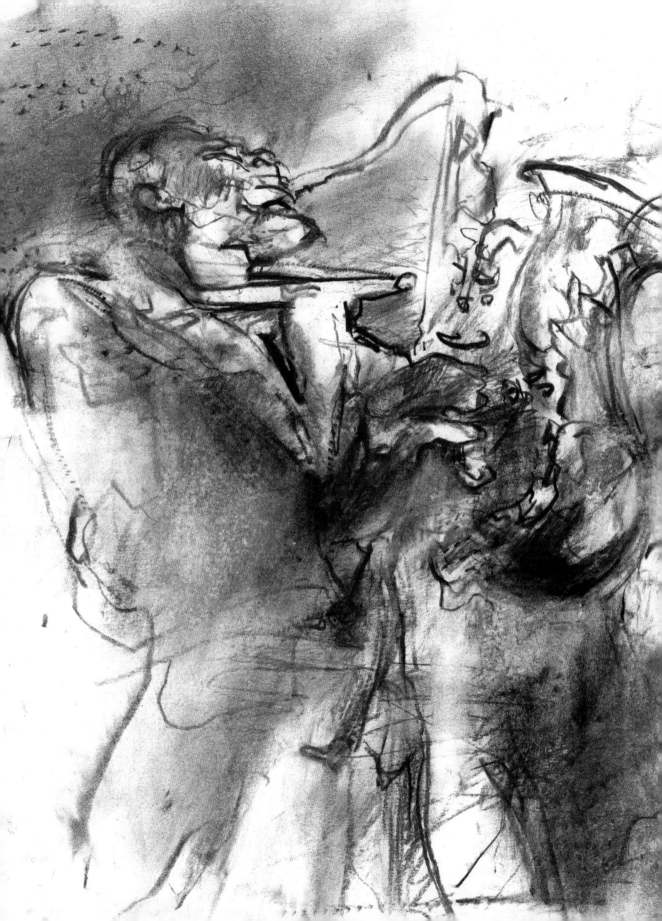

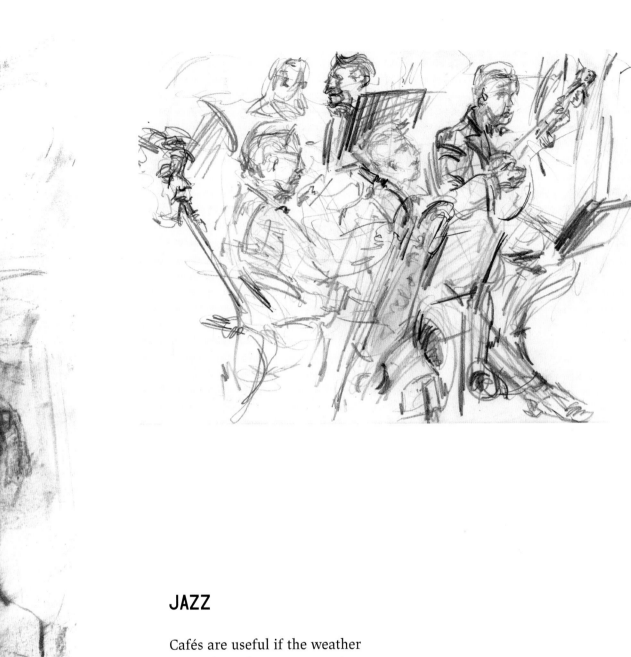

JAZZ

Cafés are useful if the weather is consistently poor or you just really need to sit down, but a venue with some atmosphere or some live music is just that bit better. Try sketching musicians from somewhere near the front.

LEFT *Saxophonist* Charcoal (P)
ABOVE *Ensemble* Pencil (J)

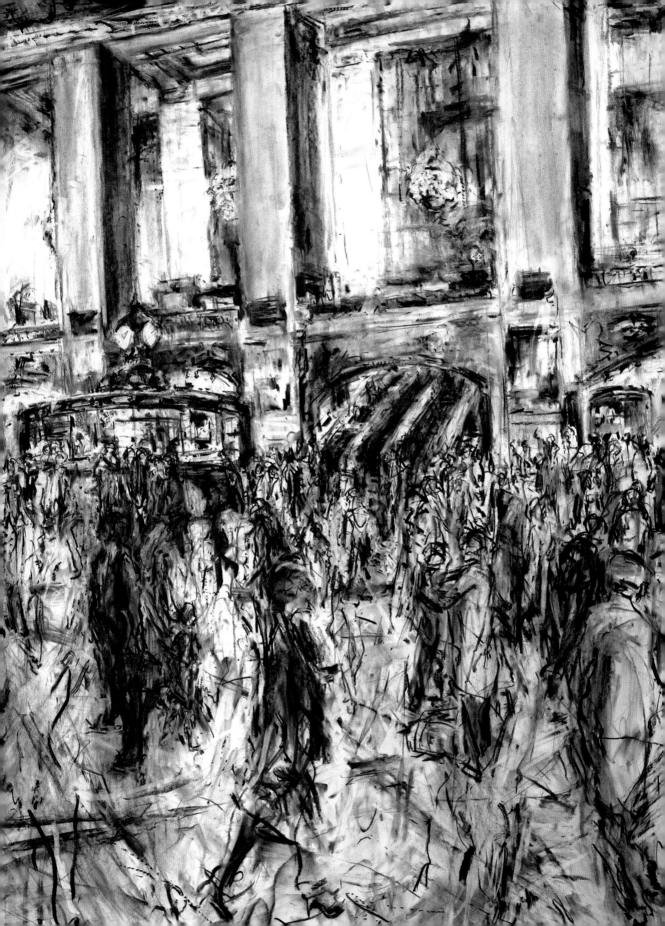

JEANETTE (BY PAUL)

She doesn't get to write this one, I do!

In our house and in our studio every scrap of paper is covered with a jotted idea for something, a small cartoon or some words that might establish something greater. Her mind is never switched off from visual possibility.

Jeanette wasn't allowed to take art at secondary school but began her artistic journey at Accrington Sixth Form College before moving on to Liverpool Polytechnic; in both places her teachers' love of the subject and open-minded encouragement nurtured her passion for urban drawing. Jeanette moved to London in the 1980s to study at the RA Schools and the RCA, although even after all these years her northern accent remains.

We've always shared a studio although we're never in it at the same time (we'd probably kill each other); Jeanette spends as much time on location gathering information as she does in the studio working on her large drawings of London's unceasing development. Without intending to, she has become a visual diarist documenting the changes in the Docklands and the City itself. The finished drawings emerge from a lengthy process of trial and error where a range of ideas are tried and tested along the way. The drawing builds up, areas are rubbed out and built back up again in a process that can take a number of months. They are always 150cm (5ft) tall, as the Fabriano roll she favours comes in that size; the lengths of drawings vary but anything longer than 250cm (just over 8ft) won't make it down the studio's winding stairway.

What does Jeanette do in her spare time? She travels to foreign cities with as many art materials as one can cram into a suitcase.

Grand Central Concourse (detail)
Charcoal 150 × 203cm (59 × 80in) (J)

KEEP EVERYTHING

For a while at least! It's so tempting to reduce all the artworks you create into two distinctive groups – those you think you like the look of and those you think you don't. The next step in this process is usually to bin the pile of don't likes. Well don't! Over time you may well learn lessons from or see qualities within the drawings that you don't quite like. You'll learn through making comparisons across your own work – by reducing the breadth of that there is less to learn from.

You might put work away for a month or two and evaluate it at a point when there's more distance between you and it; then you're not as emotionally attached to the outcome and can focus more on the process. An extra advantage is that scraps of drawings are ideal material for collage.

KING'S CROSS STATION

I love this station, especially the central tower and lattice-work ceiling, it reminds me of the roof in the Great Court at the British Museum. It's quite complicated and interweaves high above across the span of the concourse, like a large tree growing and then branching out. It took me an age to draw and I had to make many sketches to produce my large drawing. You can work out the rhythm of it if you have time and want detail, but if you're going to make a quick sketch then it's about approximations, judging the

Vault Study Pencil (J)

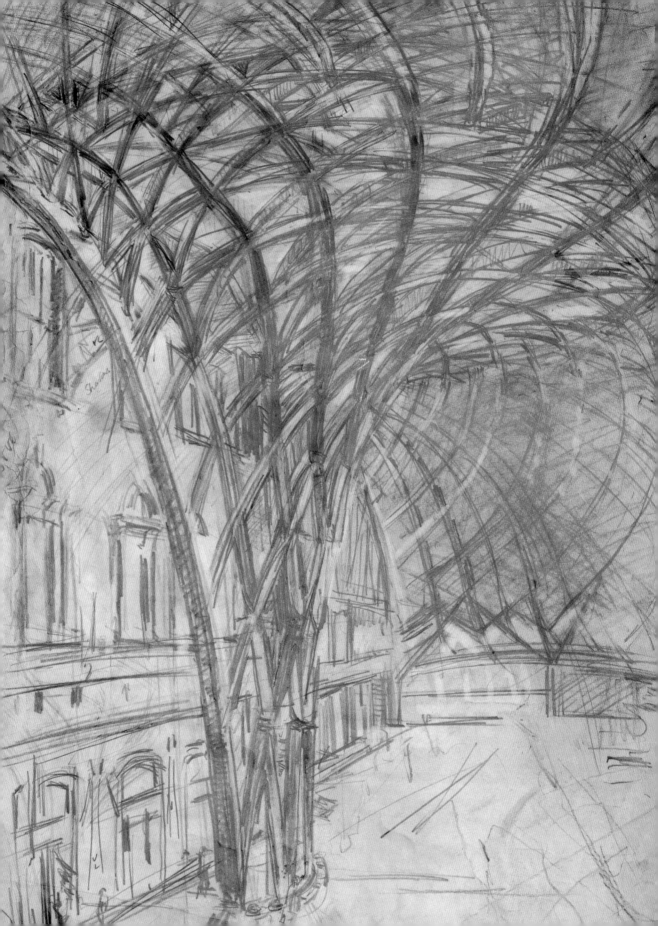

scale of the architecture, roof and tower with the people. I like to draw from the elevated section above where the cafés are, so people seem small in comparison to the architecture; the way they move about on the concourse connects the space. Remember, your drawing is just for you, not for an exam, so try not to be overawed. Sometimes an inventive impression of somewhere can be much more interesting than an exact copy, so don't get tangled up in the precise structure unless you actually want to.

LEFT *Balcony Sketch* Pencil (J)

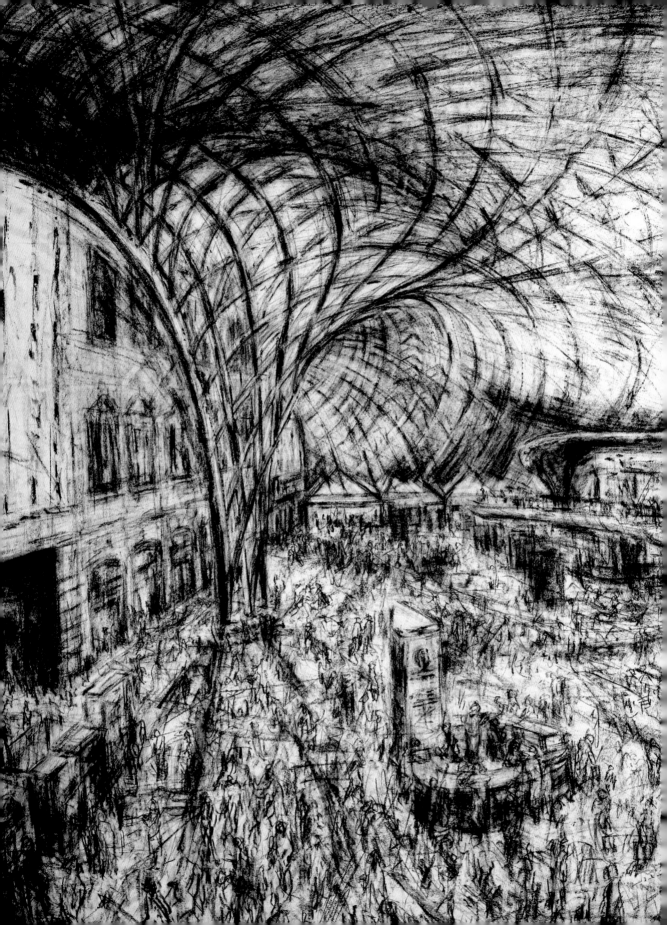

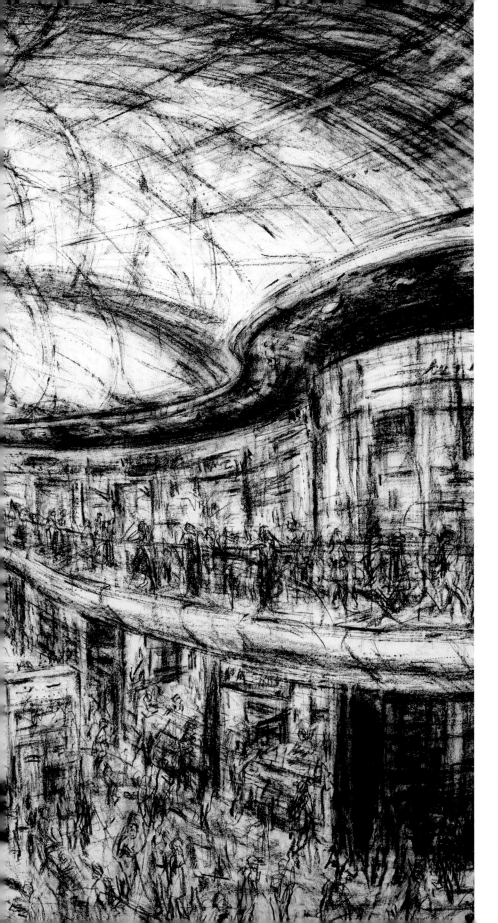

*King's Cross
Station, Concourse*
Compressed
charcoal
150 × 200cm
(59 × 79in) (J)

KNIVES

I like to use a knife rather than a pencil sharpener. It was one of the first things we learned on my art foundation course – how to sharpen a pencil properly. It's OK if you prefer sharpeners, but they only hone a small amount of the tip and I find it's too sharp and gives a very scratchy sharp line until it wears down a bit. If you use a knife it can give a long point that isn't too sharp and you can use it for tone, or fluid side strokes. It's particularly good when you want to work quickly – instead of using different materials you just hold the pencil in a slightly different way. A word of warning: don't get a knife out in the middle of a street, be discreet, and if you go into a museum or gallery with a bag search you'll probably have to get rid of it. I use a cheap click knife where you break off the blade so it's always sharp.

KNOW YOUR ENEMY

When you discover places to draw that somehow appeal to you, make a habit of revisiting them over time. Notice how the place might have changed; even if it hasn't, your own mood colours how you perceive what is in front of you so no two experiences are ever quite the same. You'll probably never be finished with your favourite locations as you'll never be finished with drawing; it's not like a computer game where you get to the final level and then complete it. Spending time in a place really pays off, giving your work a sense of depth and personal meaning. And giving yourself a genuine sense of connection.

City Study Pencil (J)

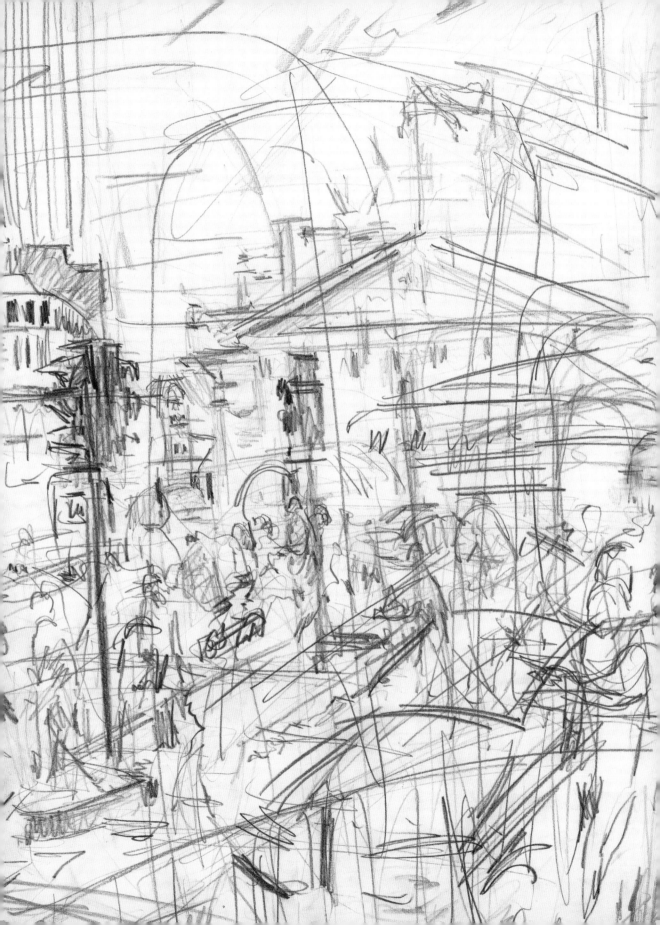

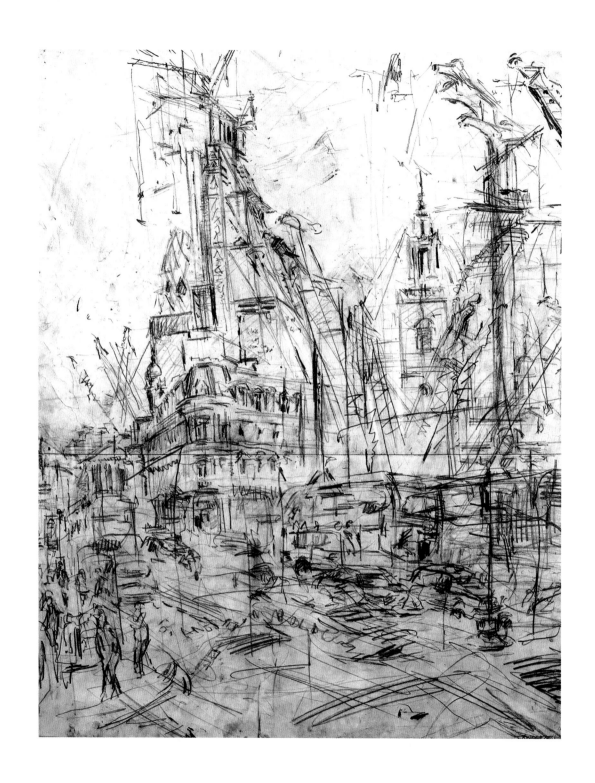

ABOVE *Rush Hour at Bank* Pencil (J)
OPPOSITE *Cheesegrater at Bank* Compressed
charcoal 224 × 150cm (88 × 59in) (J)

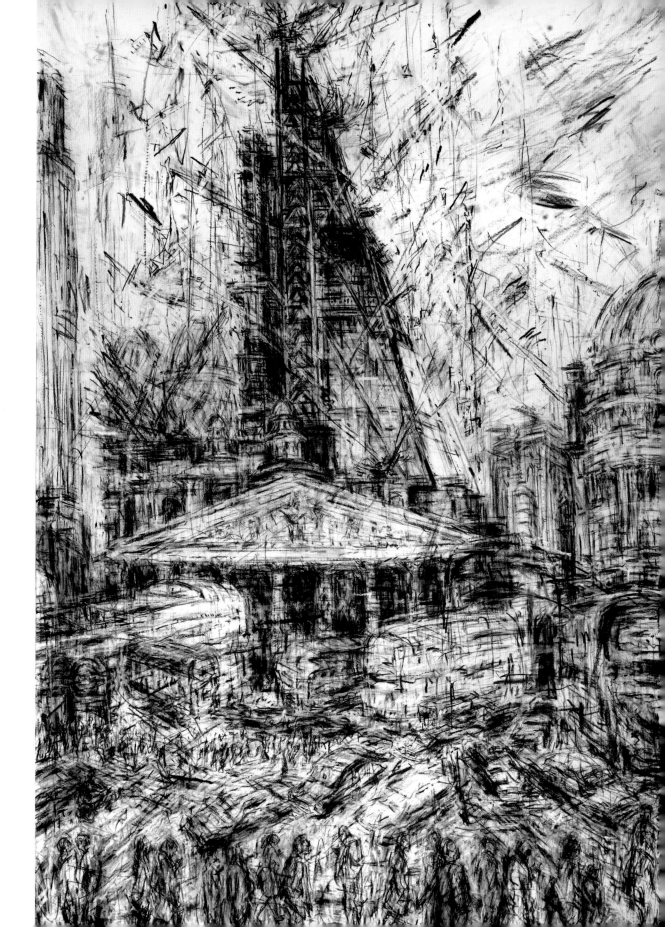

LIGHT AND SHADOW

If you're seeking to dramatize your drawing in some way, then pay particular attention to the sense of light that a place has – you might even exaggerate it slightly for visual effect. Untouched paper is your strongest source of light. Materials such as softer pencils, charcoal, pastel, compressed charcoal and ink can build tone quickly but be careful – overwork what you are doing and the light fades to grey.

Exercise

Starting from the mid-tone (a sheet evenly covered in graphite or charcoal) is a handy way to start a picture that is primarily about light and shadow. Draw further to go darker, and use an eraser to create highlights or brighter areas.

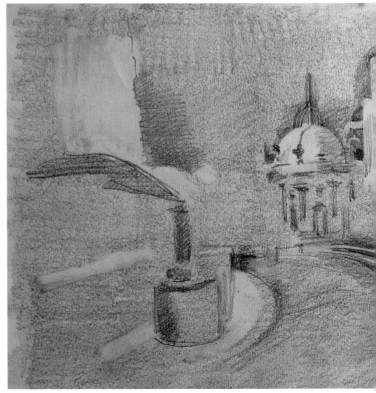

City Square, Leeds (stages 1–4)
Pencil (P)

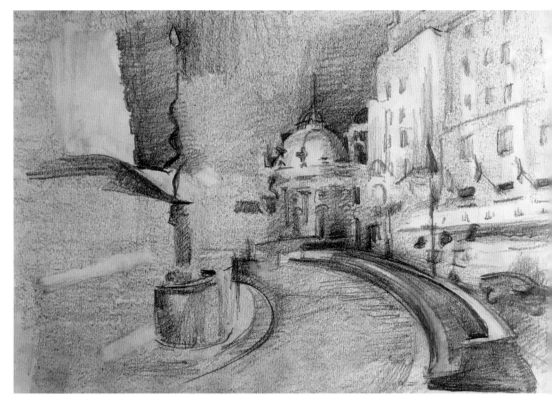

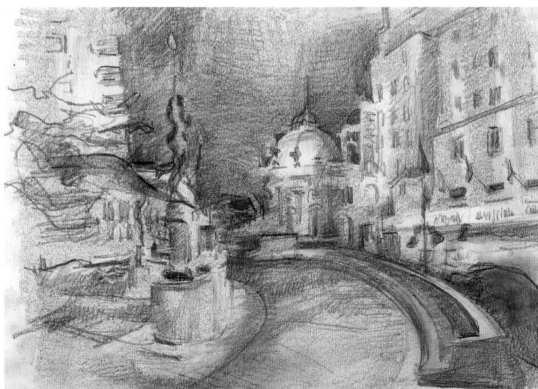

LINEAR PERSPECTIVE

People get more worried about this part than anything else – keep calm, and don't get too stressed about it. I have never in my life drawn a set of perspective lines and then fitted my urban drawings into these. It only works absolutely when you close one eye and keep perfectly still, which I can only do for 30 seconds anyway. Chances are, when you're out sketching you will only have a small proportion of the drawing that relates to this; representing the experience of space interests me so much more than linear perspective. There are a lot of books about drawing that teach perspective systems, but I find all the diagrams and explanations a bit confusing. I have always played around with the rules to let my work be an interpretation of the scene, not a strict copy.

When you are looking straight ahead at a scene, whether sitting or standing, that is your eye level. When buildings disappear into the distance and touch the line of your eye level, or horizon level as it's often called, that's the vanishing point. Any lines above the eye level gently slope down towards this point in the distance, any lines below it slope up to it.

OPPOSITE, ABOVE *Cars* Pencil (P)
OPPOSITE, BELOW *Regent Street, London* Pencil (J)

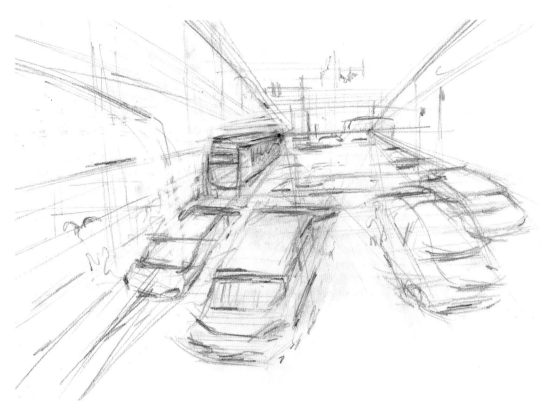

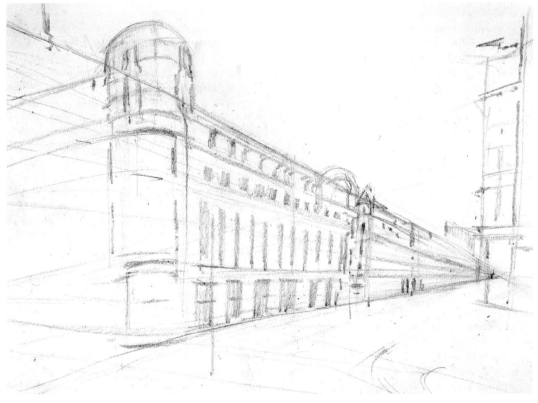

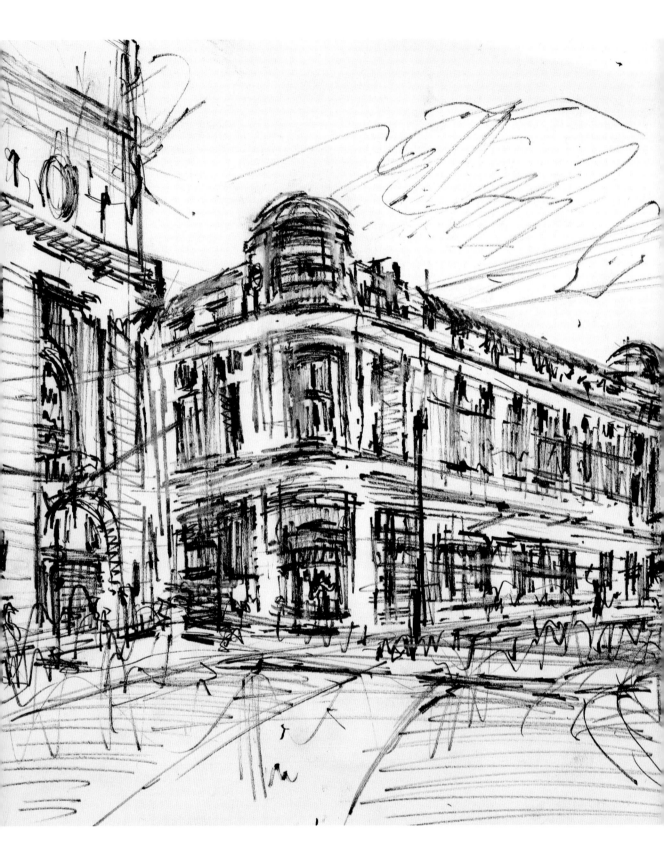

Lines in the middle have no angle slope, they are straight. Lines always go towards the vanishing point on your eye level or horizon line.

Rather than put these linear perspective lines down first, I loosely judge the angles as they tip down or up, below or above my eye level. Is it an 8 per cent slope, 15 per cent, 30? I always draw the verticals first, as these are straight, then judge the small angle between them; you just have to be consistent, and if it feels right to you in your drawing, then it is. Nobody is really going to know if your sketches are absolutely correct or not. The more city sketching you do, the more this will be easier to judge. Work with a pencil and rub bits out until you get it how you want it – I do!

Regent Street, London
Brush pen (J)

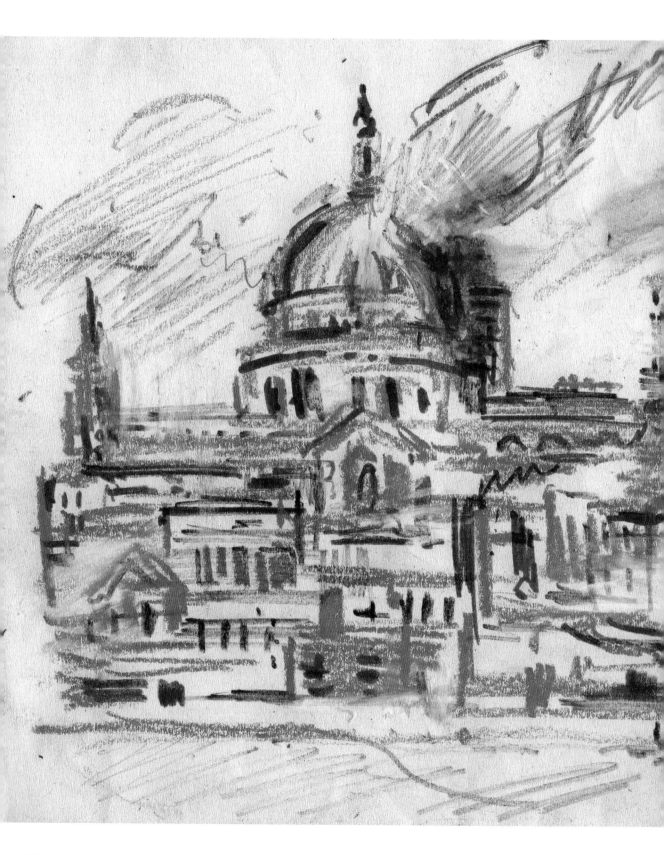

LONDON

Like many great cities, London spreads out before us – something we can never entirely see or understand. Its roots go down deep into history; its constant redevelopment unearths previously hidden wonders, tears great holes in what we think is around the corner and jostles old against new in the bustling confines of its centre. That sense of the unexpected, that sense of its unlimited potential, draws people to it or in some cases repels them. Its suburbs, more orderly in some respects, still throw up the odd wonder: concrete dinosaurs, Art Deco Tube stations, former picture houses and gin palaces. London is not one thing, it is many things – born there or not, it is yours for the drawing.

St Paul's Cathedral
Pen, pencil, chalk (J)

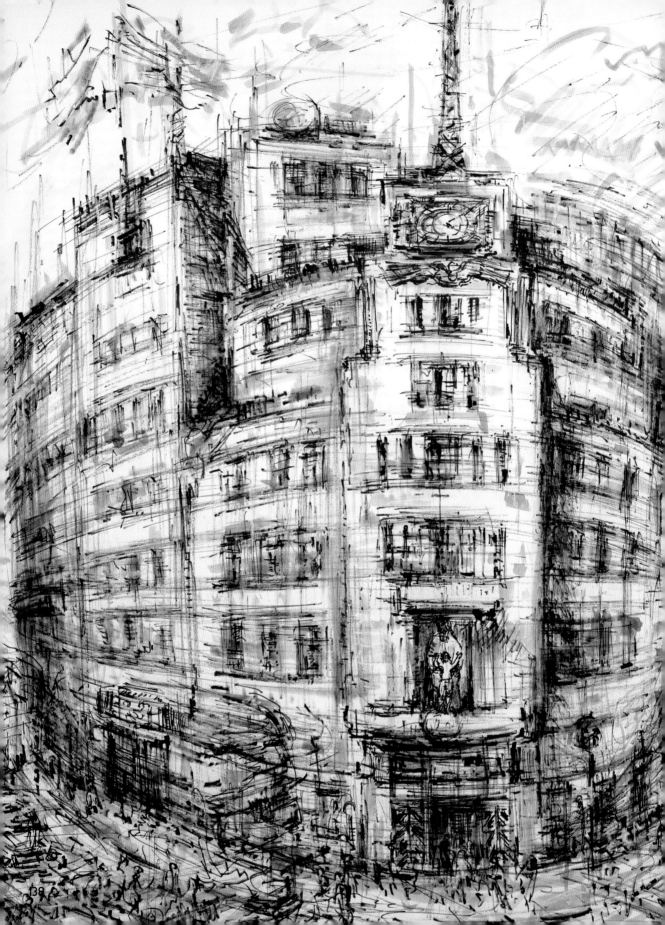

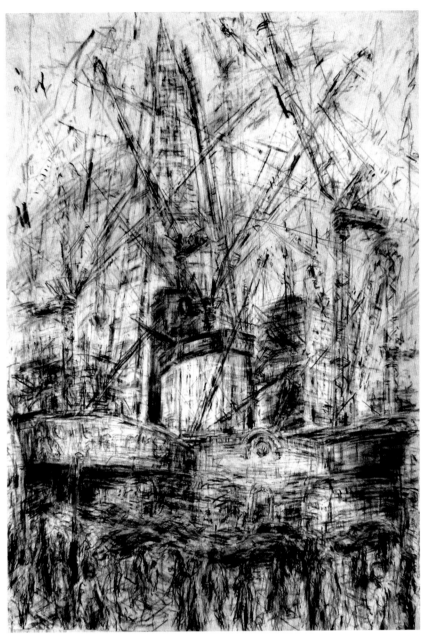

LEFT *Broadcasting House*
Brush pen, pencil (J)

ABOVE *Completed Shard and
Construction at London Bridge
Quarter* Compressed charcoal
224 × 150cm (88 × 59in) (J)

PAGES 140–141 *Liverpool Street
Station* Compressed charcoal (J)

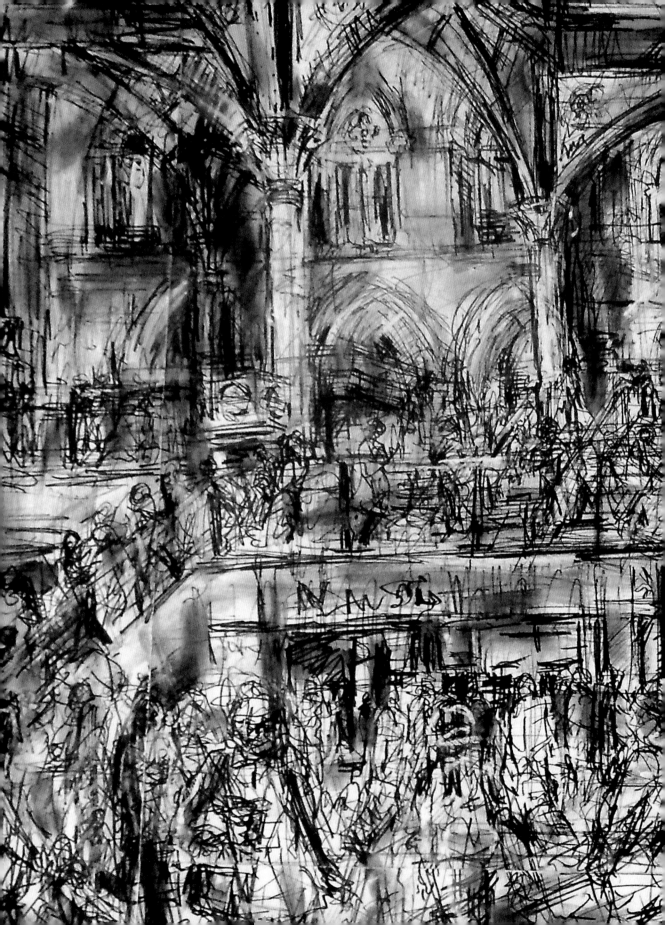

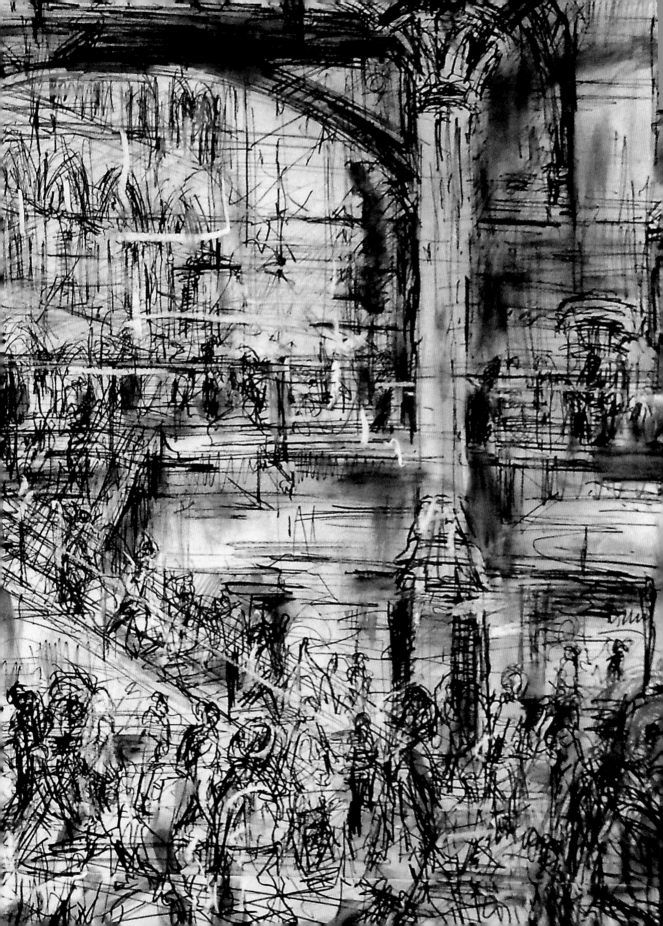

LONGEVITY

Drawing might be something that interests you for a number of weeks, months or years ... or a lifetime. The question is, how do you keep that interest going and maintain your enthusiasm? Being excited by your chosen subject matter is part of the answer, but so is renewal – not being stuck in too much of a rut, developing an approach to drawing that can evolve and even surprise you. Avoid creating strict rules for yourself where they aren't needed, try not to narrow things down so much that you endlessly refine a single technique. For every opinion and rule there is about drawing, a contradictory standpoint also holds true, so don't paint yourself into a corner.

MATERIALS

Art materials have to be at the very heart of your activity, and each one has its own strengths and weaknesses that you will have to explore and exploit to become a more proficient artist. At first, try to select the right kind of material for what you're trying to achieve (why spend hours out in the cold shading away with a pencil when some charcoal might give you something similar in a quarter of the time?). Having reached a certain point you might find yourself not just playing with materials but wilfully doing the reverse of what might be expected, for example, by being delicate with large

sticks of charcoal or aggressive with a fineliner. I always like to think of how Jimi Hendrix reinvented guitar playing – there aren't any strict rules on how materials should be used. Part of the discovery of art is your own journey and how your own use of your tools develops. If I find myself becoming overfamiliar with my materials and seem to be making the same old thing in the same old way, I might then purposely choose something that I'm less familiar with, less well-practised, and enjoy discovering what it can do.

Experiments with materials.

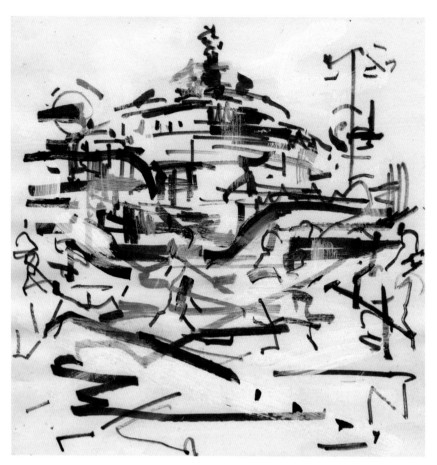

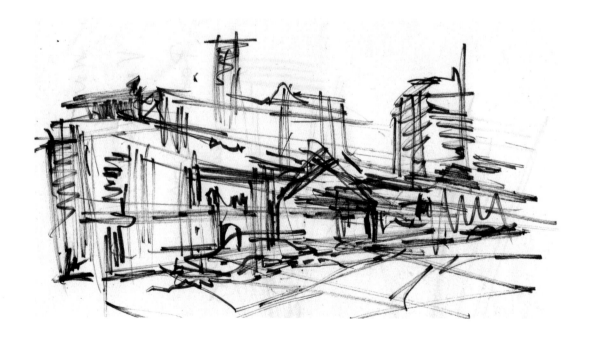

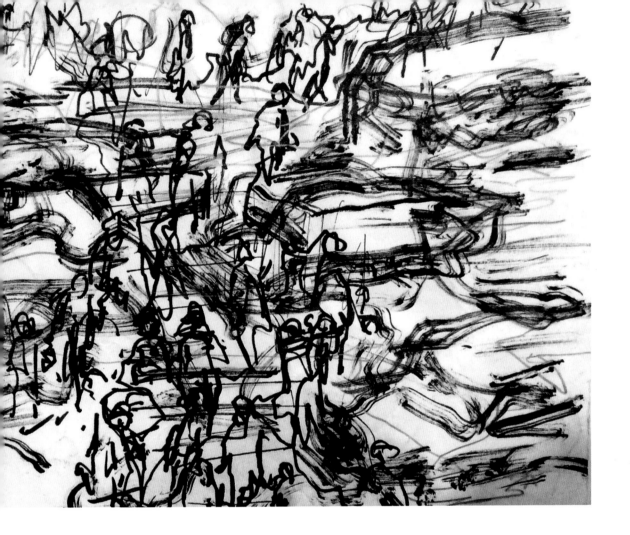

MEMORY

If I'm struggling with how to develop a composition in the studio and nothing is quite coming together, I might draw what I'm working on as I travel home on the train using memory alone. We can't copy a memory, only hope to capture the feeling of something in quite a simplified and evocative way. This is the strength of this exercise – what from all of this information appeals to us most? The result will be a long way from complete or perfect, but in some unselfconscious way might trigger a sense of recognition, uncovering what the whole thing might just be about.

OPPOSITE, ABOVE *Southgate Underground Station*
Permanent marker (J)
OPPOSITE, BELOW *London*
ABOVE *Shibuya* Both brush pen (J)

MISTAKES

... are no bad thing. They
are what we learn from. In a
drawing, mistakes are part of
the decision-making process.
We often tend to magnify
faults and downplay successes,
but within a drawing, the odd
bits, the accidental happenings,
can actually add to the work
and give it personality. If there
is something that is obviously
wrong, then just get rid of it
and have another go without
feeling too put off. If you can
do this as a matter of habit,
then your drawing will start to
look after itself.

ABOVE RIGHT *Dippy at the Natural
History Museum* Pencil (J)
OPPOSITE *Sculpture Study, Victoria
and Albert Museum* Pencil (J)

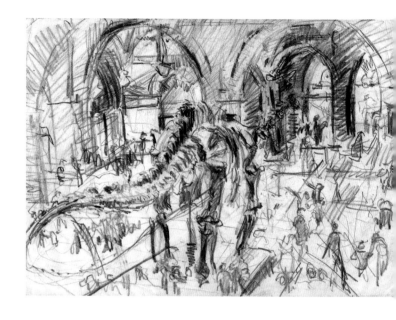

MUSEUMS

As well as containing fabulous
collections, museums often
have grand spaces and
fascinating architecture.
People tend to move in and
around at a slower pace than
in the street and so are a
bit more artist-friendly. The
relationship between people
and objects within the light-
filled spaces creates a very
distinctive subject and, if
the weather is unexpectedly
poor, a museum gets you out
of the rain and provides you
with something to do. You
might want to keep a museum
sketchbook dedicated solely to
this activity.

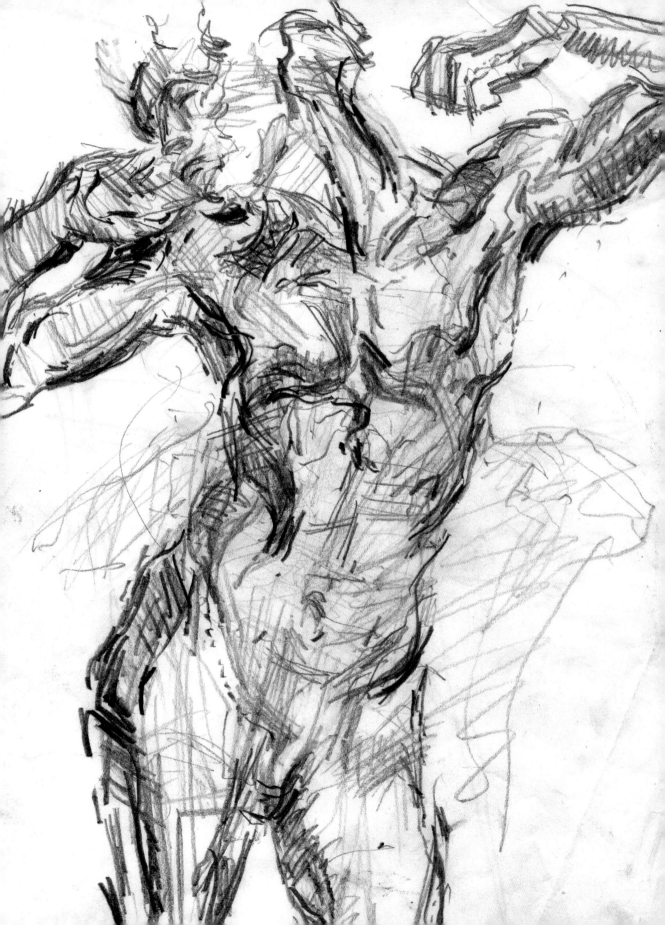

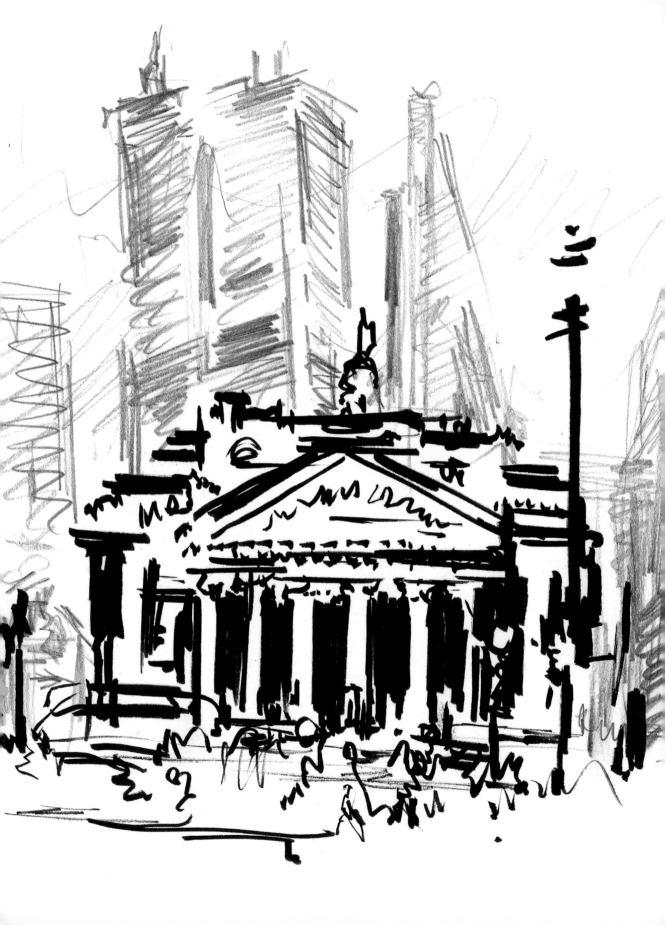

NEAR AND FAR

This is one of the key elements in creating space. If you make the objects that are closer to you darker, bolder or more intense they'll appear to jump out of the picture; things further away drawn comparatively lighter, more gently or with less information will tend to recede, and this will create a sense of space. It is also possible to do this in reverse so that the viewer is pulled past the closer objects towards the focal points in the distance, but this would be part of a more complex approach rather than one simple process.

OPPOSITE *Royal Exchange at Bank*
Permanent marker, pencil

ABOVE *Royal Exchange and Cheesegrater* Permanent marker, brush pen

RIGHT *From Hornsey to Harringay; Finsbury Park* Both pencil (J)

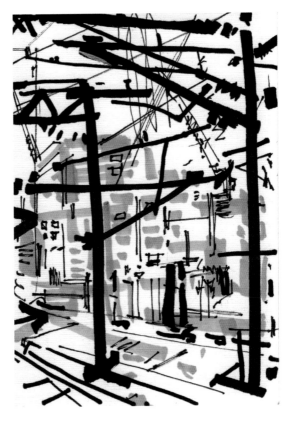

Exercise

Draw a building in the foreground with a dark marker/felt-tip pen. It would be good to draw some solid and light areas and parts with smaller details, a variety. Behind this, using a pencil, draw any buildings that visually touch it, not just an outside edge, but using your pencil to create more solid areas with tone, so that these are different from the paper colour. Experiment on another sketch with colours, darker in the foreground, lighter in the background. Also try using materials with different widths, wider in front, thinner behind. There are many combinations you could use, so play around with the idea to create different types of sketches, even reversing the foreground/background materials.

Tube Sign at Bank
Charcoal, felt-tip pen (J)

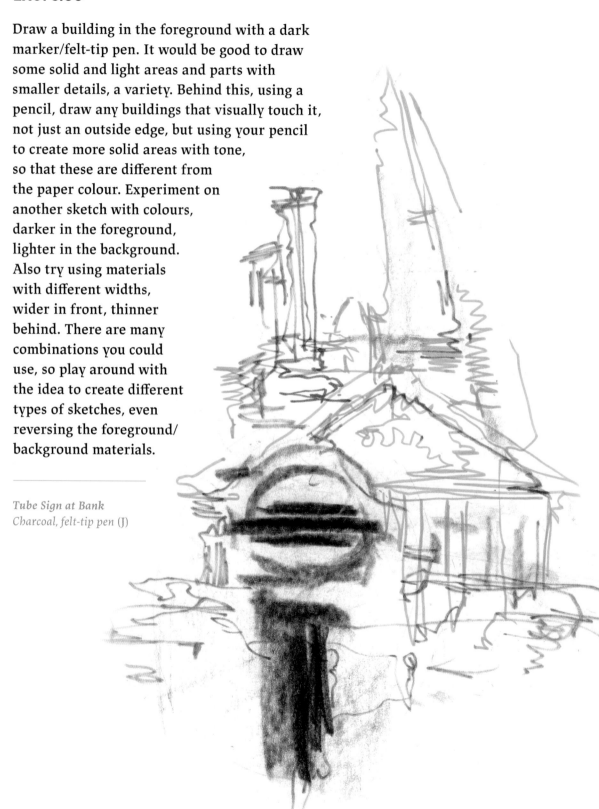

NEATNESS

We might often describe ourselves as neat or untidy people according to how we see ourselves. Instinctively we might like everything in its proper place or, on the other hand, be quite happy with chaos. As far as drawings go, neatness isn't a word I use at all. I like drawings that are particular and specific to both their subject and the art materials used. It's possible for a neat and tidy drawing to be accurate or inaccurate in those regards. Tidiness for its own sake guarantees you nothing, so don't waste energy obsessing about it. It would be equally true to say that messiness for its own sake won't get you too far either. It's not automatically expressive of anything or a mark of artistic authenticity. Neither have a moral superiority. Allow the subject to suggest what kind of drawing is most appropriate.

NECK PILLOW

Do you take one of those neck pillows on a flight with you when you travel? Well, they have other uses too. I always take one on a long-haul flight, then when I go out to sketch, I take it with me. It's brilliant to use as cushion to sit on and great as a kneeler when you need a low angle of a view.

NEW YORK

We could have produced a whole book on just drawing New York ... well, Manhattan really, as I haven't yet got round to drawing in the other boroughs. It just has so much life and energy; I fell completely in love with it the first time I went many years ago. I've never had any problems with anyone in authority drawing there, even in Grand Central Station or up on the Top of the Rock, which is a stunning vantage point on the top of the Rockefeller Center (though it's not too good for Paul's vertigo). In my opinion it's better than drawing from the Empire State, as you can see that building when you look out. Grand Central Station is my most favourite place and Times Square is so tremendously busy. You do have to be careful with your possessions in these places as there are many pickpockets. I often clip my bag to me and have it on the floor between my feet as I do a lot of my sketching standing up. When the pace gets too much there are fantastic galleries – MOMA, the Met and the small but wonderful Frick Collection – on a rainy half-day you'll be glad of the (comparative) rest.

Empire State Building
Brush pen, chalk (J)

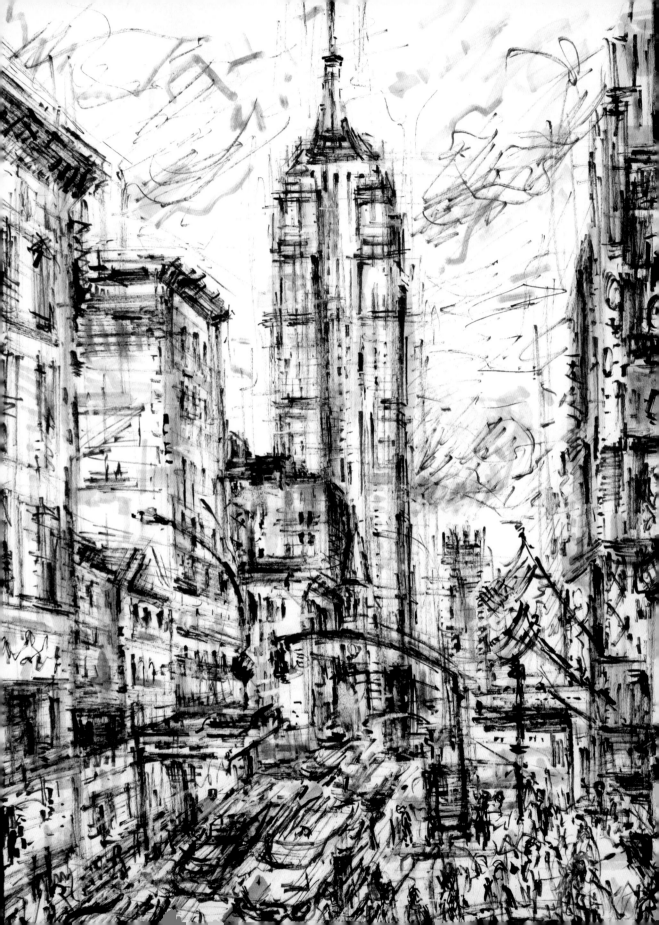

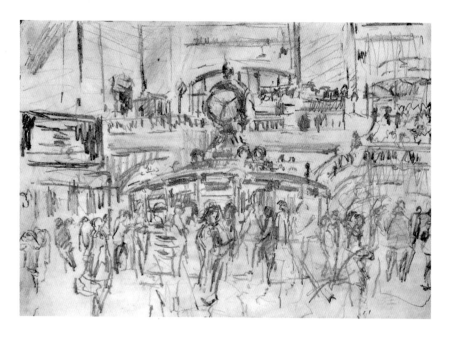

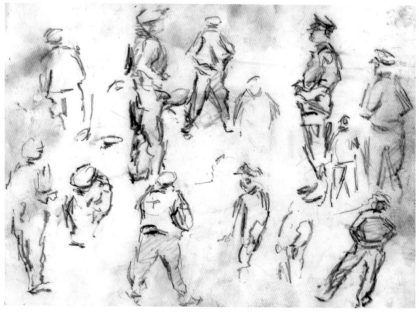

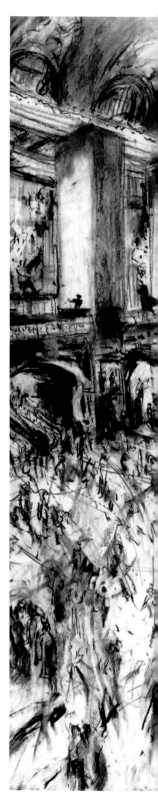

TOP *Grand Central
Concourse* Pencil (J)

ABOVE *Cops* Pencil (J)

RIGHT *Grand Central
Station Interior, New York*
(detail) Charcoal
150 × 210cm (59 × 83in) (J)

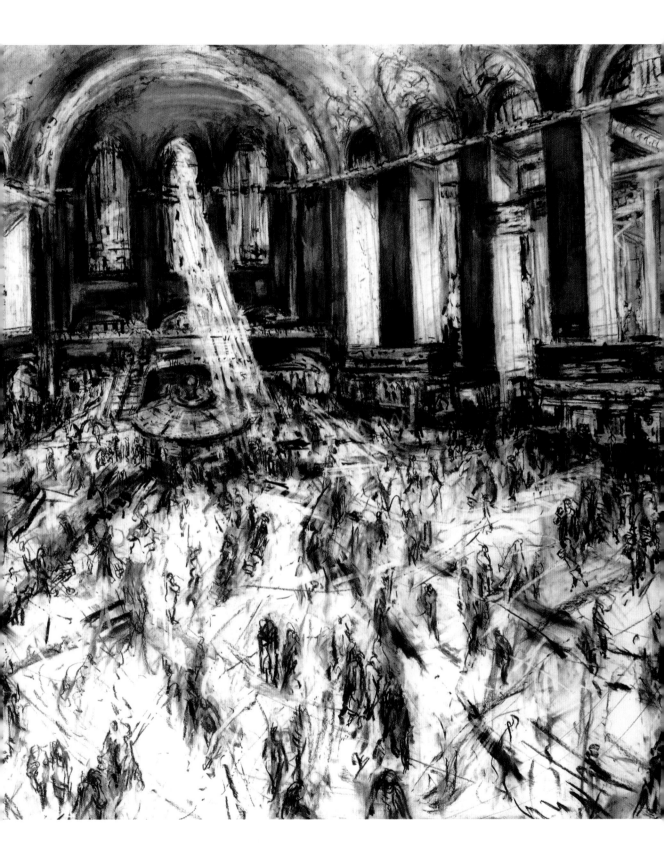

NIBS

Old-fashioned dip pens take a bit of getting used to – they're the thing that artists drew with for centuries. With the advent of the fineliner you might think 'Why bother?', but they have a quality of line that has just that bit more personality. The downside of them is their practical awkwardness on location, but it can still be worth it – one of their pluses is that you're forced to be decisive. If you hang around with a nib full of ink, touching the paper without doing much, it has a tendency to make a small blob. As annoying as that might be, it is part of it. You can brush some water over your drawing when it's partially dry to add to the image and disguise the blobbing a bit should you want to. You can also get a tiny metal plate that clips to the underside of your nib allowing it to hold more ink, so you can go longer without dipping.

RIGHT *Tokyo Study* Ink (P)
PAGES 158–159 *Developed Tokyo Study* Ink and wash (P)

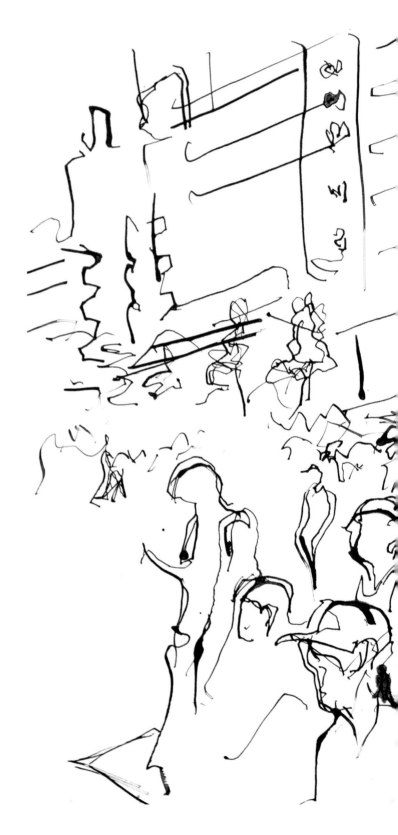

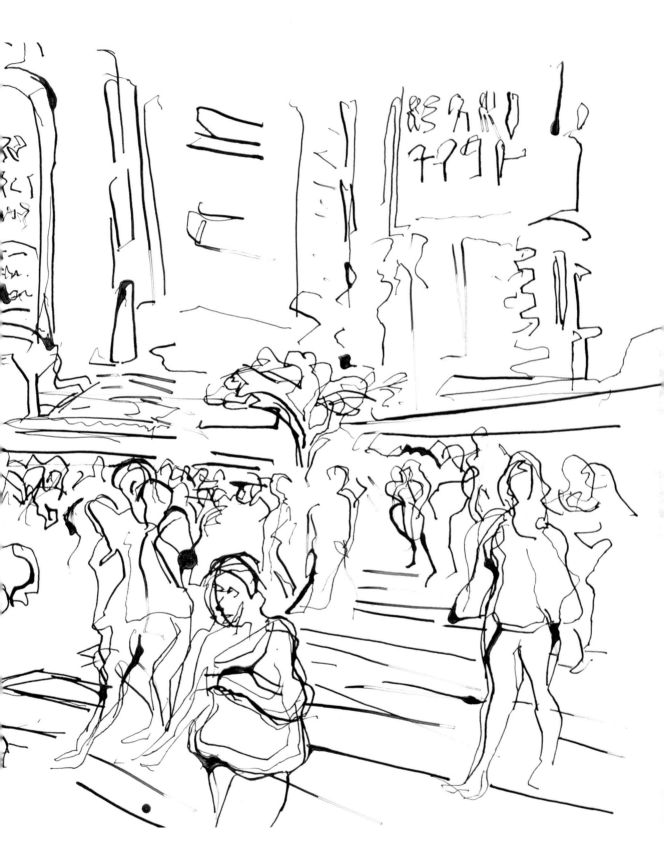

157

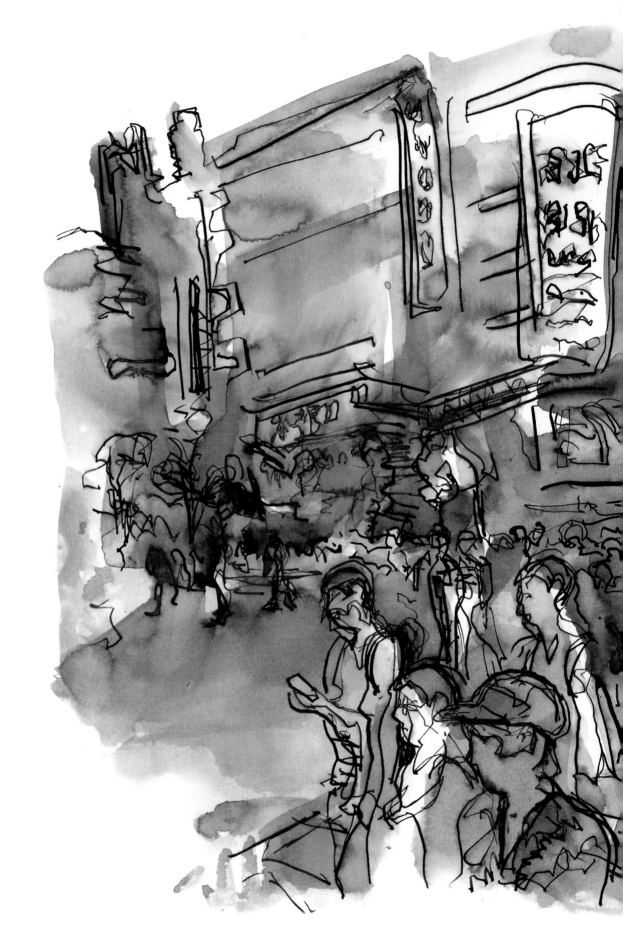

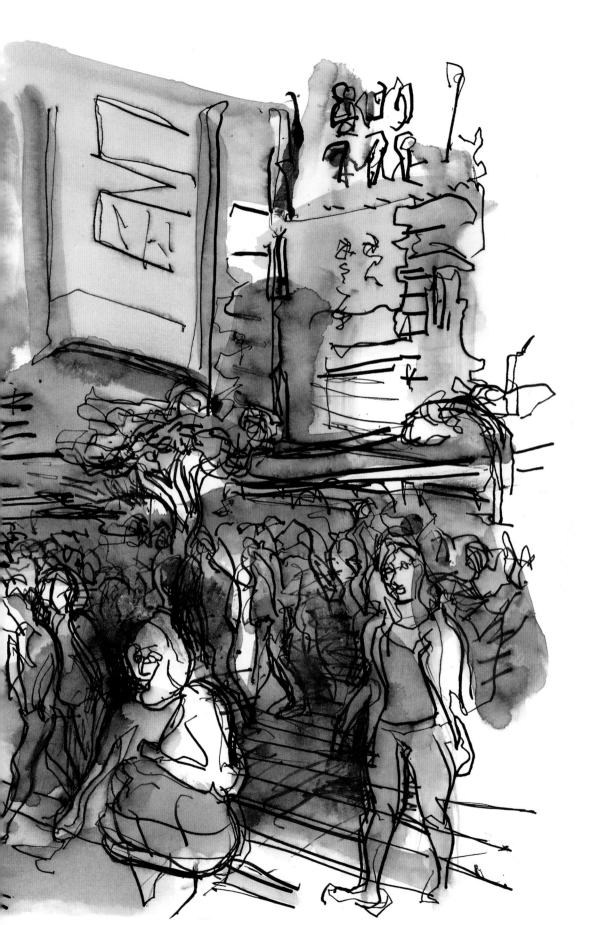

OLYMPIC PARK

The studio where we are based is in Hackney Wick, a stone's throw away from the Olympic Park. When London won the 2012 bid, the development of the area became a dramatic spectacle visible from the Greenway (a public right of way – the security on site was incredibly strict), from which I drew the construction of the stadium, the Aquatic Centre and the ArcelorMittal Orbit tower in pencil. This wealth of information was fed into a series of large drawings in compressed charcoal back at the studio. I'm used to travelling to find inspiring subject matter, but just this once, it came to me.

OPPOSITE *ArcelorMittal Tower Near Completion* Compressed charcoal
215 × 150cm (85 × 59in) (J)

PAGES 162–163 *Aquatic Centre, Stadium and Stratford Work* Compressed charcoal
150 × 208cm (59 × 82in) (J)

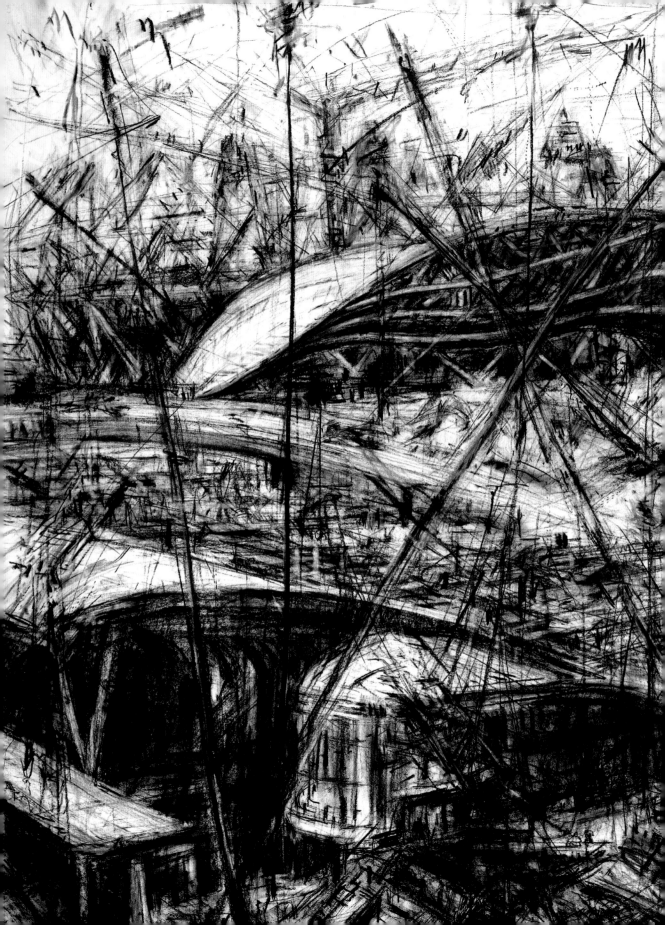

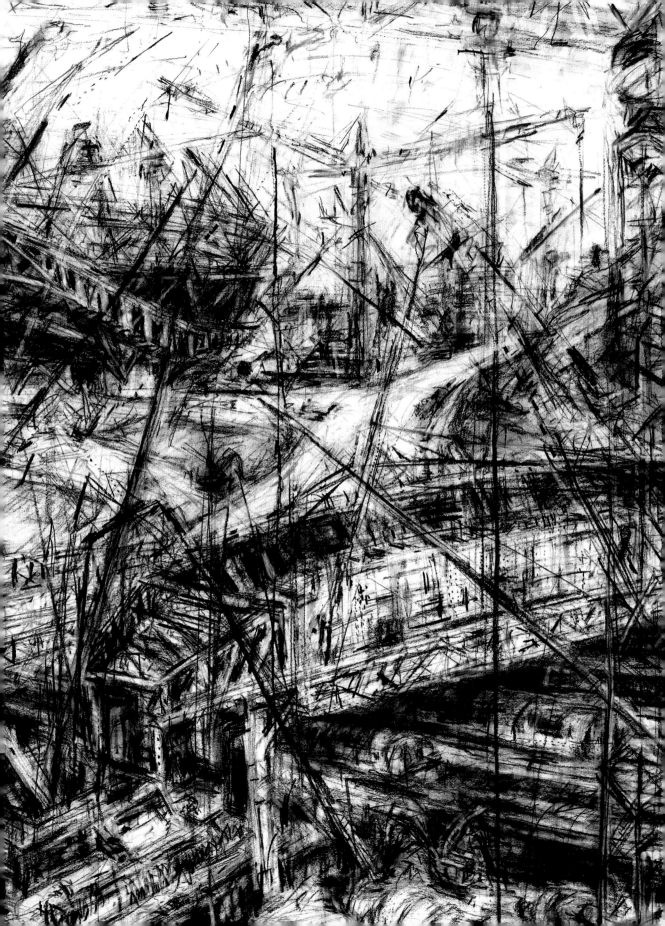

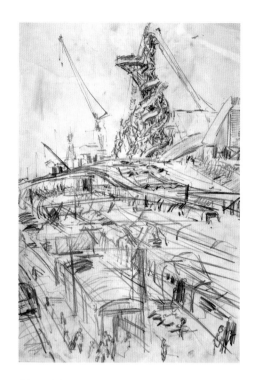

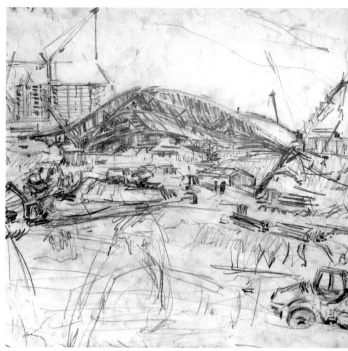

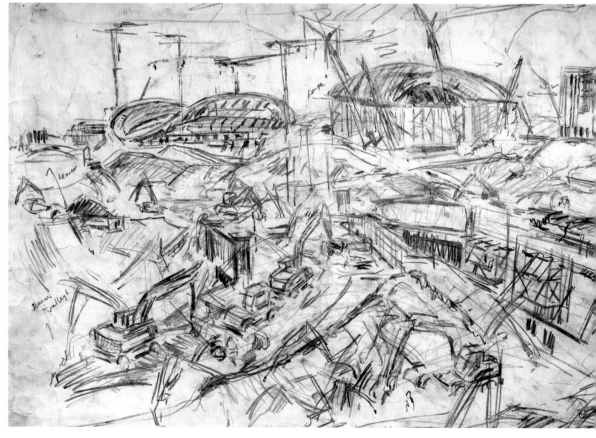

OMG

Everyone has their sense of what visually interests them. The first time I saw Times Square in New York and Shibuya Crossing in Tokyo I got this feeling of pure amazement, but then a worry – can I do it justice in my work? The answer is always probably not, so just see if you can let your enjoyment of being in a place come out through your sketches. Even if I don't think my first sketches are doing the scene justice, by standing there sketching for a while I get to properly see a place, to get a feel of it, notice things. Sometimes the sketches that follow the initial ones feel a bit more relaxed and joyful. Your sense of wonderment is just as much the subject as the location.

OPPOSITE, ABOVE LEFT
At the Base of the Tower
OPPOSITE, ABOVE RIGHT *Aquatic Centre Under Construction*
OPPOSITE, BELOW *Site Works*
All pencil (J)

ONE SIZE FITS ALL

It doesn't. Parts of this book might inspire or inform you, other parts might not be for you at all. It's not our aim to tell you what kind of artist to become or promote any single method as being the correct way to learn and develop. Your own tastes, interests and proficiency will change over time. No one is ever the finished article with infinite wisdom, which is a good thing. The advice we would give is to try a range of things, some of which might be familiar, others that might be more challenging. Creating a sense of choice for yourself as an artist will allow you to explore a range of avenues.

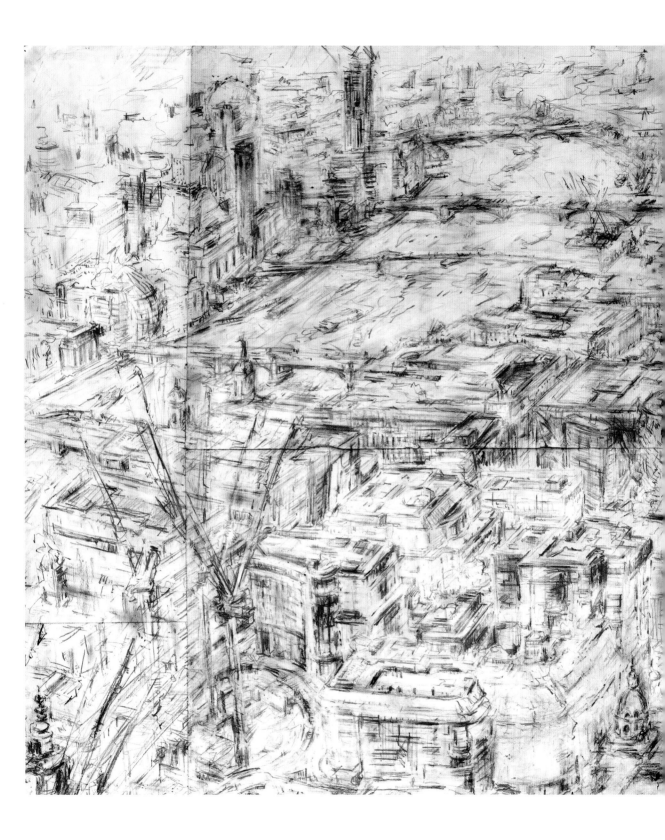

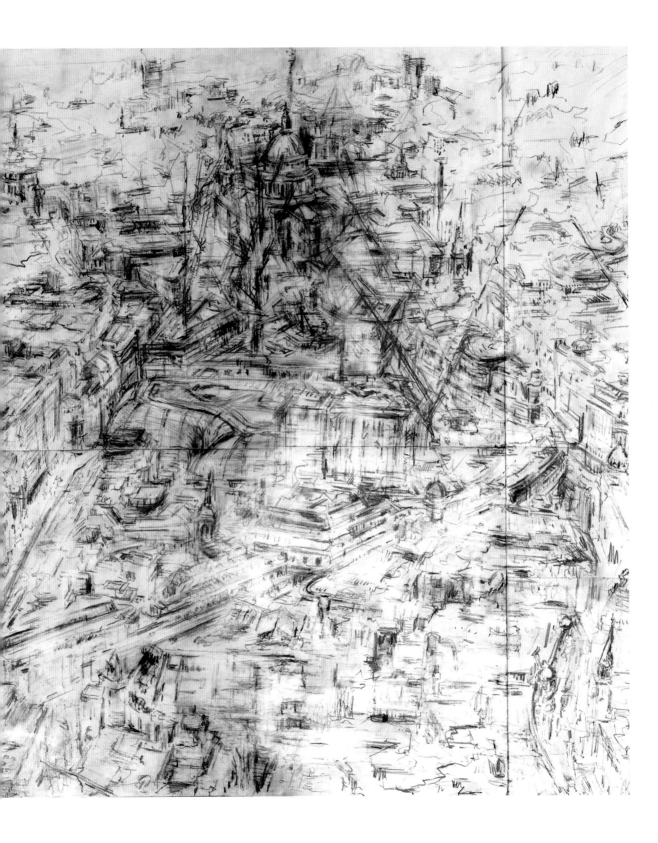

PANORAMA

I often take students onto bridges or my favourite place – the view from high up in the Sky Gardens at the Walkie Talkie building in London – to draw panoramas. It often feels like there's too much information out there and students sometimes panic. I give them a smallish oblong sticker and tell them first to pick a spot and draw one thing within this oblong, then to stick it on their page and draw outwards from this, like a spider's web. You can just draw a smallish light rectangle on your page and fill this then spread out – it really helps with scale and concentration. I would suggest working on a double page in your sketch book or halving a paper lengthways to make a long thin piece. You can also fold the paper into a concertina and just draw on one section at a time, then open it out and work on sections in a bit more detail and to see the whole view. You can buy concertina sketchbooks, but simple ones are easy to make and you can have many different sizes. I keep a couple in my bag just in case – some have a variety of papers haphazardly stuck in to create the unexpected as I draw.

PAGES 166–167 *London from the Sky Garden* Pencil (J)
RIGHT, FROM TOP *London Panorama* Pen, white paint, collage (J)
St Paul's Panoramas Felt-tip pen, pencil, sticky labels (J)

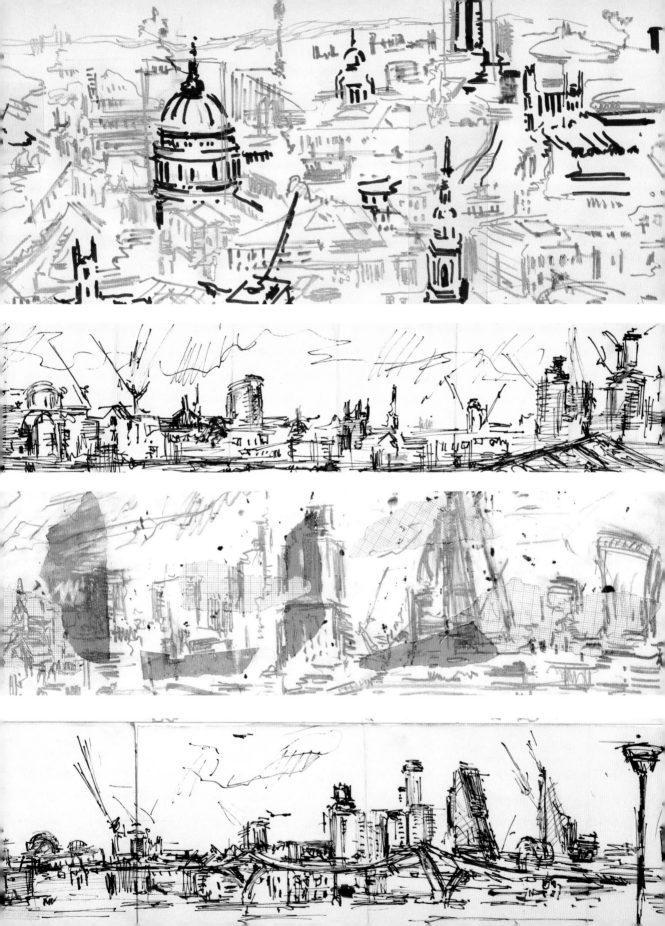

PAPER

There are many types of paper out there but the first thing to look for is whether it is acid-free. If it is, then it has a chance of lasting a long time (if that's important to you). Chances are that if it's not labelled as acid-free then it isn't. The next thing to look at is the gsm (grams per square metre); this refers to the weight (and thickness) of the paper, and usually it's between 100 and 200. Any pad that you buy should mention these two things on the front. Heavier paper takes liquid media and rough treatment better, but you might struggle to roll it up!

Even cartridge paper comes in a range of textures from perfectly smooth to really quite rough – the rougher ones pick up charcoal and pastel quite nicely. Cartridge paper also varies in colour a little, from hard clean whites to warm, creamy off-whites. Sugar paper, parcel paper and handmade textured papers are also available. You might fancy working in bound sketchbooks instead of loose sheets, and if from time to time you find yourself sketching on envelopes or bits of office A4, that's not a bad thing either – just find what's right for

you. It shouldn't really need saying, but expensive paper doesn't guarantee a fantastic drawing – sometimes the fear of ruining the paper makes the drawing self-conscious and timid, so once you've got your equipment sorted don't distract yourself with thoughts of quality or price, just do what you're going to do.

PARKS AND RECREATION

People are a bit more relaxed in parks and gardens – they're less likely to rush off as soon as you start drawing them. If you're after a good place for buildings, people and trees, then they're not a bad place to start. And if you're new to drawing outside, they're a decent nursery slope – you can build up a sense of what you're trying to do, practise with a few new materials, even mess up from time to time without feeling too under the microscope.

RIGHT *Café at Grovelands*
Charcoal, pastel (P)
PAGES 172–173 *Grovelands House*
Permanent marker (J)

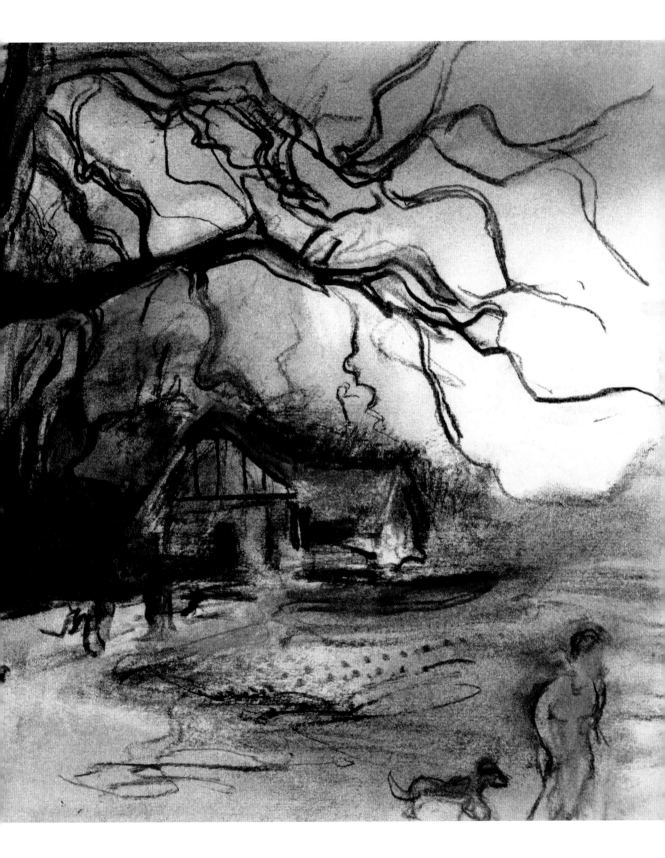

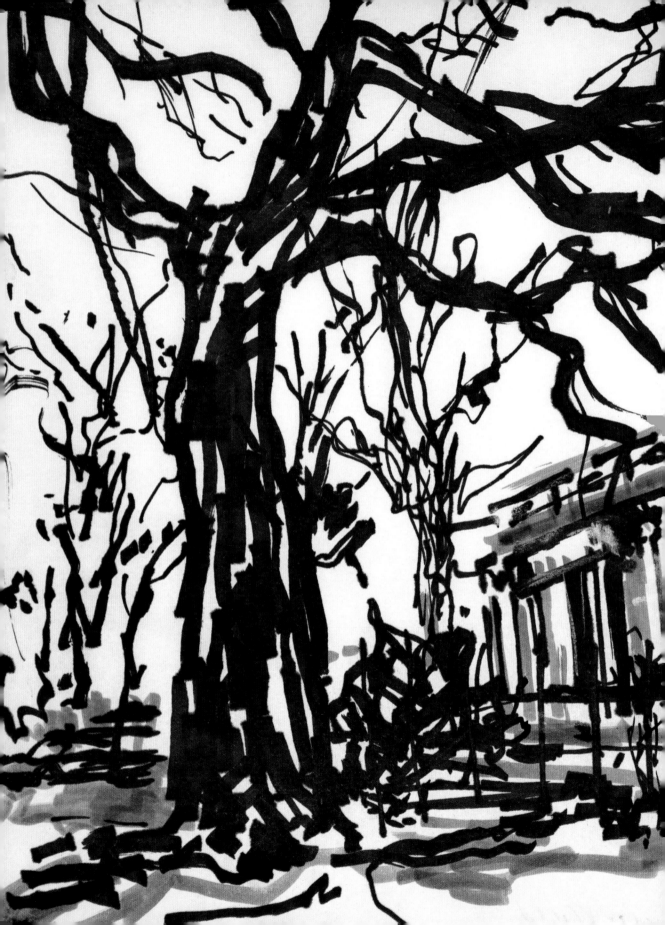

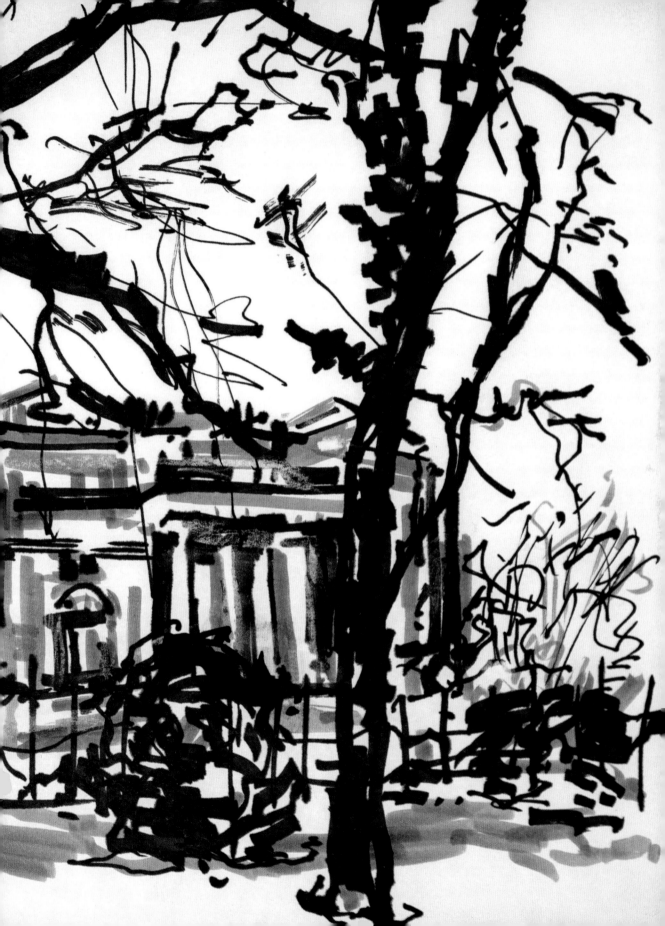

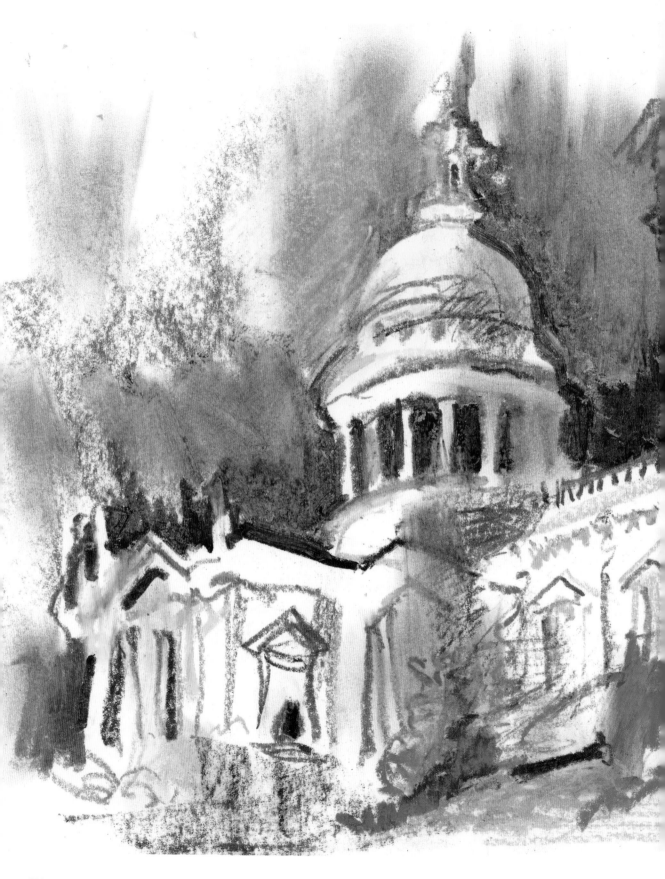

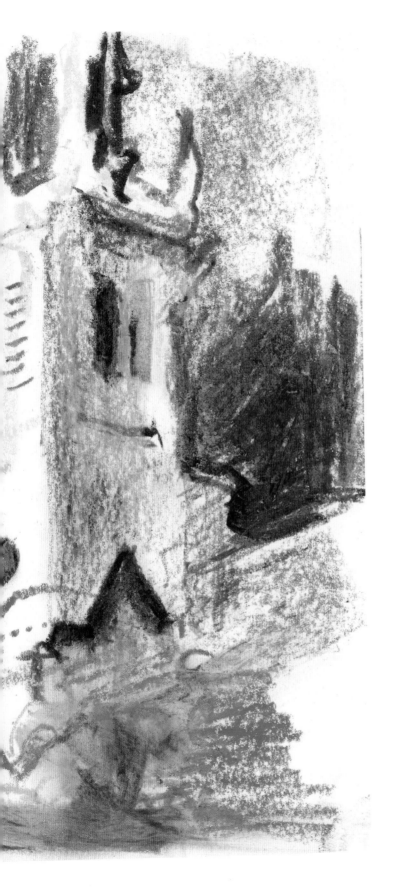

PASTELS

These are a great way of adding colour quickly and effectively, and can be applied as line or smudged in to create thin layers of luminous colour. They overlap and blend well, making them quite responsive to spontaneous decision-making. On their own they might sometimes lack a bit of linear definition, but they combine very well with charcoal and most forms of ink (when dry)!

Oil pastels don't glide over the paper with the same ease as chalk pastels but are less messy. You'll also have to work harder to blend them; they don't mix well with charcoal or chalk pastel. Any drawing that has an element of either pastel will need to be fixed either with artists' fixative or hairspray.

St Paul's Study Oil pastel (P)

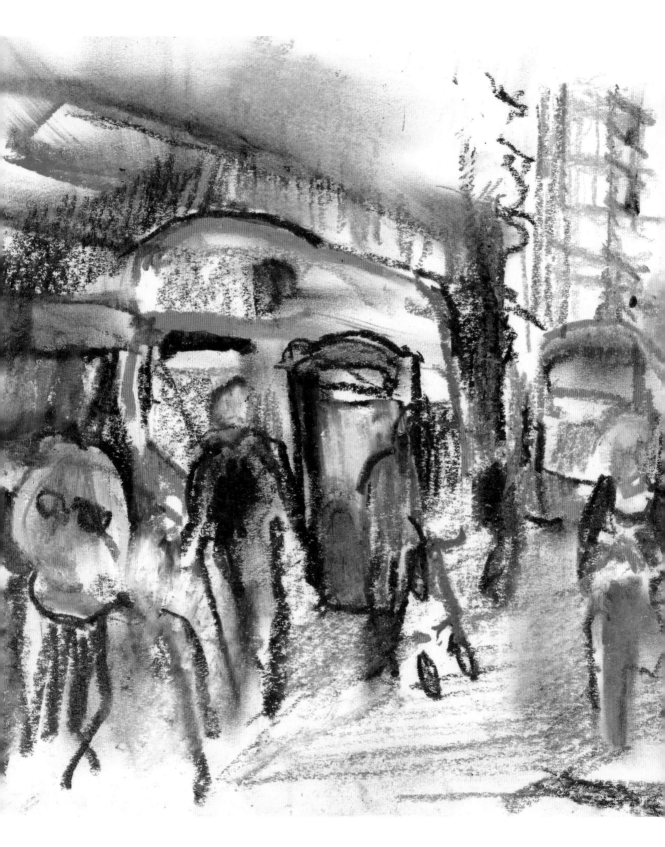

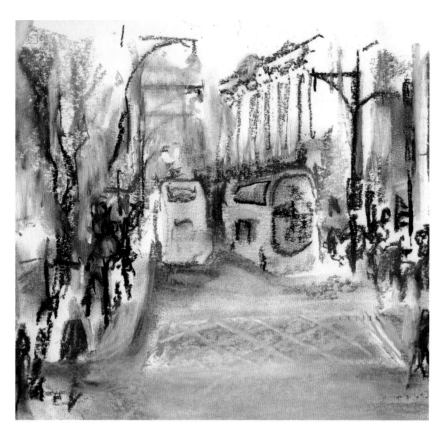

LEFT *Street Sketch*
Oil pastel (P)

ABOVE *Oxford Street* (detail)
Chalk pastel (P)

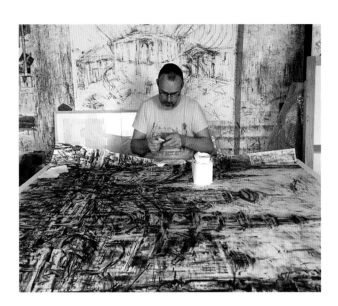

PAUL (BY JEANETTE)

Paul supplied almost all of this book's colour examples; in the studio he is painting as often as he's drawing. When I have a big exhibition on or need something framed up he becomes a patient and invaluable assistant (he's not like this at home). Initially coming from quite an academic background, he has gained a taste for experimenting with art materials, although when he plays around with fixative you can smell it for days afterwards, so don't try this at home. Paul once won the Jerwood Drawing Prize, beating a much better-known artist into second place. Yes, reader – that was me.

RIGHT *The River Remembered*
Ink, pastel over gesso (P)

179

PENCILS

Pencils were probably at the very beginning of everyone's journey into art. We both use pencils a great deal of the time: Jeanette swears by a 4B when out on location, while I prefer something a bit harder like a B or an HB. At art college one tutor used the phrase 'the tyranny of the pencil'; if we, the students, thought of drawing it would probably be in terms of drawing out shapes then shading them in with our pencils. The pencil can push us towards outline and tone, but finding other ways to use it is incredibly useful. From faint, jittery, stuttering marks to intense scribbles, the pencil is a tool capable of great variety, even if you have to work harder in order to create it.

St Paul's from Above (detail)
Pencil (J)

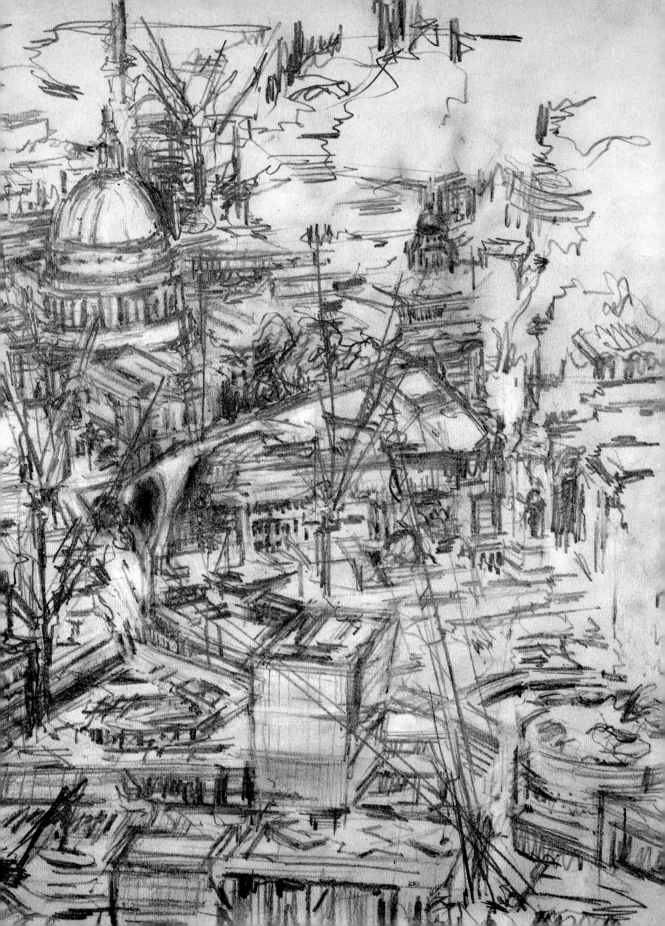

Exercise

This is something that every 'how to draw' book will tell you; have a go at taping two pencils together and drawing with those. Why? We have led ourselves to believe that to draw properly we must get the edges right. But the static edge is a concept not a reality (move your head a little as you look at your subject and all your outlines are now in the wrong place). The two lines together will allow a picture a greater sense of mobility and also demonstrate that fixation on a single line is not the only way. When the ageing French master Ingres passed on advice to the young Degas it was this: draw lines. Lots of lines.

The White Tower
Two pencils together (P)

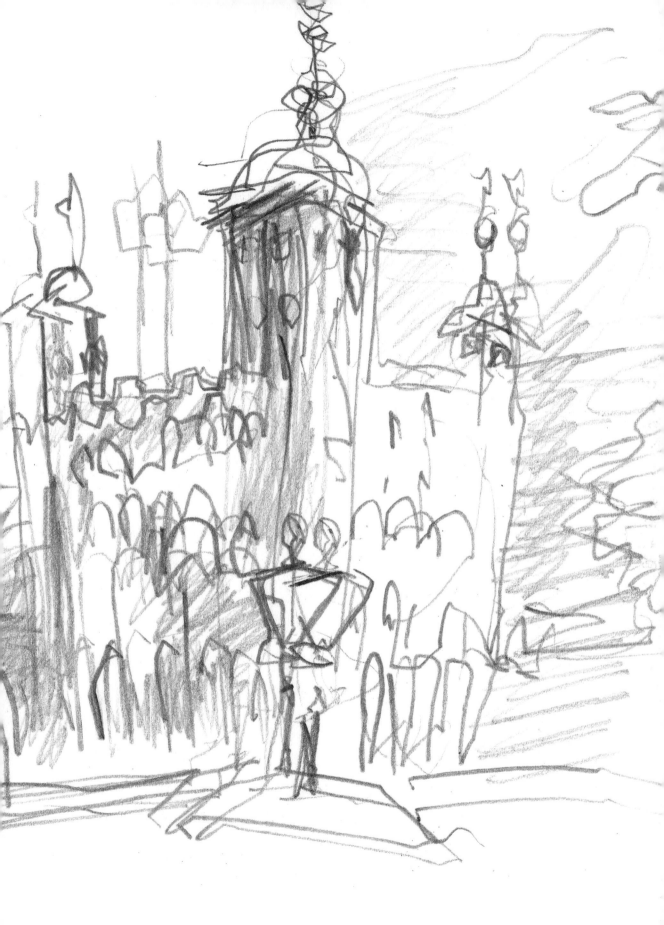

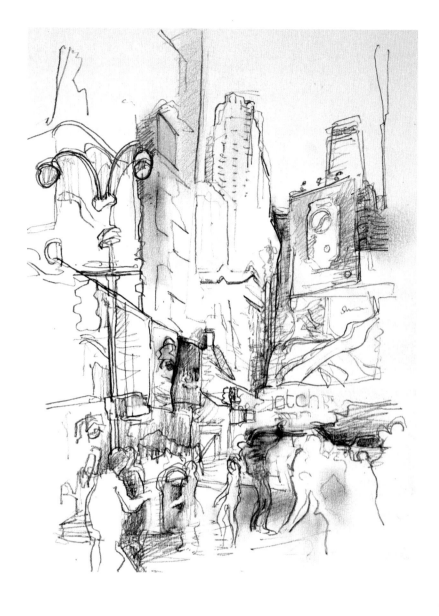

ABOVE *Times Square* Pencil (P)
RIGHT *St Mark's, Venice* (detail)
Two pencils together (J)

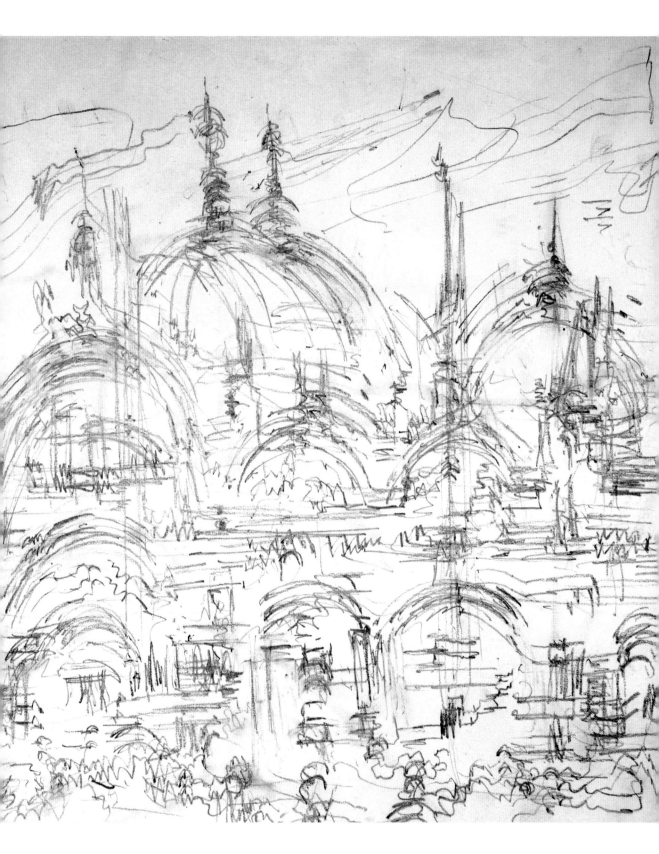

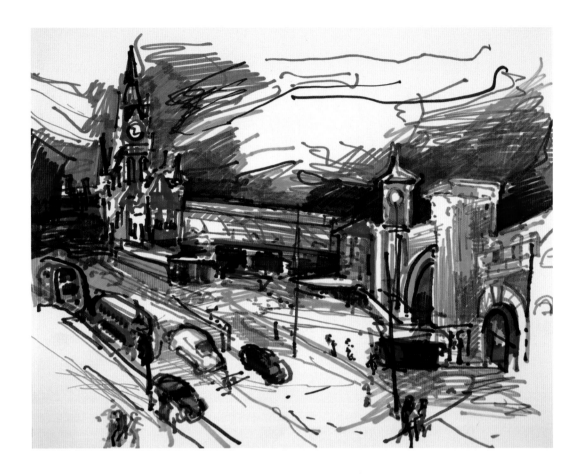

PENS

There are so many different pens available, from old-fashioned dip pens to felt-tips, biros, calligraphy pens, fineliners, permanent markers and pens with synthetic brush endings. Always take a range of pens out with you so that you're not tempted to fall into habit. Play around with what your pens can and can't do, just like any other art material – don't assume that you already know. In general, once a pen's mark is down then it's there for good (ink erasers tend to remove as much paper as they do ink) so think carefully about what you're going to do, and then be bold. Should you need to cheat, though, a bit of white pastel, gesso or paint can sort out the odd mistake if needs must.

ABOVE *St Pancras and King's Cross Stations* Felt-tip pen (P)

OPPOSITE *The Shard and Borough Market* Brush pen and white paint (J)

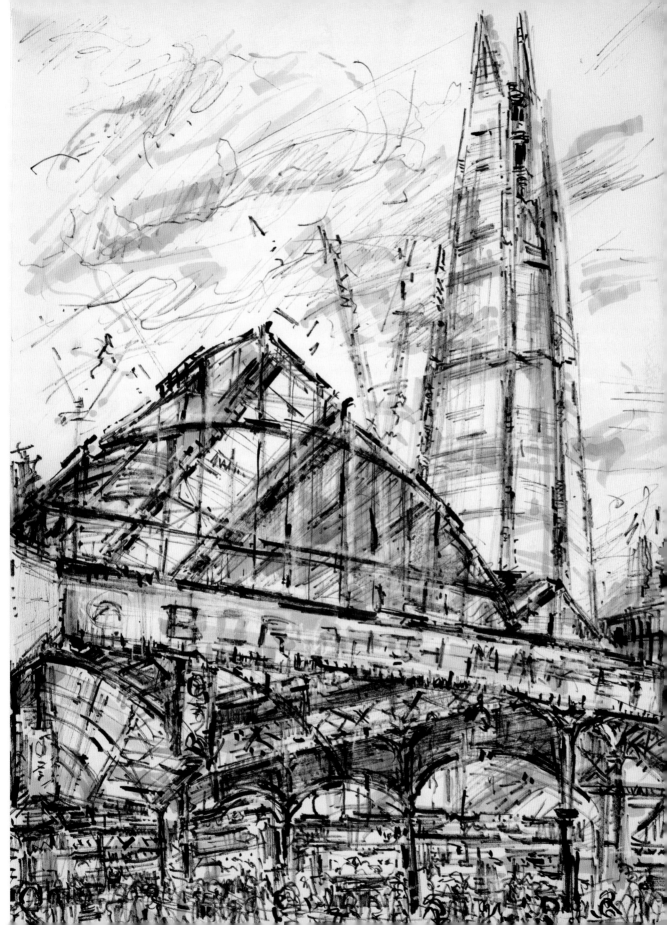

Hornsey Station
(detail)
Pen, chalk,
white paint (J)

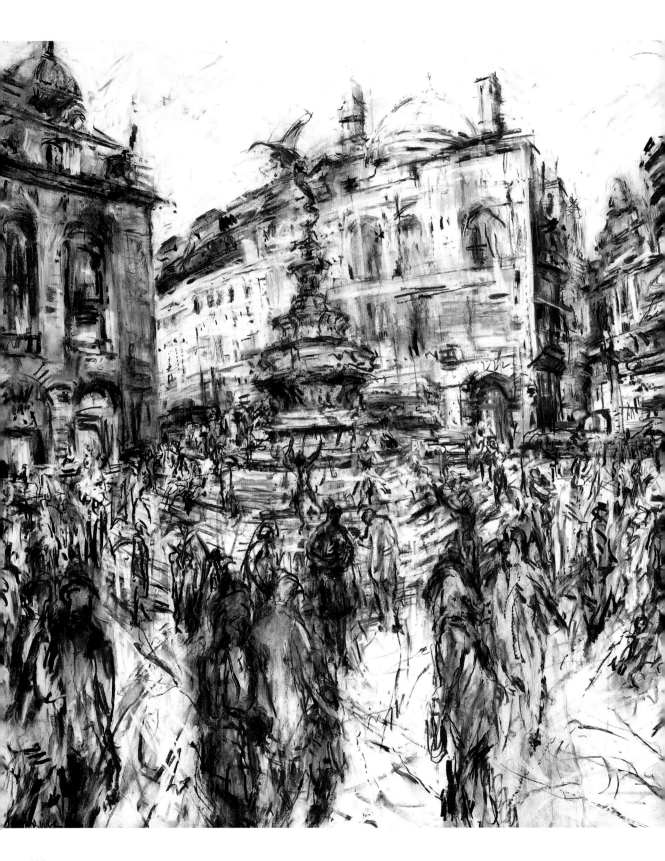

PICCADILLY CIRCUS

'It's like Piccadilly Circus' is a common enough phrase. In reality, it's one of London's landmarks that seemingly never sleeps. People, traffic, advertising, architecture, all swirling around the statue of Eros in a perfect combination. Drawing there is without doubt challenging, but it's exhilarating and rewarding too. As a student at the Royal Academy of Arts I saw Piccadilly on a daily basis, so it's not just another part of the city but something that symbolizes my connection to the past and to the location.

LEFT *Piccadilly Circus, Eros*
Charcoal 141 × 186cm (56 × 73in) (J)
ABOVE *Adverts and Eros* Pencil (J)

PLAN

I make many sketches on location – if I want to use them to make a larger picture at the studio I'll have to make plans to work out the composition. I often do several of them, some quite large, A1 or A2 in size, but mostly a lot smaller. I put all the different sketches on the floor and combine them together; I often have sketches from slightly different viewpoints so I have to make decisions on which aspects to include. I execute the plans quickly and fluidly, usually in pen and occasionally charcoal; both these materials give a nice flow. I was pleased that one of these plans won the Trinity Buoy Wharf Working Drawing prize in 2019, a recognition that even quick sketches can be valued.

ABOVE *Oxford Circus*
Permanent marker, white paint (J)
RIGHT *Nanjing Road*
Permanent marker, paint (J)

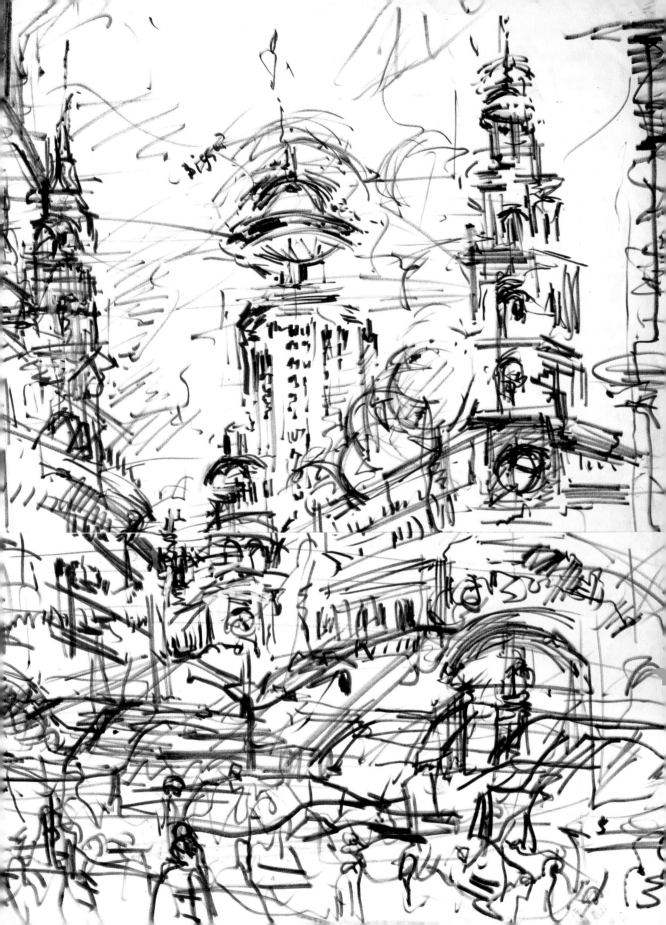

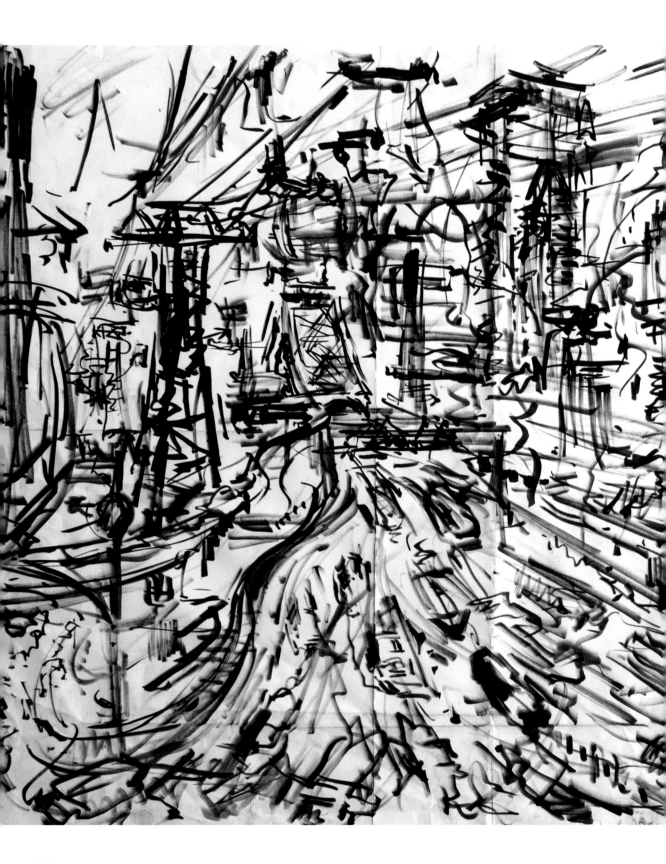

PRACTICE AT HOME

It cannot be stressed enough that practice, although not necessarily making perfect, will without doubt lead to improved confidence and then results. You might feel a little awkward, a little bit on the spot, going to locations and expecting miracles to happen. Practising at home could be the answer – getting things wrong as many times as required, exploring your art materials away from the wind and the rain and the pigeons. Build your confidence in your own time without feeling that you have to perform. Through necessity some of the drawings in this book weren't actually drawn on location; the feeling of being there isn't quite the same but that doesn't make the drawings themselves any less interesting. You don't have to set aside hours on end; see how far you get in five minutes, then ten, and then thirty.

It was only during lockdown that I started using photos and secondary images exclusively to work from rather than outside sketches and memory. Exploring large cities across the world online created a sense of fun that became almost a guilty pleasure. Would I prefer to be out sketching in a city rather than using photos? Absolutely, but it's not always possible, so make the most of your time and creativity at home.

LEFT *Cable Cars, Roosevelt Island* (detail) Permanent marker, white paint (J)

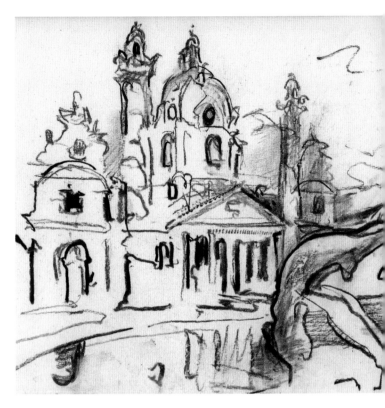

PROCESS

The artist processes the reality in front of them, translates it somehow. The subject is the origin, the artwork is the destination. The decision-making of the artist is the part between those points. To be more aware of how a subject might be processed, try this.

RIGHT *Karlskirche, Vienna*
Clockwise from top left:
charcoal; pastel; charcoal, chalk and pastel; charcoal and chalk (P)

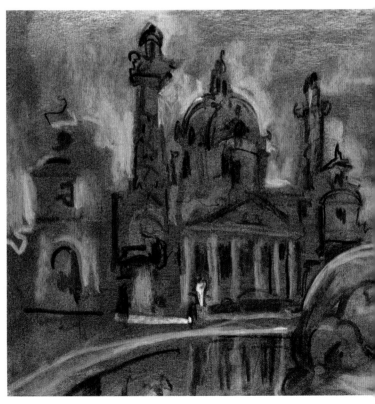

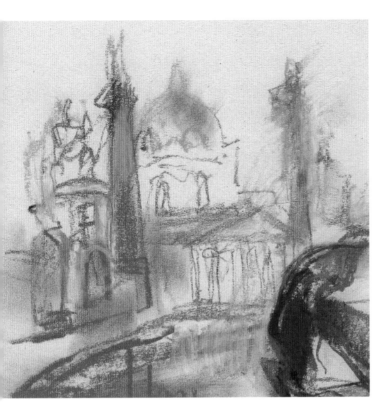

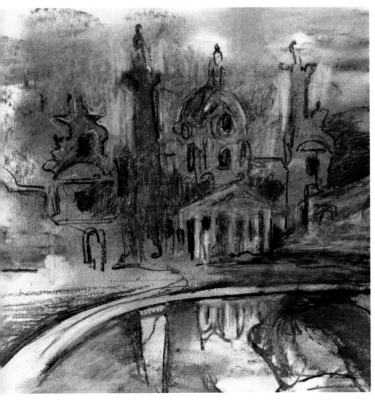

Exercise

Have a photo of a place in front of you or, if you prefer, visit an interesting location. Make four A4 drawings of the subject that will develop your sense of decision-making. Give each the same amount of time (say, not more than ten minutes each).

Draw your subject first in charcoal to gain familiarity. Then create a grey ground on the next sheet and make a drawing of the same subject using charcoal and an eraser, or charcoal and chalk, that is purely concerned with light and shadow. Make a third drawing concerned with creating the effect of near and far (use colour if appropriate). Change how heavily or lightly you press to create variety, allowing some marks to fade into the space while others jump out. Finally, make a fourth drawing, only using the first three for reference instead of the subject.

QUALITY OF LINE

It's very easy for a drawing to develop into a sequence of interlocking shapes that will flatten out your whole picture. The hardest thing isn't hand/eye co-ordination or proportion, but creating the idea that your drawing exists in space, rather than two dimensions. You have to fight against the picture's inherent flatness rather than reinforce it. Unevenness is a good ally in this – if something isn't fully or uniformly described, its position is not entirely fixed and a push and pull in space begins to happen. If you use your materials at different speeds, varying the amount of pressure, then you will create a range of events in your drawing. Generating quality of line might seem odd at first but after a while it will become second nature and you will have built a visual language to deal with the contradictions of your subject and of drawing itself. The abrupt, the delicate, the fluid and the ambiguous will all take their places within the world you create.

Charcoal is good for the following exercise, but it's also worth trying other materials. These are abstract marks to start with, but should help you discover quality of line and how to manipulate it.

ABOVE *Hornsey Station*
Marker pen, chalk (J)
RIGHT *The Flatiron, New York*
(detail) Pen (J)

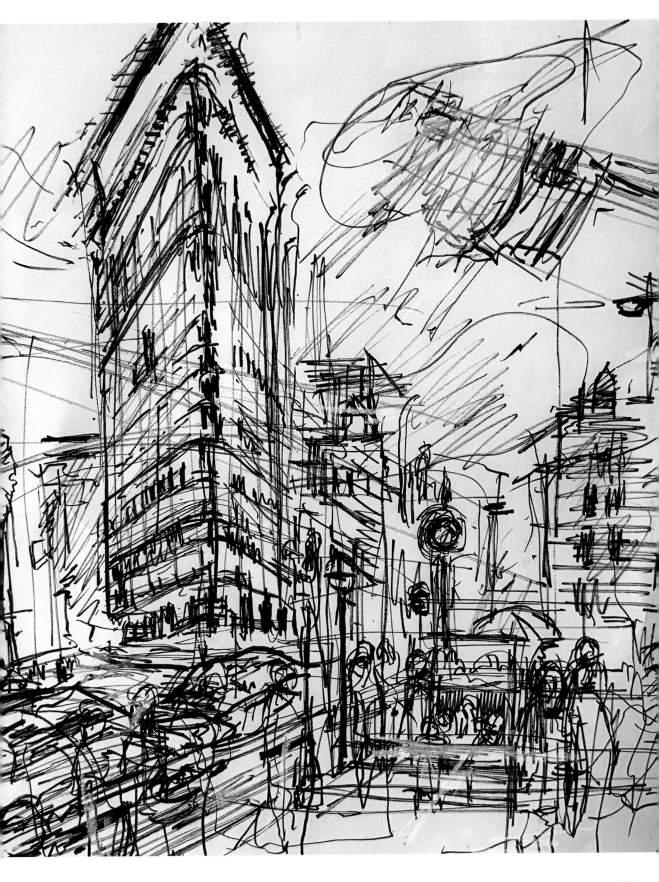

199

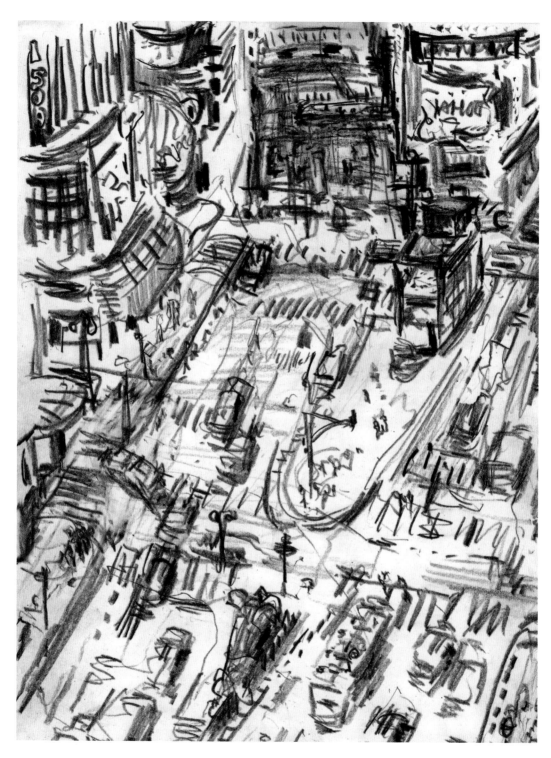

ABOVE *Looking Down on Times Square*
Chinagraph pencil on satin photo paper (J)
OPPOSITE *Approaching St Paul's* Ink (P)

Exercise

Draw a long sharp line wriggling around on your paper, going up and down, always on the move, without too much thought behind it. Something that began in a gentle way might become more hard and angular and then more broken, becoming scribbly and ever more black as the marks gain density. As odd (or even childish) as this kind of activity might seem, this kind of playing becomes second nature after a while and when harnessed to observation it will bring your drawings to life.

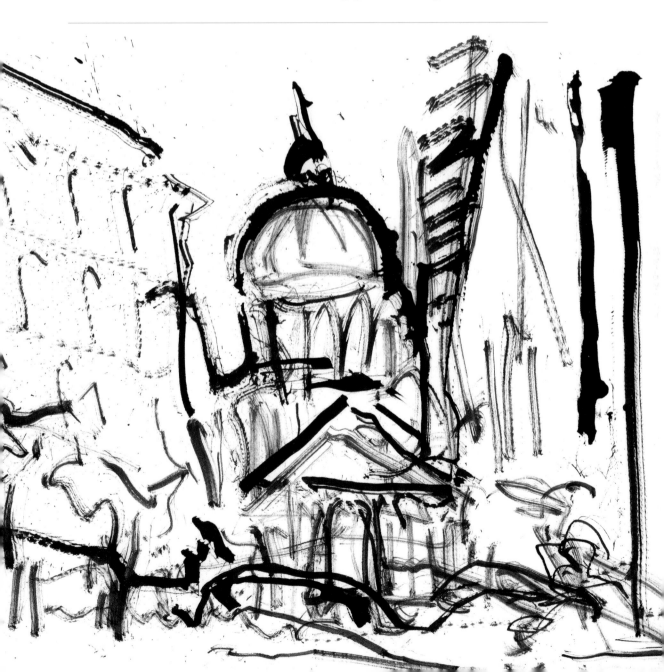

QUALITY VERSUS QUANTITY

You'd imagine that quality is the greater of these two but if you're starting out, how do you actually get there? Through quantity. It's not an either/or situation – if you do lots of work, of course the results will be varied. The key is to constantly compare and contrast your outcomes to see where you might like to go with your work and to develop strategies and choices that might help you get there. There will always be a gap between what you want and what you end up with on the paper – as irritating as that may be, it is the same for every artist out there and in a funny way it will also be the thing that keeps you going.

QUITTER

We're always told not to be one. Sometimes it pays off to keep fighting with a drawing, exert some willpower and get yourself out of a tricky situation. On the other hand, cutting your losses and not wasting any more time on something that clearly isn't going to work is the intelligent thing to do. How do you know which of these is right at the time? The answer is that you probably don't – it'll be more down to how you feel. Don't beat yourself up if you do give up on a drawing – we've all done it. It doesn't mean that you're a terrible artist. If you do give up on something, have a cup of tea, create a bit of space between that and what you are about to do and go again. Being a quitter from time to time is absolutely fine. Just don't be a serial quitter.

Market Stall, Tokyo
Fineliner, brush pen, pastel (J)

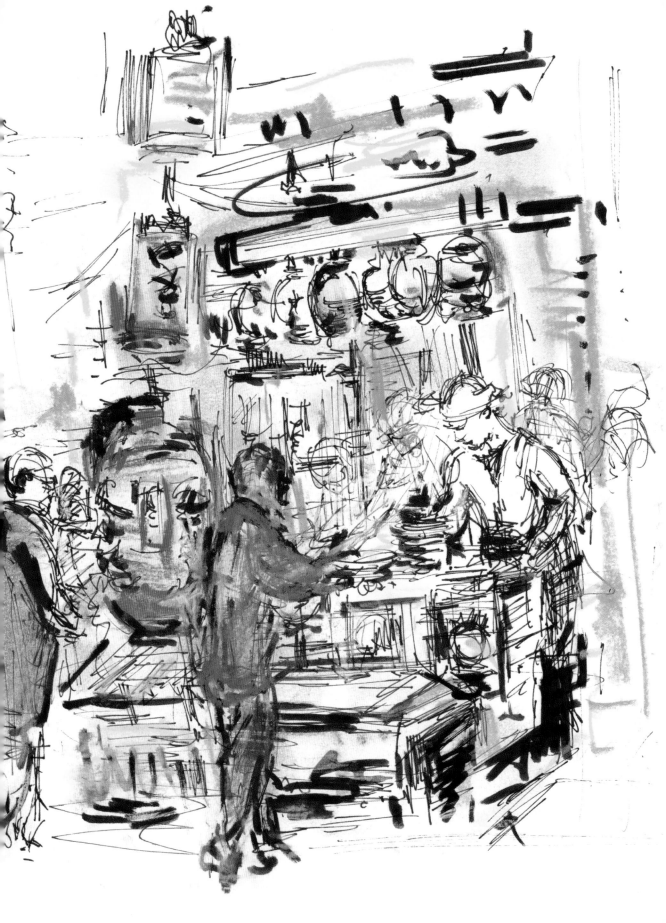

REPORTAGE

Your drawings might not aspire to be grand artistic statements but simply to record the world in a more modest, objective fashion. You might call it a form of illustration rather than a form of expression but, however it might be described, reportage has taken on a life of its own much in the same way that urban sketching has. You don't need a big subject – imposing skyscrapers, historic cathedrals – just day-to-day life.

RESULTS

We all want good results in return for our efforts, but don't expect too much too soon. Often that weight of expectation gets in the way of producing anything so, if you can, approach your work with the idea that it is in some way liberating, handing you the freedom to explore, to discover and even – from time to time – fail. Drawing for your own purposes is not an exam, so live a little and see what develops.

Greenwich Market Biro, pastel (P)

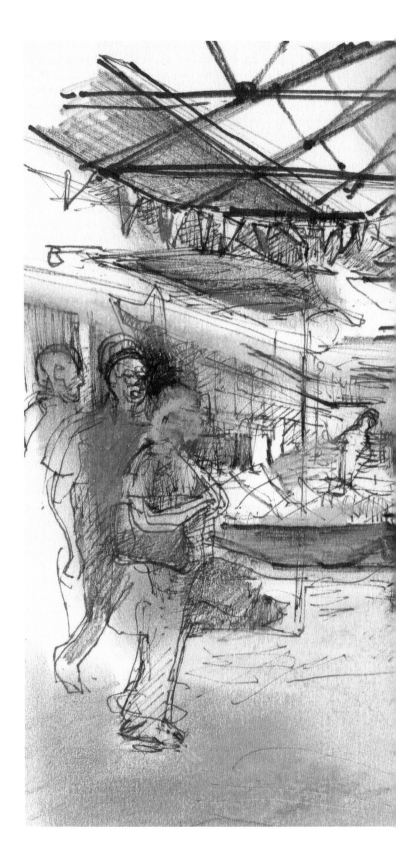

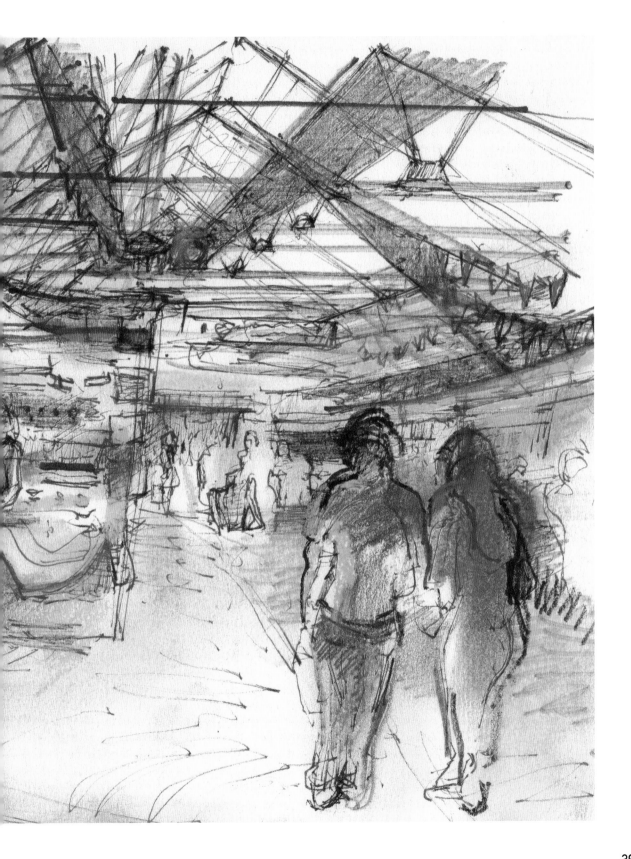

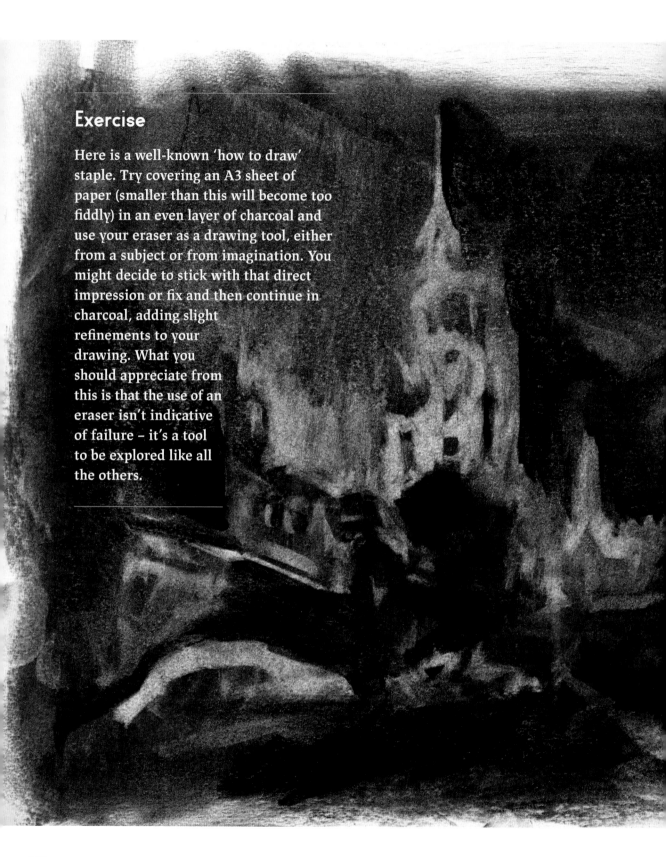

Exercise

Here is a well-known 'how to draw' staple. Try covering an A3 sheet of paper (smaller than this will become too fiddly) in an even layer of charcoal and use your eraser as a drawing tool, either from a subject or from imagination. You might decide to stick with that direct impression or fix and then continue in charcoal, adding slight refinements to your drawing. What you should appreciate from this is that the use of an eraser isn't indicative of failure – it's a tool to be explored like all the others.

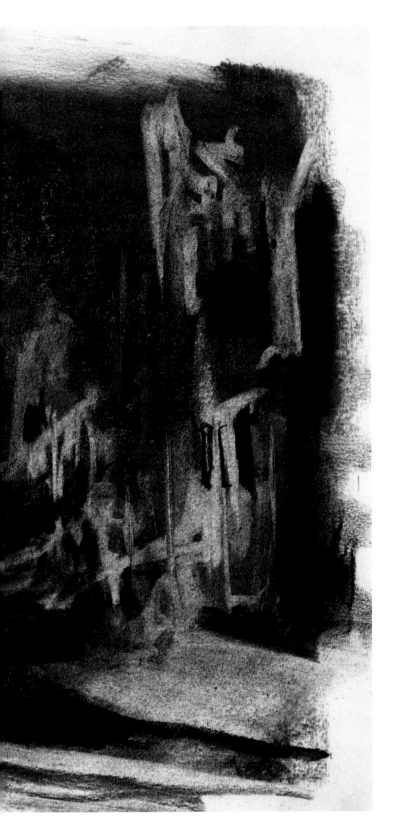

RUBBING OUT

We might wish for our drawings to be perfect or to look clean; anything out of place gets rubbed out, all our mistakes hidden from critical eyes. If you think of your drawing in terms of graphic design, then that might be the kind of image that you're after. Reality, and much of drawing, isn't quite like that – what if your drawing, as much as being a record of what you are seeing, was also a record of your thoughts and decisions over time? Rub out completely only when you really have to. Draw on top of what you have already done. Drawing is about finding relationships and connections between things on the paper; if you are constantly starting that process from scratch you won't get too far. This attitude is at the heart of Jeanette's large drawings; things come and go – are made and unmade – in search of the most effective balance.

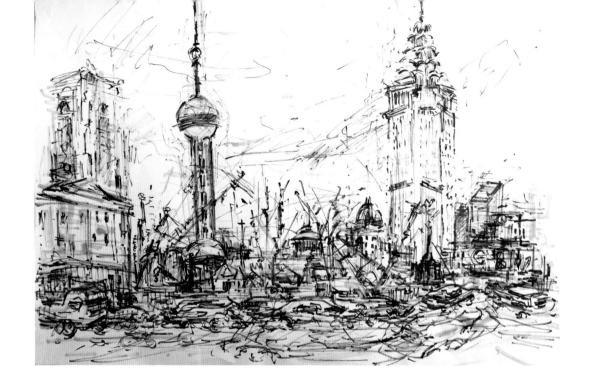

SHANGHAI

What an amazing place to draw Shanghai is. I thought I'd messed up as I'd booked to go on one of their biggest national holidays, 1 May. Yes, it was very busy, but I got to see Chinese nationals going about their daily lives and not just tourists. I worked in Old Shanghai, the Bund, Pudong and the busy shopping area of Nanjing Road.

I didn't draw the amazing European buildings on the Bund, lovely as they were; I drew from there across to Pudong, to what the Chinese themselves built rather than what the Europeans did. Pudong is the new business district with the tallest, sleekest skyscrapers, but one of the oldest is my favourite – the very retro-feel Pearl Tower, which has a revolving restaurant inside with a great view. The old part of the city may have been redeveloped with tourism in mind but was still very interesting to draw. I found drawing on Shanghai streets easier and a lot less hassle than I'd anticipated. Knowing how to say a few words in Chinese really helped.

ABOVE *Busy Shanghai*
Pen and chalk (J)
OPPOSITE *Jing'an Temple, Shanghai*
(detail) Pencil (J)

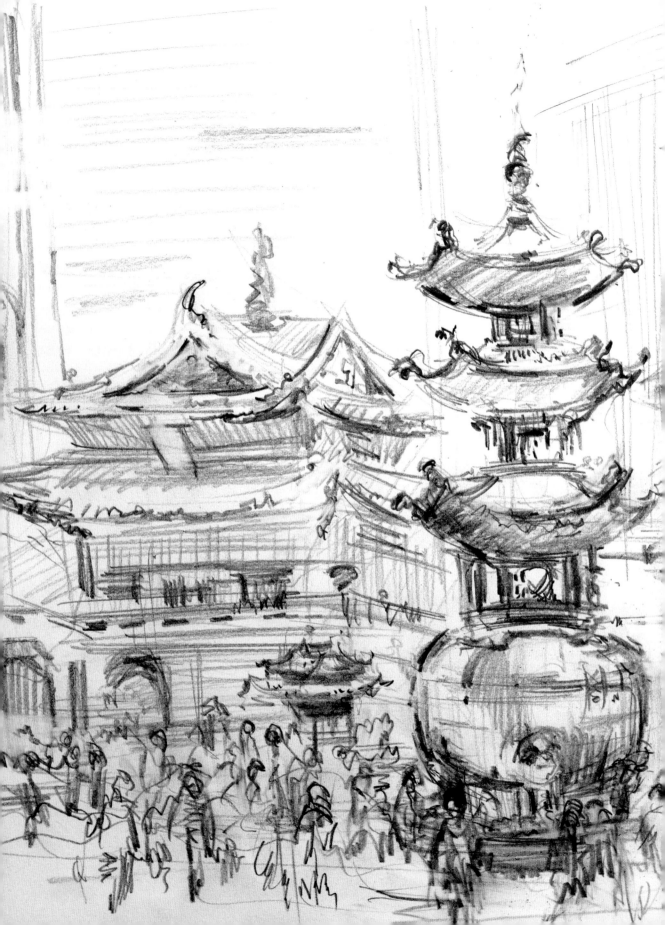

SIGNS

Signs can be tricky but I enjoy drawing them; their light and fracture can add another kind of interest to the drawing. It is too easy to put everything in – letters, lights and faces – so you have to be careful, or this is all that will be focused on, and not the rest of your sketch. If you put in a lot of meticulous detail it can slow the work down and become tiresome, or bits can jump out and become too separate. I often put signs and advertisements in, then rub bits out or tone them down; this creates the feel and buzz of their energy without them overwhelming the entire sketch.

Times Square, New York Pencil (J)

ABOVE *Eros with TDK* Pencil (J)

OPPOSITE *Times Square, New York*
Pencil (J)

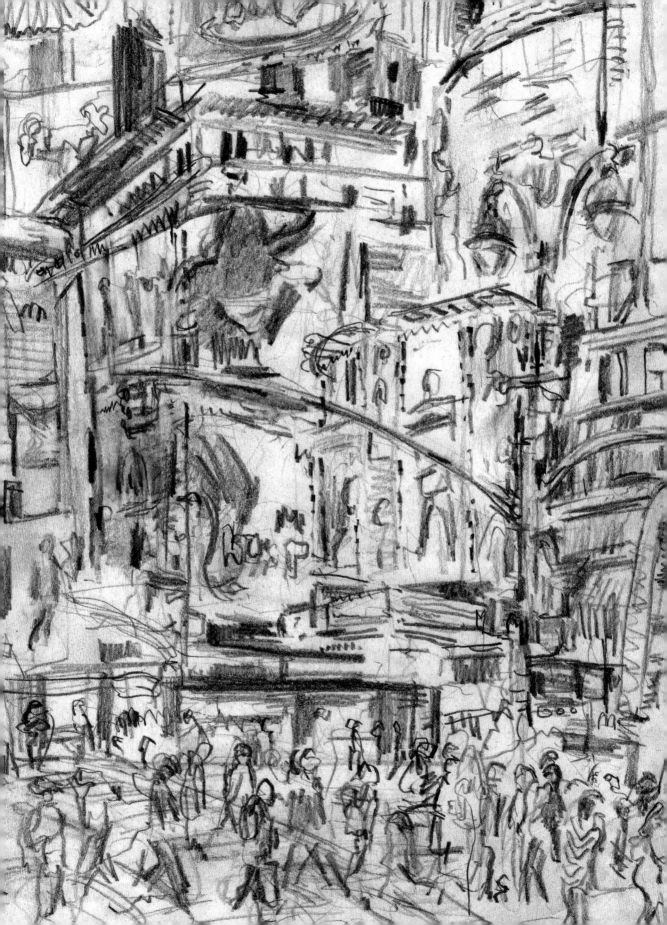

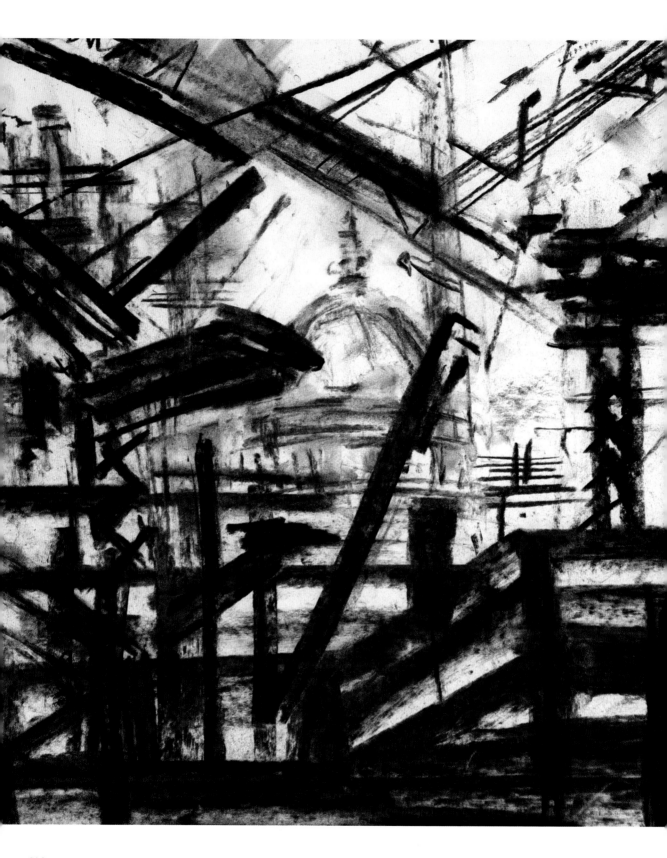

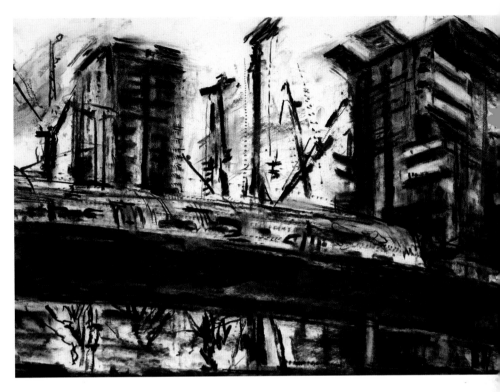

SILHOUETTE

Perhaps the simplest, yet most striking of sketches. Without many details, the dark form surrounded by bright light stands out on the page. I start with strong and bold shapes but I also like to add just a few lighter or smaller elements to add another dimension.

LEFT *Construction with St Paul's* Charcoal (J)
ABOVE *Docklands Study* Charcoal (J)

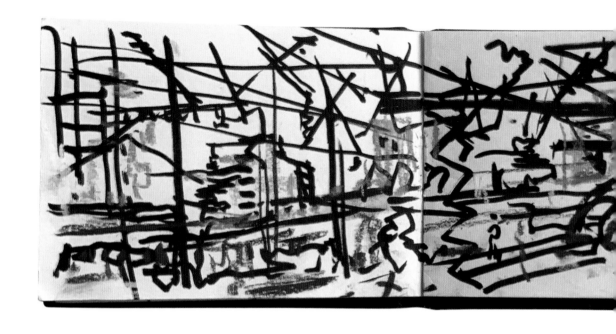

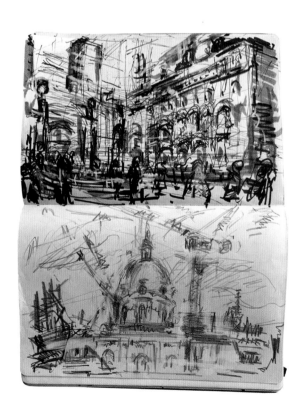

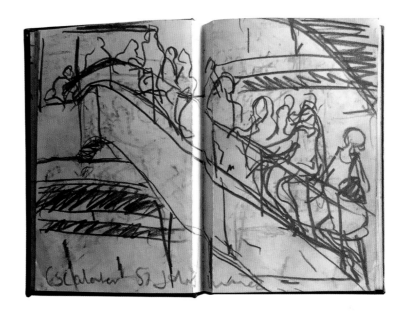

SKETCHBOOKS

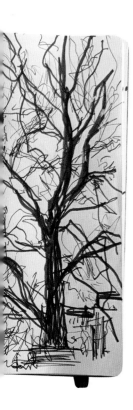

These are like diaries. I have a set of them from when I was younger and it's amazing looking back at them; the way I drew, what I looked at and also what I wrote. I can see how much myself and my practice has changed yet somehow remains similar in essence. Sketchbooks, to my mind, should be full of ideas, sometimes realized, sometimes not. Some people have perfect books, filled with full drawings all perfectly finished. This is fine – perhaps you are that kind of person – but I do think sketchbooks are the places where ideas are given space, risks are taken and avenues explored. I've now changed sketchbooks for loose-leaf pages when I'm out drawing so that when I get back to my studio I can lay all the pages out together and work on a large composition. A lot of my sketchbooks now have some drawings in but also notes about ideas, exhibitions, etc. I draw every day, but it might be on a scrap of paper as often as in a book, or sometimes even on a newspaper while on a train if an idea strikes me. Your sketchbook should work for you.

LEFT AND ABOVE *Various sketchbooks showing scenes from London and Liverpool.* (J)

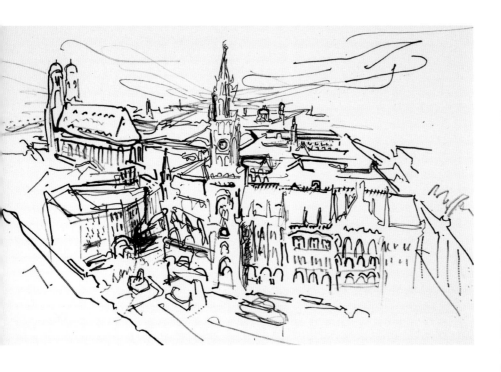

SKEWERS

Wooden barbecue skewers make really good dip pens for ink. You'll get a decent point, a blunt end, and if you bend and break it very slowly it often splinters as it breaks to create a kind of wooden brush that can be used to create lines that crackle with a broken energy. Their length allows you to put a bit more pressure on them if you hold them higher up to create a kind of 'whip' to your stroke in a way that you can't get with a cocktail stick.

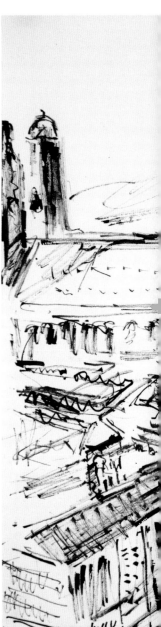

ABOVE AND RIGHT *Marienplatz Cathedral, Munich* Ink (P and J)

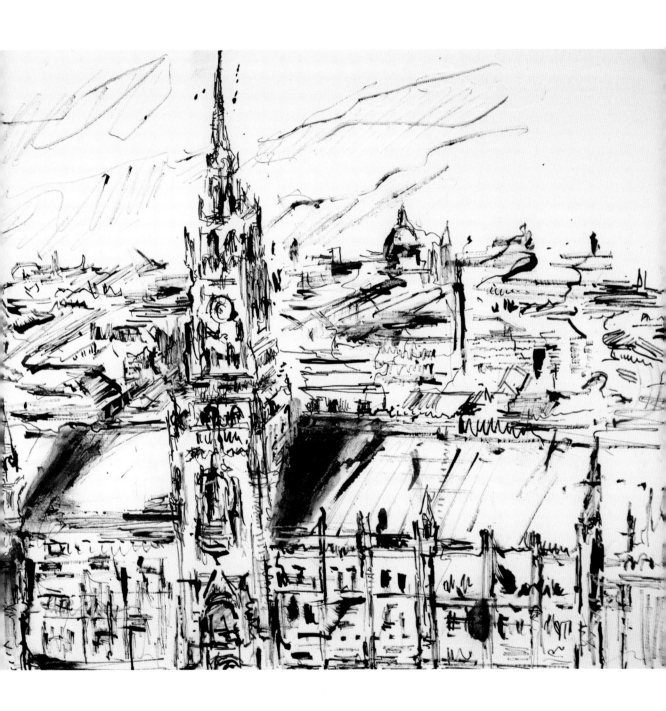

SKILL

We all admire skill. Most skills are developed through dedication and practice rather than being some sort of gift from God. In drawing, it's probably wiser to pursue a range of skills as opposed to endlessly honing the one thing you do well enough already. After drawing for 30 years, I would say that the real skills in drawing aren't to do with anything technical and can't be learned: they are being able to make the right decision instinctively at the right time and knowing how to ride one's luck. These things tend to come with experience and make the difference between a good drawing and an excellent one.

SPACE

A sense of space in a drawing has to be built in by you. Simply drawing the buildings and objects that you see does not guarantee that your picture will feel spacious. Too many evenly drawn outlines will flatten your image, but if you can create unexpected journeys and connections for the eye a sense of space will begin to develop. There are basic formulas, which are a start, but won't necessarily deliver the feeling of being there: more detail close-up, less further away; tonal contrasts diminish as we go further back into space. A dynamic sense of space is related to building up layers in a drawing, allowing some marks to jump out, others to get lost, the scattering of focal points that encourage the eye to rove; an eraser can be used to restore an airiness to a picture if it's getting too clogged; line can move the viewer around the picture at different speeds as much as it can illustrate the scene. Space is reliant upon a combination of all of these things, so experiment with their balance, allowing things to come and go and become lost and found as the picture evolves.

OPPOSITE *Road Study* Pencil (J)
PAGES 222–223 *Sheikh Zayed Road, Dubai* (detail) Compressed charcoal 150 × 200cm (59 × 79in) (J)

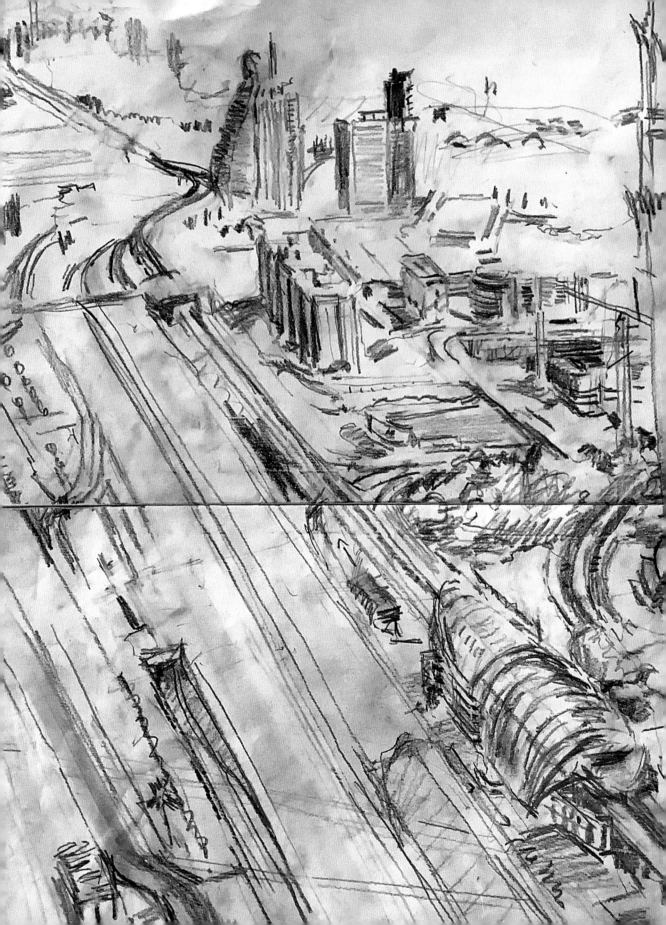

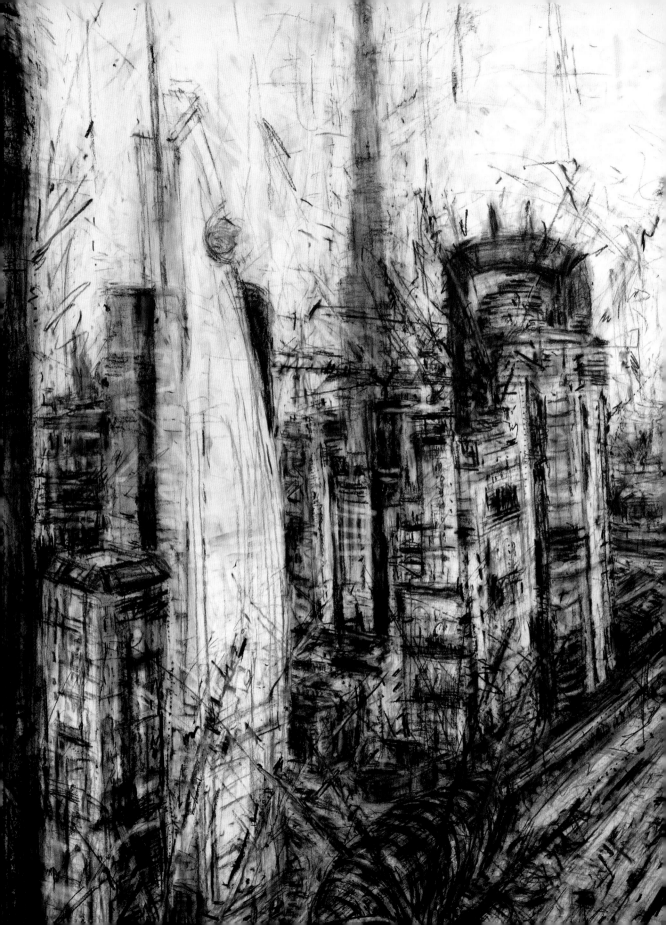

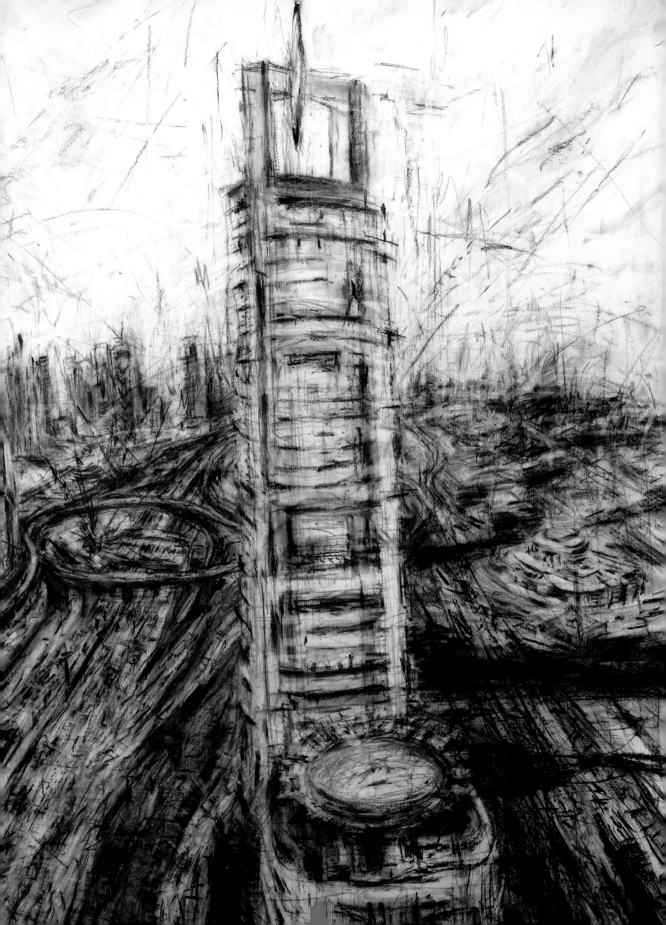

SPIDER TECHNIQUE

The greatest superhero
is of course Spider-Man
– he spins a web of any
size. That's what I try to
do when I sketch outside:
connect parts, like a web.
I don't draw perspective
marks then try to fit the
scene into these, I start in
one place – generally in the
middle – and draw elements
that connect. I work on
something next to my start
point, above it, below it,
and then next draw what's
connected to that. I move
across the paper this way.
I don't put everything in,
I still make decisions, but
it stops me squashing or
elongating elements to fit
into a space. It's useful
to use if you have a lot of
information to take in;
think of the whole but start
in one place.

STATUES AND SCULPTURE

Every town and city has
an assortment of historical
monuments and public art
dotted here and there. It's
a handy starter exercise to
track them down and make
a few drawings; use different
materials each time if you
want to challenge yourself
further – it provides good
practice and you know your
subject isn't going to move,
like an outsized, outside still
life; you can also explore how
subject and environment
combine. It will also turn you
into a connoisseur of both
good and bad sculpture.

Wellington at Bank
Compressed charcoal (P)

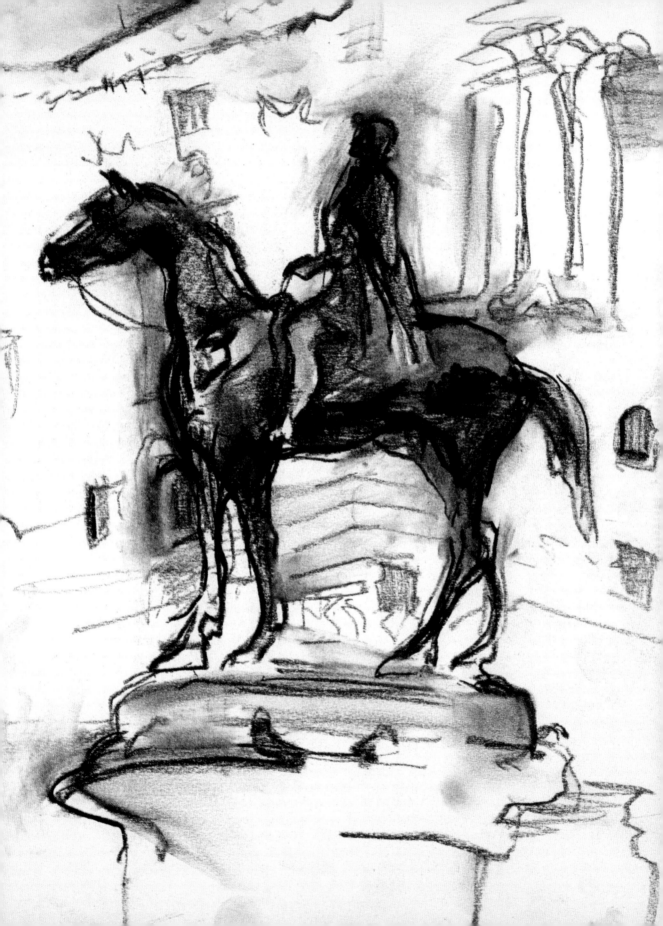

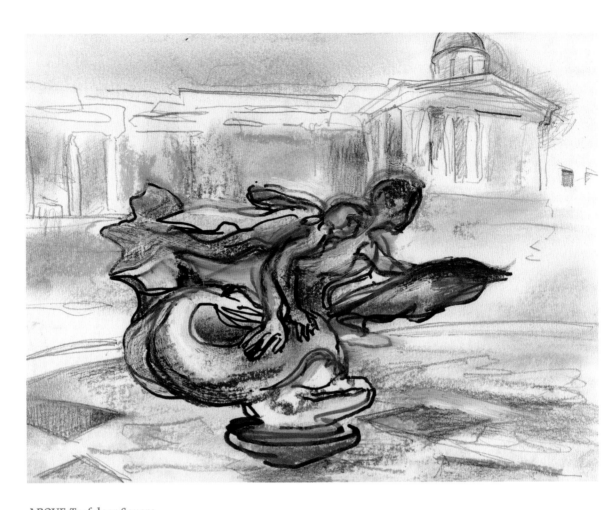

ABOVE *Trafalgar Square
Fountain Ornament*
Ink, acrylic, gesso (P)

OPPOSITE *Reflective Tear,
Canary Wharf* Pencil (P)

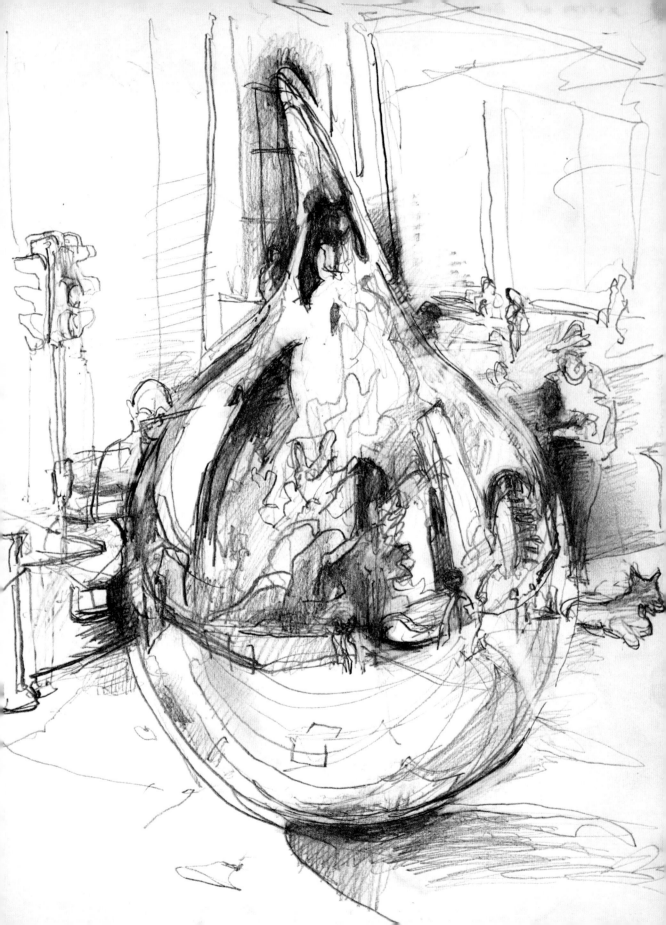

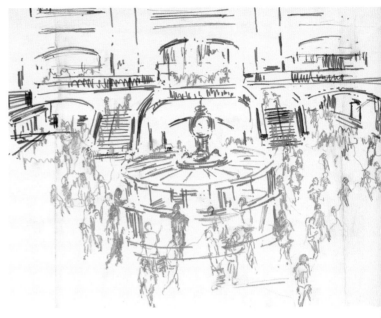

TEXTING

I often say to the young people I teach that sketching is like texting (you then immediately get their attention). Sometimes you have to abbreviate a message you send to someone if you haven't time to write out a longer one. When you're in a hurry you leave out letters, but the message can still be understood: 'r u ok?' Sketching can be like this; you don't have to put in all the details to make a place recognizable and for it to be an interesting sketch.

LEFT *Olympic Park, London* Pen (J)
ABOVE *Concourse, Grand Central Station* Felt-tip pen, pencil (J)

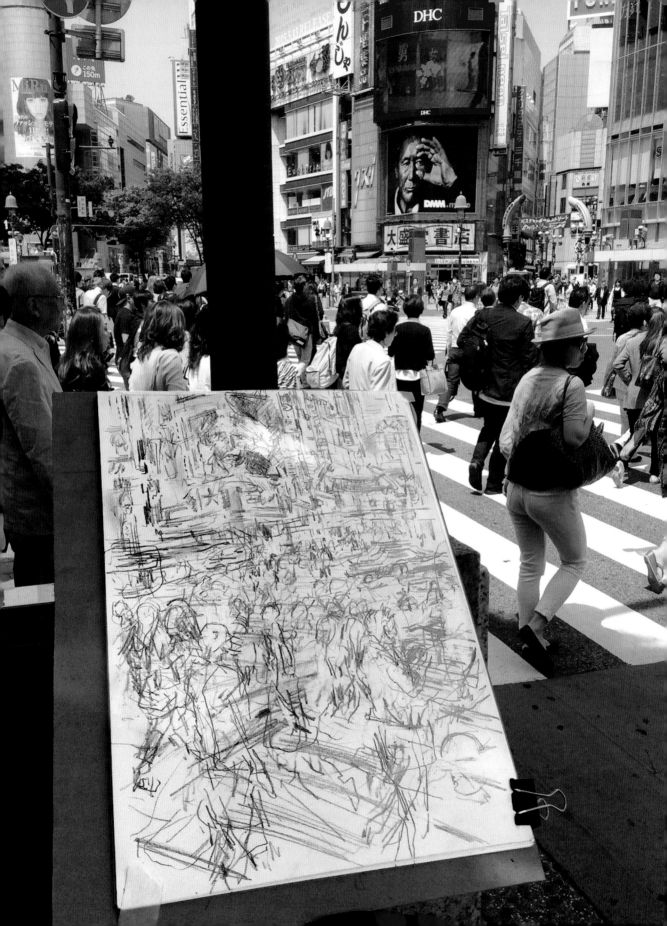

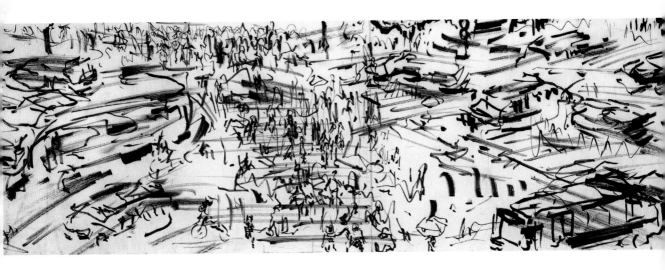

TOKYO

It had always been a dream of mine to go to Tokyo and especially Shibuya Crossing. It's where there are many pedestrian crossings in the middle of Tokyo going towards Shibuya Station – have a look on YouTube if you've never seen it. It's incredibly busy and there are all kinds of flashing signs and so much noise – it has incredible energy. I was lucky enough to have a hotel that looked right down on it, and when I was exhausted after a day's drawing I would have a beer and sushi and just sit and watch everything going on. There's a great vantage point from the Starbucks above the crossing. I loved drawing the people and cars below, but even more I enjoyed being in among the fray drawing from ground level, right in the middle of the crowd. There are other really interesting areas, especially Ginza, which comes alive at night. The museums and state galleries are amazing and I didn't realize how much the calligraphy and traditional landscapes I saw in these had influenced me until I'd been back home for a while. My prints had taken on more of a feel of the brushstroke, and the space I was using seemed to echo some of the ancient paintings.

OPPOSITE *Bridge at Shoreditch*
Pencil (J)
ABOVE *Shibuya Sketch* Brush pen (J)
PAGES 232–233 *Shibuya Crossing, Tokyo* (detail) Compressed charcoal
150 × 210cm (59 × 83in) (J)

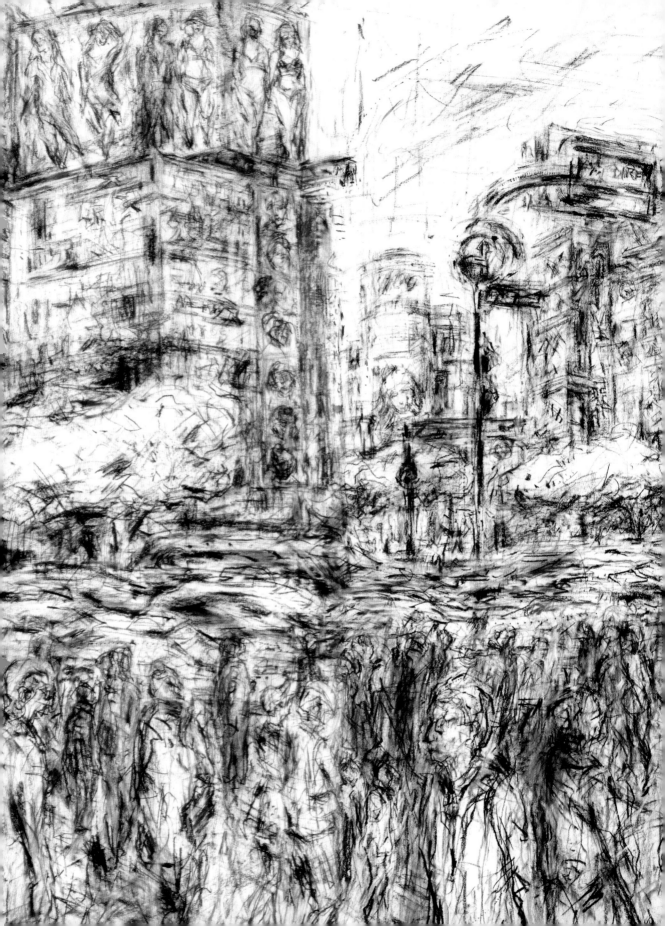

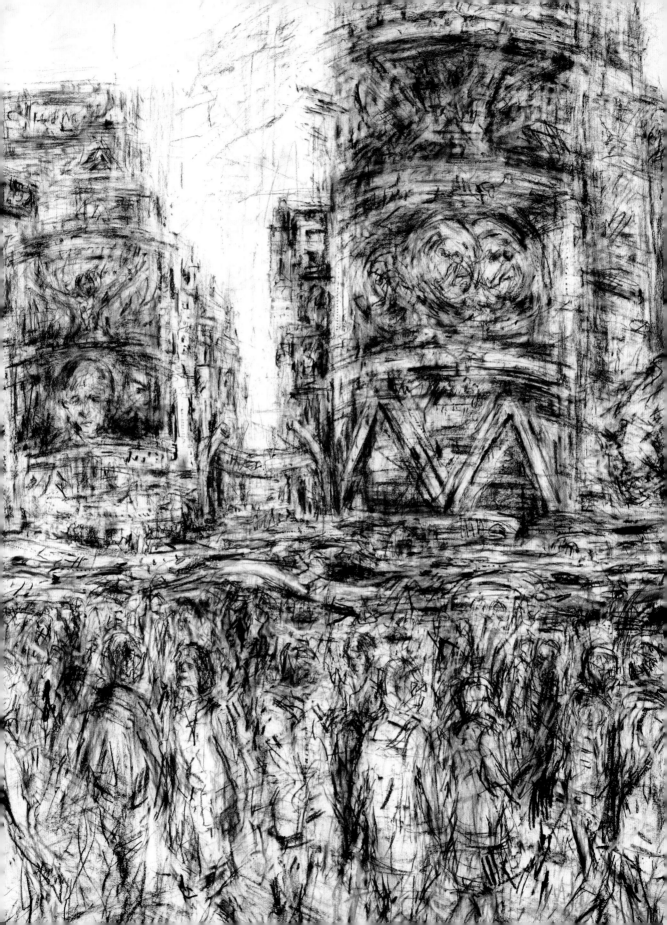

TRACKS
AND TRAMLINES

I love drawing trams; they
seem so elegant, their long
carriages snaking past
buildings right in the centre,
part of the fabric of the
city. I really quite fancy
drawing them driving up
the steep, hilly streets of San
Francisco. I have drawn them
in Manchester, which is a
bit more down-to-earth but
equally as interesting. I like
the way trams follow exactly
the same route, so if you don't
get as much of them drawn
to start with, you know in a
short time they will be back in
exactly the same place so you
can continue. Tramlines make
great patterns on the floor,
often curved or crossed; they
make that often empty area
more interesting to sketch.
Wires running overhead can
disrupt the sight of buildings
and make the sky more varied,
setting a rhythm through your
drawing that brings the space
to life.

Trams Passing Manchester Central
Pen and chalk

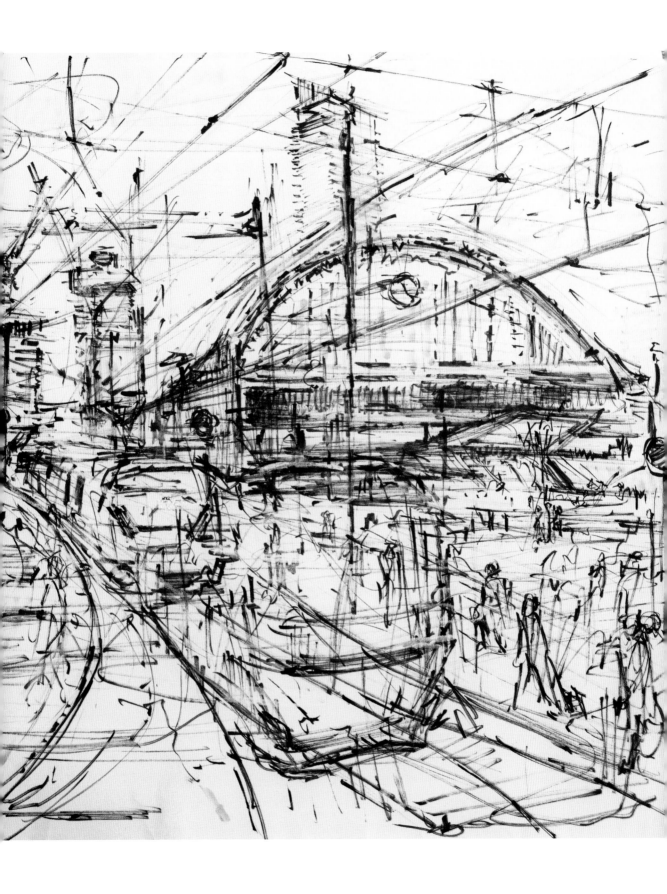

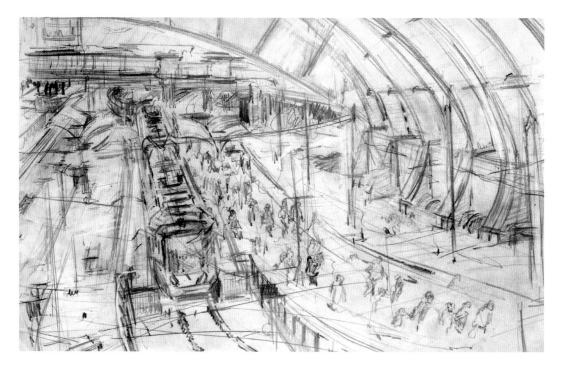

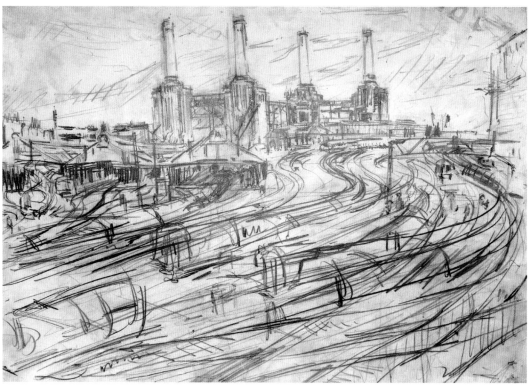

TOP *Manchester Victoria Station* Pencil (J)
ABOVE *Battersea Tracks* Pencil (J)

OPPOSITE *Columbus Circle, New York*
Compressed charcoal 212 × 150cm (83 × 59in) (J)

236

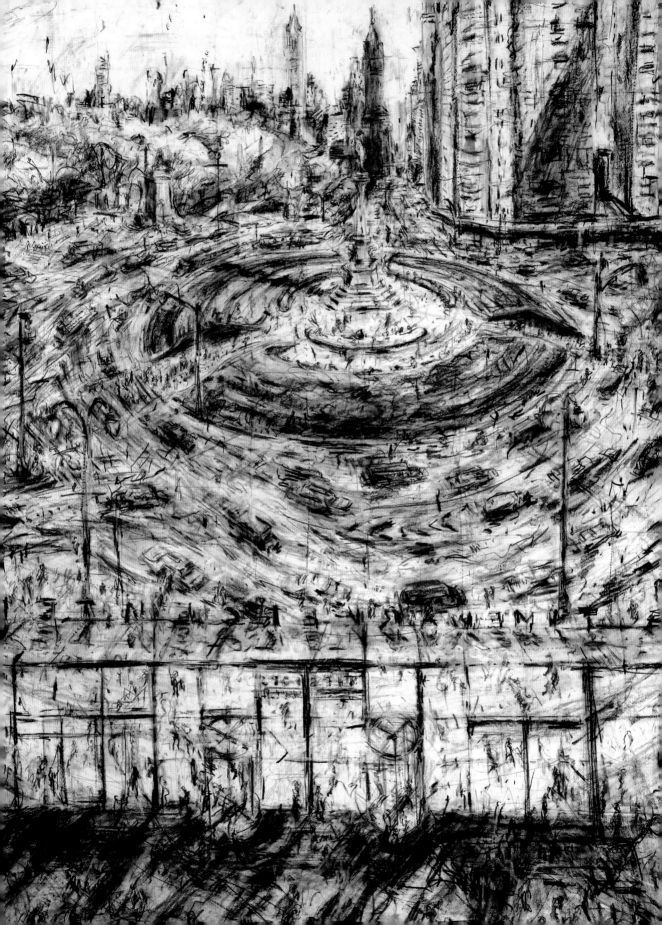

TRAFFIC

Unless it's stuck at lights or in gridlock, traffic is on the move. The challenge of capturing that movement to animate a street scene is fascinating. Buses, trams, taxis and cars have shapes that are known to everyone, so use as much or as little information as you need to create the balance between motion and recognition. Like pedestrians, they move like blood cells teeming through the city's arteries, bringing life to its every part.

ABOVE *Car Studies* Charcoal (J)
RIGHT *New Bridge, Shoreditch High Street* Compressed charcoal 150 × 200cm (59 × 79in) (J)

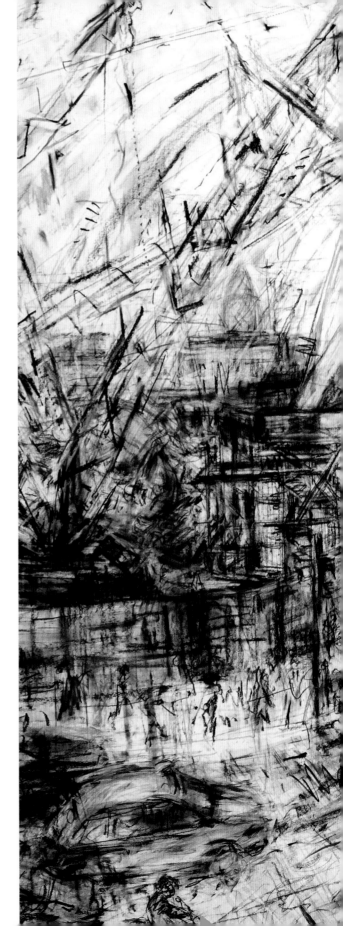

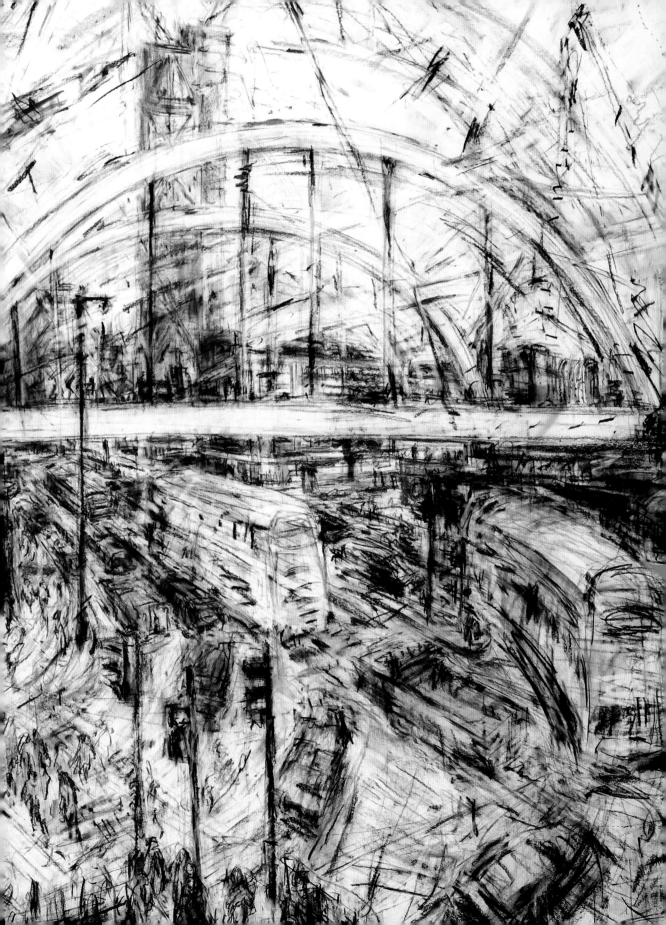

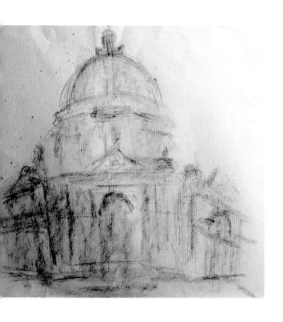

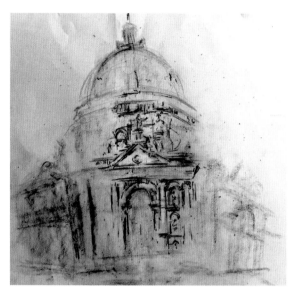

UNDERDRAWING

If you're in a hurry and making a sketch to capture your impression of a place you might need to just whack it down on the paper and hope for the best. As a strategy there is nothing wrong with this, but if you have a bit of time to spend and the subject strikes you as somehow complex or demanding, you might think about an underdrawing. Without being too tentative, gently establish an idea of how the parts combine to make the whole image. Draw quite evenly but as you do, start to develop an idea as to which parts of the image will be your main focal point, and which can be

more suggestively rendered. If you've used charcoal, then you might fix this and then, once the spray has dried, rub the picture out, which will leave you with a half-strength 'ghost image' as your foundation. Having made an underdrawing, you can then continue on top with the confidence of knowing you've sorted a few issues out, and carry on with a bit more daring, knowing that your sketch is structurally sound. For our example, Jeanette has used a graphite stick on its side to begin her drawing.

ABOVE AND OPPOSITE
The Salute, Venice (right to left, stages 1–3) Graphite (J)

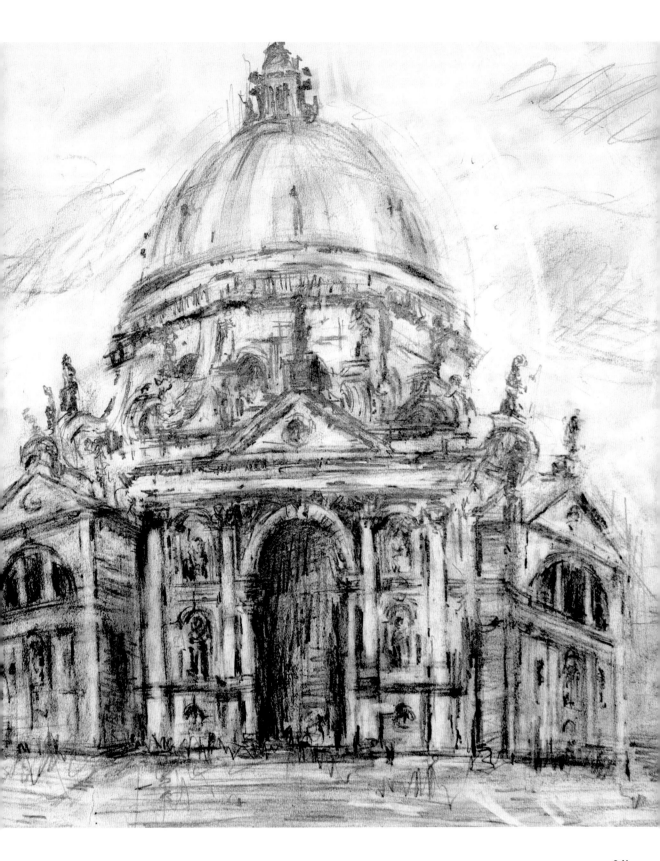

UNDERGROUND STATIONS

The first drawing I ever made in London was of people on the escalators inside Swiss Cottage Tube station; 30 years on and it still has the old-fashioned lights and looks very retro. I was deeply influenced by the drawings of Leon Kossoff and the work is very black-and-white with very little mid-tone. I wish I could get back some of that bravado and contrast, but alas, that was a younger me. Recently I've been drawing a series of the Art Deco underground stations designed for the Piccadilly Line by Charles Holden. They are really lovely and the jewel in the crown of the northern end is very near where we live, Southgate. It's the only

Southgate Tube Station (detail)
Charcoal 113 × 143cm (44 × 56in) (J)

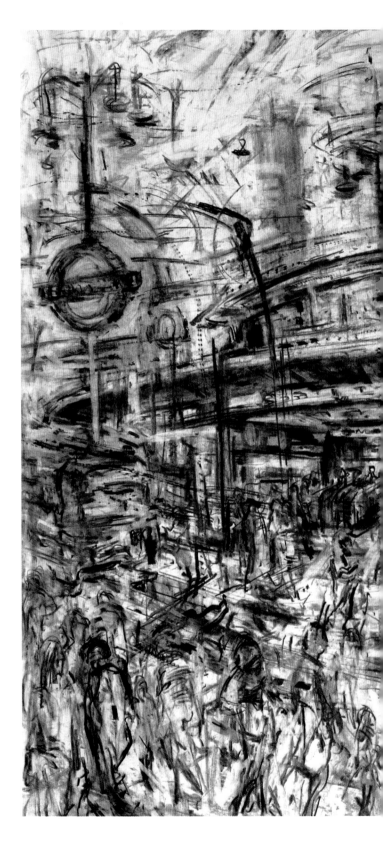

242

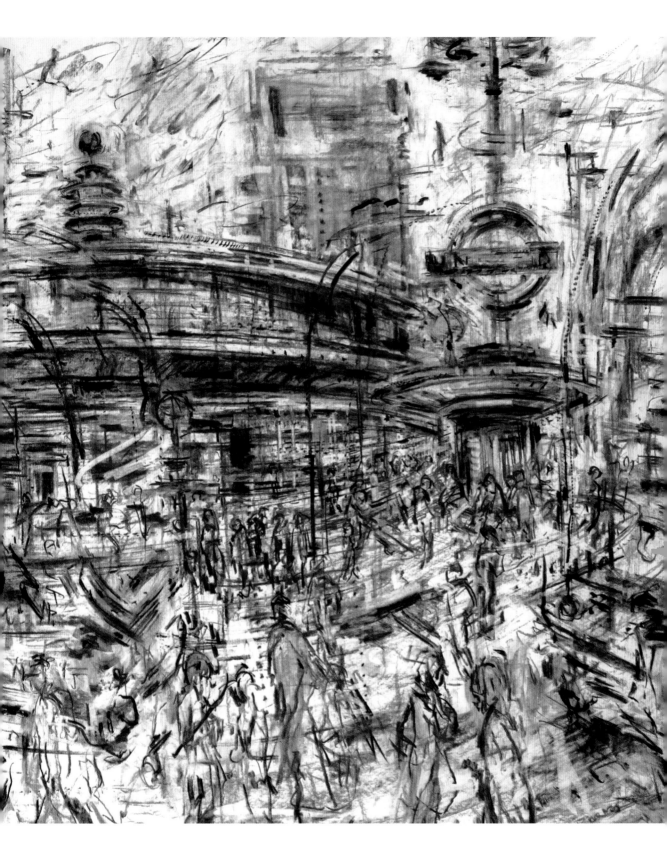

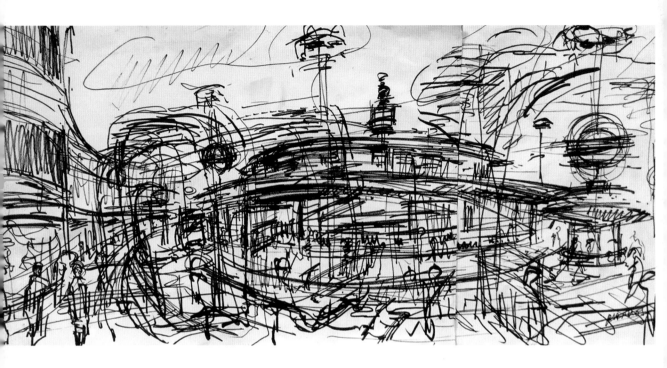

circular standalone station and has a futuristic light on the top that looks great at night. People are passing through them all the time, so if you don't finish a sketch of a person someone else will pass a few seconds later. Tube stations are also very human in scale; with big railway stations the difference in scale between people and architecture is vast, but not here. It's not so easy to draw inside them now as you have to ask for permission.

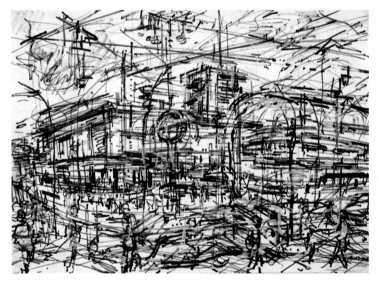

ABOVE *Southgate Sketch*
Permanent marker (J)

ABOVE LEFT *Turnpike Lane Station*
Permanent Marker, chalk (J)

OPPOSITE *Swiss Cottage Escalators*
Compressed charcoal (J)

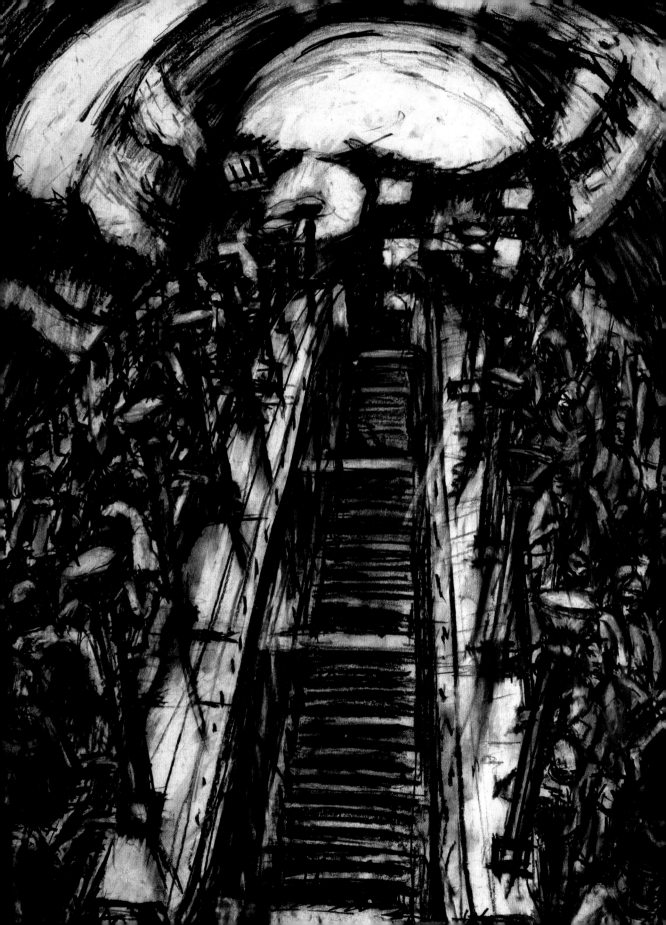

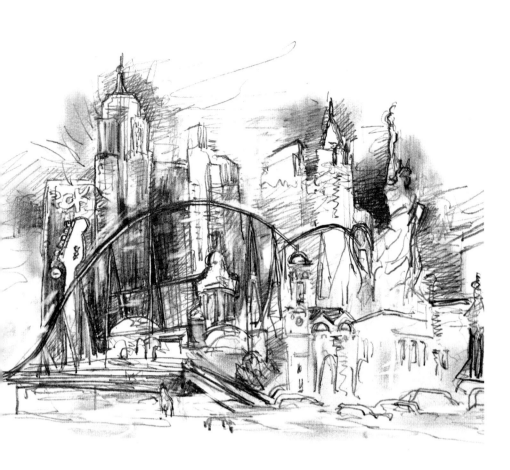

UPSIDE DOWN

During a class I will often tell my students to turn their drawings upside down. I do this myself, it's so you can tell what needs to be done to the drawing. When you have it upside down it becomes a design, marks on paper, not a figurative scene – this allows you to see what to add or how to change the composition. Try it, it works.

VEGAS

Las Vegas is pure spectacle – an unreality. A variety of historical landmarks have been reproduced (albeit disconcertingly out of scale to one another) and forced together. As if that's not enough, there's a rollercoaster twisting its way through it all, and that's before you hit the casinos. I visited the place to concentrate on drawing,

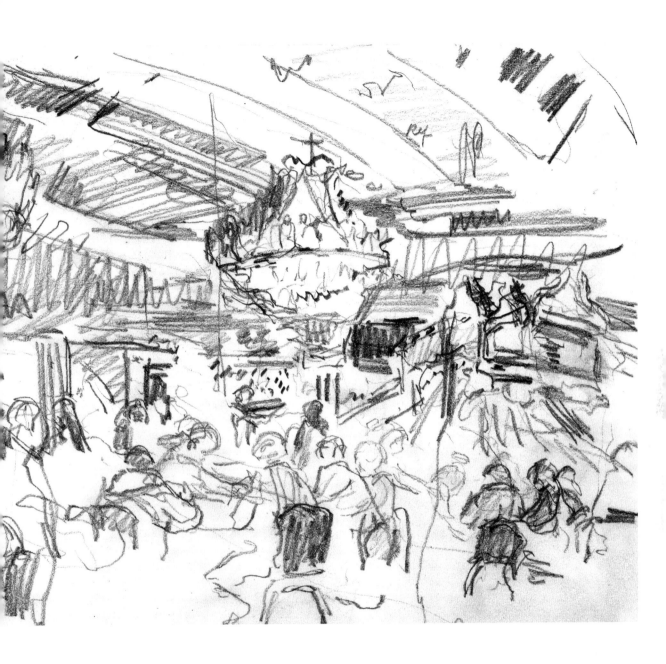

limiting my gambling to $50, which I lost within 30 minutes (Paul would have gambled much, much more, which is why he was banned from coming). The casinos are just as fascinating in

their own right, but they frown upon sketchers as they imagine that you're casing the joint.

OPPOSITE *Never Never Land* Pencil (P)

ABOVE *Casino Interior* Pencil (J)

VERTICALS

When you are sketching buildings, the easiest thing to put down are the verticals, as these are always straight and they don't have angles – you just have to note how long they are and what they touch. Be careful, though, not to put a couple down and then try to fit everything in between, as it's easy to make the gap too wide or too narrow. Draw something connected to one vertical and then move across the paper, putting down anything interesting that catches your eye before you get to where you think the next one should go, then the space between should be more or less correct. Always be prepared to shift a vertical line slightly if necessary; this isn't a mistake, it's a consideration that will eventually help your drawing.

VIEWFINDER

Some people find this a useful tool to block off other things in your view when looking at a scene ... I really don't like them. I love seeing things coming into my peripheral vision and seeing how parts of the city recede into the distance. Even if I don't include this aspect, I think it influences the way I approach my sketch. They are, however, easy to make, so if you fancy giving it a go, this is how to make one.

Decide what ratio you'd like, and draw this box shape out onto a rigid paper or piece of card, leaving enough paper surrounding the box to act as a frame. Fold the whole sheet in half to cut out with scissors, or use a knife, ruler and cutting mat to avoid folding it.

Viewfinders might help you focus or they might cramp your style – either way, it's important to be aware of what's happening at the edges of your picture and build that into your design, regardless of how you construct it.

Albert Square, Manchester Pencil (P)

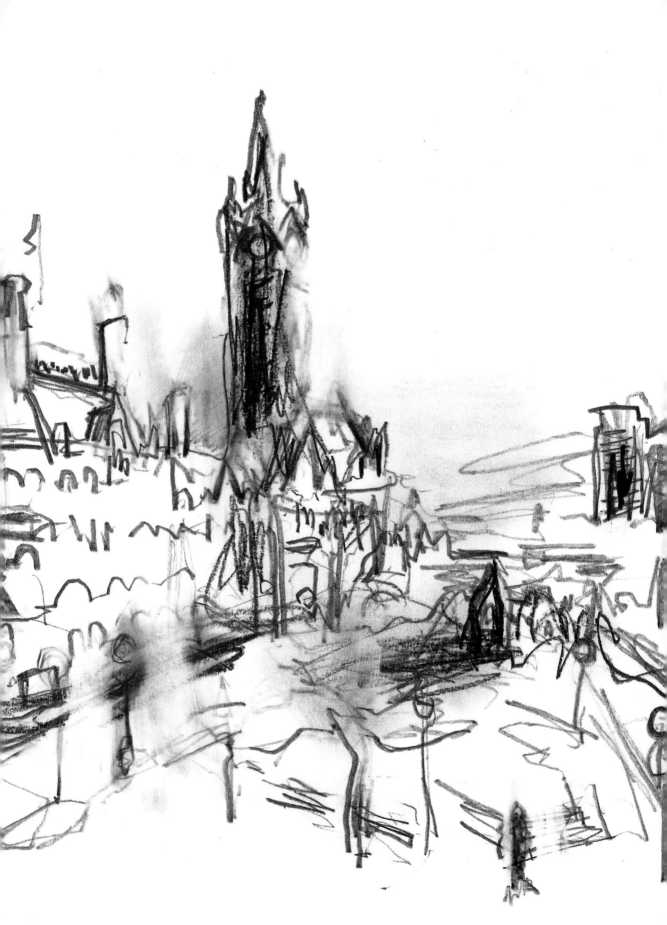

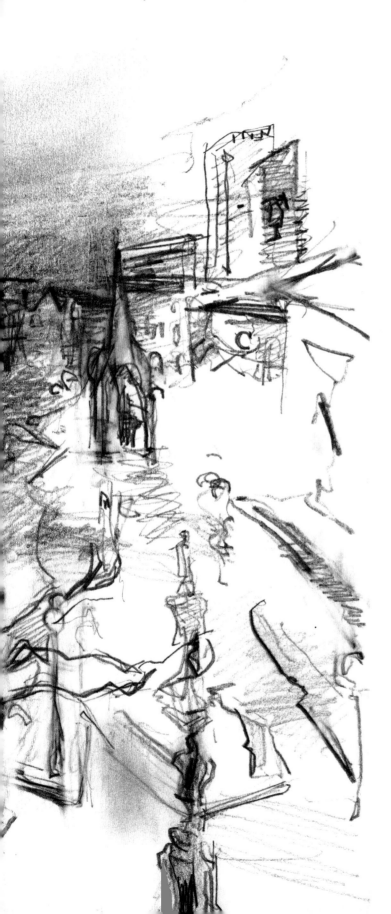

VIOLENCE

This might seem a funny word to find in a book like this, but drawing is as genteel or as furious as you want it to be. There's a scale of visual effects that you can create, ranging from something that subtly fades into your paper to something that screams its presence on the page, almost to the point of jumping off the paper. Every decision you make will be somewhere between these poles.

Teachers often talk about 'loosening-up exercises' to encourage students to be more physically active in their work. Behind each mark is your bodily action, so for certain effects you'll have to work quite hard. Never be scared of doing this or worry that it might spoil your picture. Using the same art materials, take a view of a subject and render it delicately, then violently, and finally in a way that utilizes both of these approaches together.

Albert Square, Manchester Pencil (P)

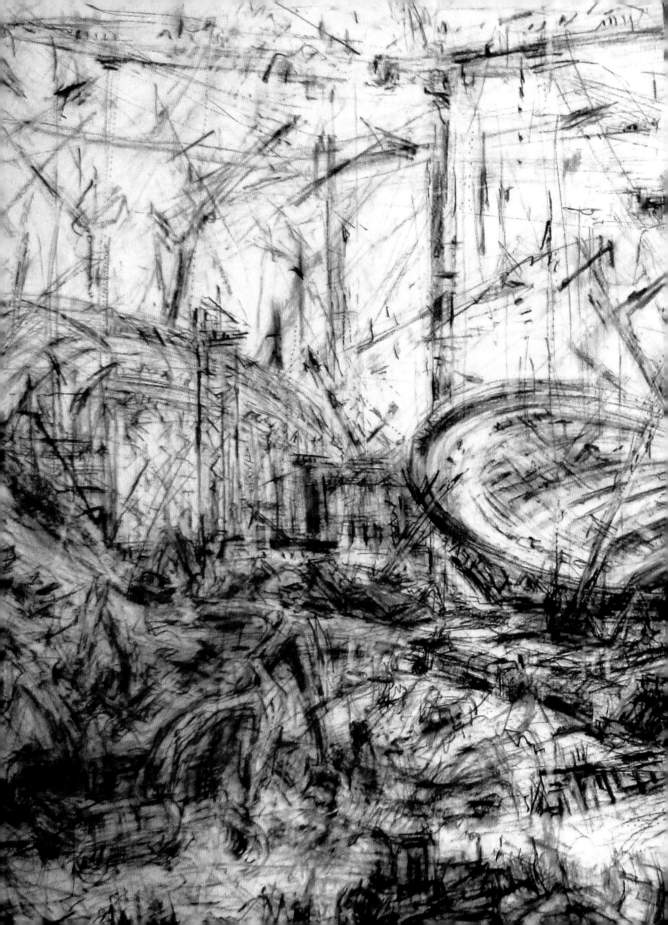

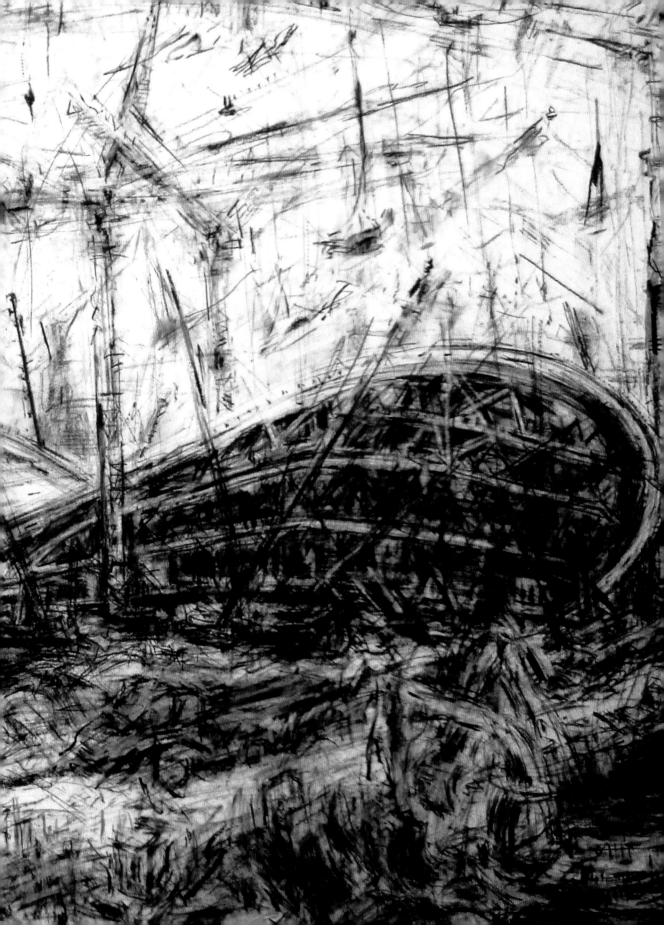

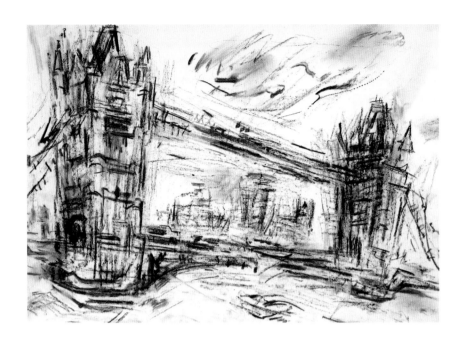

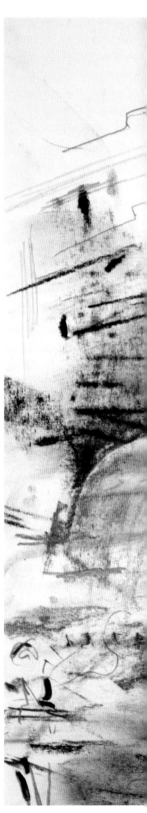

VISUAL LANGUAGE

As fantastic as your drawings might be, they can never be real. They are an invention using the visual qualities inherent in the materials you're using. There's a lot of talk in this book about what materials can do and the different ways in which they might be used, because visual language is so important. The drawings you find yourself spending the most time looking at won't automatically be the ones with the most impressive subjects, or the most finished – they'll be the ones where the materials you have chosen are transformed by your imagination as you look at them. The drawing is somehow very strongly both the location and the way in which it's been drawn at the very same time. This is the magic of visual language.

PAGES 252–253 *Olympic Velodrome* Compressed charcoal (J)
ABOVE *Tower Bridge* Charcoal (J)
RIGHT *Bishopsgate Buses* Pencil, felt-tip pen, wax crayon, pastel (P)

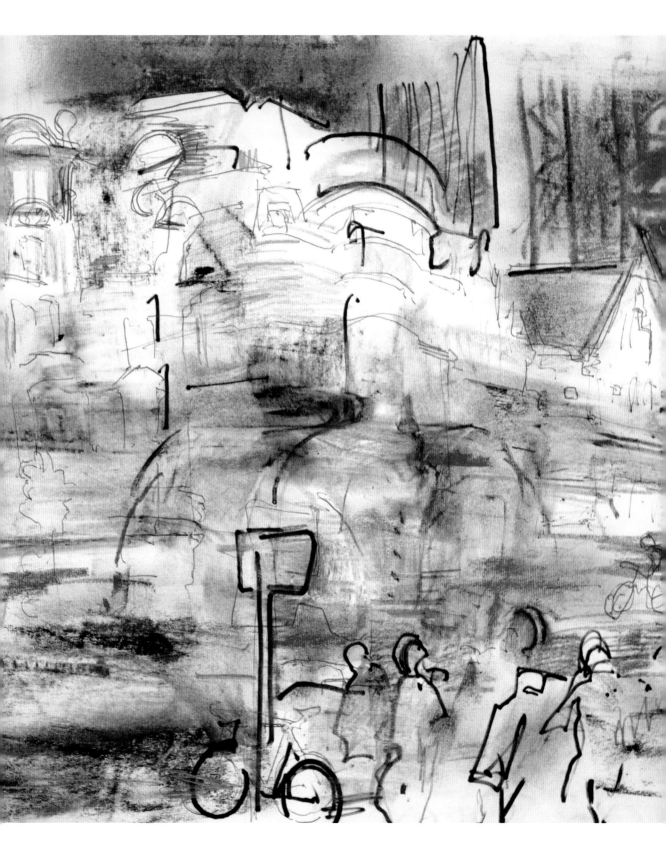

255

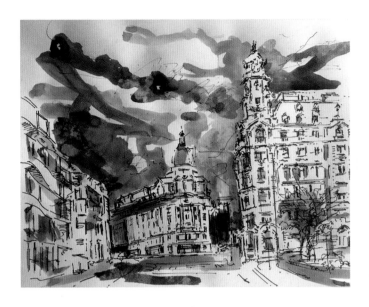

WATERCOLOUR

Watercolour was actually designed to be taken out on location; you can get a range of small but useful box sets. When it comes to technique you can either make a picture how you've seen them done, or completely go your own way and use watercolours as you please. Wetting the sheet and using big brushes to make evenly gradated skies, then letting that dry before adding detail, isn't so practical beyond the studio, so you might decide to make a drawing and then add colour on location. It's possible to draw, add a tonal

ABOVE *Near Finsbury Circus, London* Fineliner, ink (P)

RIGHT *Near Finsbury Circus, London* Fineliner, ink, watercolour (P)

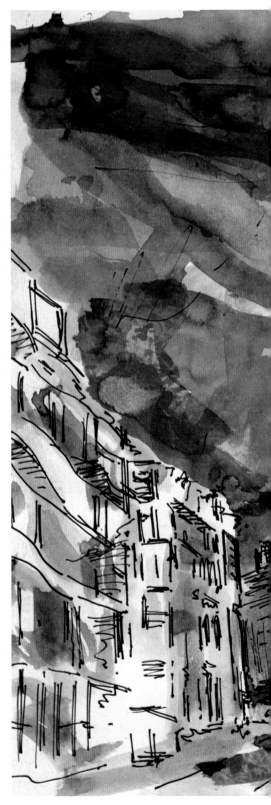

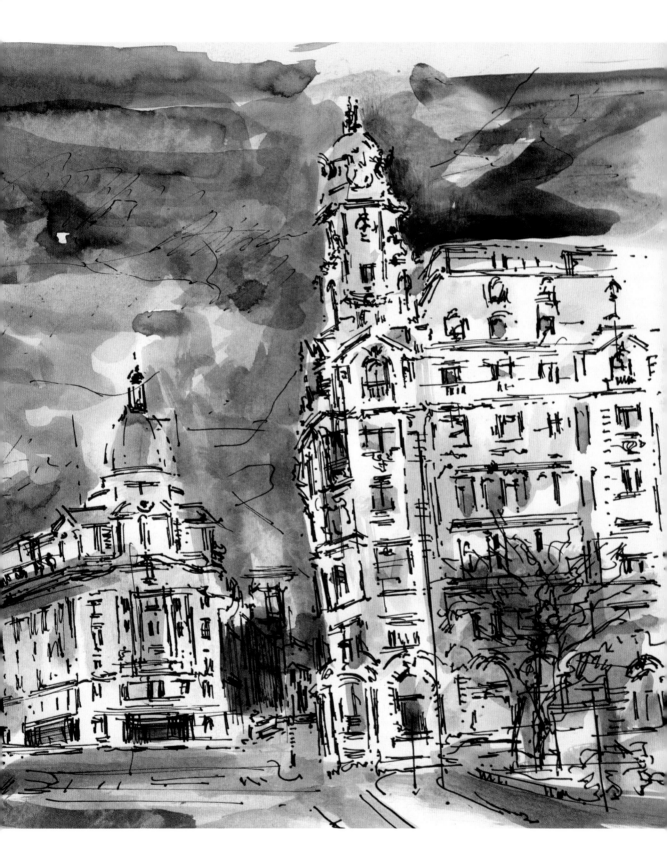

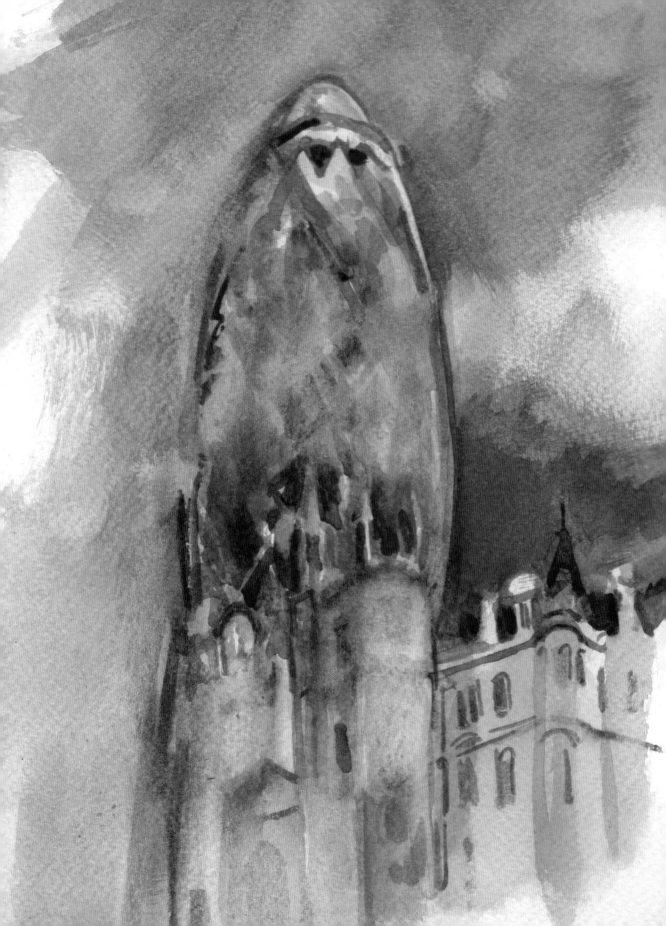

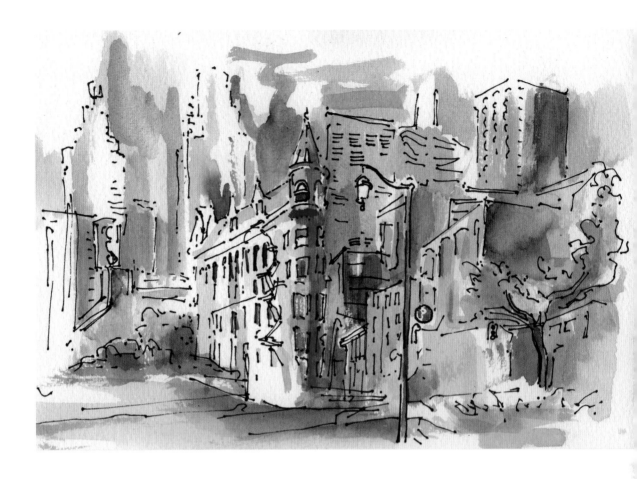

layer of diluted ink, and then finally add colour, or – if you're feeling adventurous – just go for it without any underdrawing. Whatever you decide, do make sure that you have paper that is up to the task of absorbing water. Experts soak and stretch their paper in advance to eliminate buckling but that's a little too far for me personally. Watercolour sketchbooks and pads are also available should you wish to really involve yourself out of doors. Be

careful to keep your whites white (you can buy masking fluid if things get really serious with this medium – there's also a white in most box sets which isn't fantastic but it helps a bit). Try to use a range of brushes rather than just the tiny one that comes with a set – this will give you the option to be bold as well as careful.

OPPOSITE *The Gherkin from the Street* Watercolour (P)
ABOVE *Toronto* Fineliner, watercolour (P)

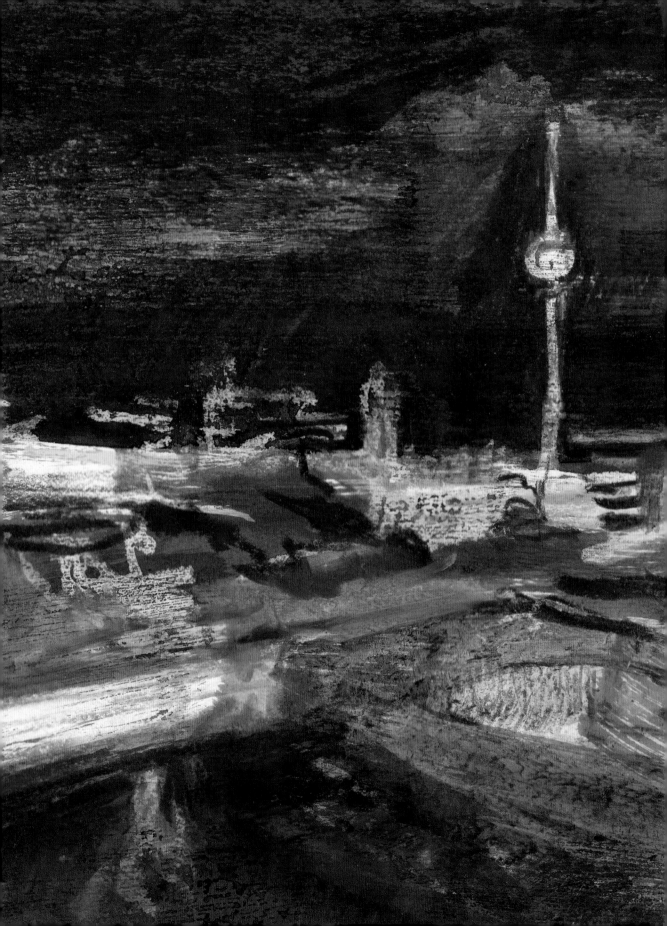

WAX RESIST

This is something that comes out of the 1960s almost – a bit like tie-dye. You could add it to the number of 'disruptive' approaches to using materials, similar to the gesso or the glue stick that we've already mentioned. The wax will stop any water-based material getting through to your paper. Use a coloured crayon and you'll know precisely where this will happen; use natural wax or something white and it will come as a bit more of a surprise. You might associate this kind of activity with pre-school, but direct, less refined experimentation has its place alongside what might be considered to be more sophisticated techniques. Henry Moore used wax resist to great effect in his drawings of people taking shelter in London's underground stations during the Blitz. The examples here have been layered once the diluted ink has dried to create a bit more depth.

Berlin Panorama Oil pastel, ink (P)

WEATHER

Always try to exploit any variable that your subject might offer. The weather can bring mood or drama to something otherwise static. Glass-fronted buildings are great to draw on cloudy, windy days – huge towers can become ghostlike as they merge with their surroundings. Try not to lock down buildings with harsh edges but look at how the weather actually affects how we see things. If you know that rain is on the way later, set yourself up in spots that aren't too exposed – in the absence of cafés, arcades and large doorways offer you the chance to keep on drawing without getting wet. Look for somewhere above street level – people hurrying past, umbrellas up and the light reflected in wet pavements, make a great subject from a dry vantage point.

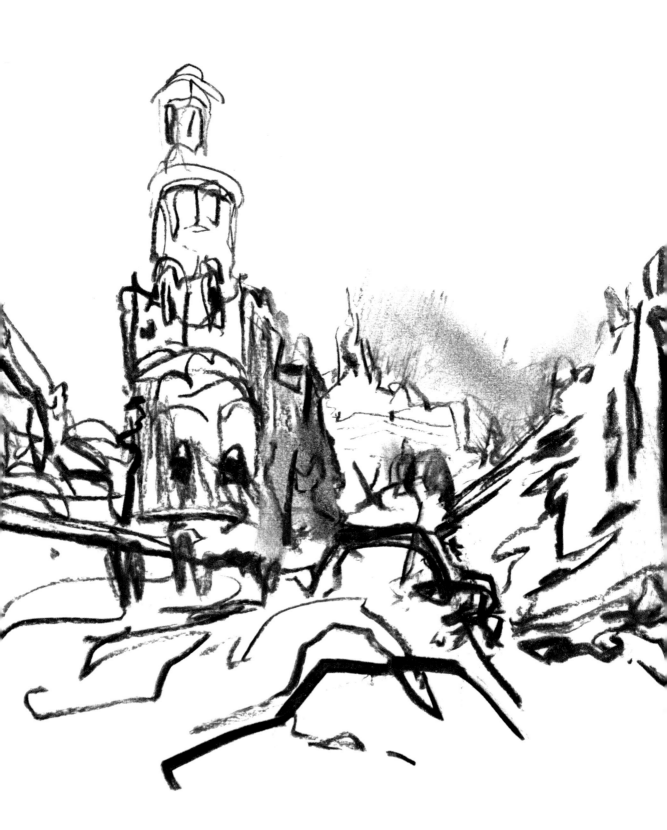

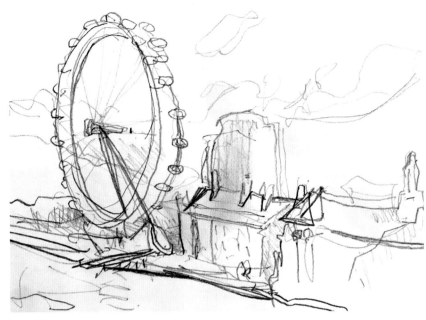

WRONG HAND

Many 'how to draw' books will encourage you to draw with the hand you use least. Why? Because it is less practised, less cultured, less controlled. The resulting drawings will have a greater sense of energy, at the expense of accuracy. The books will tell you that this is useful (and they'd be right – energy and unpredictability are useful elements within drawing), but the more you rely on your wrong hand to do this for you the more use it gets, the more practised it becomes and so eventually it will perform in much the same way as your 'better' hand.

So why bother tricking yourself into creating this type of work? Your regular hand can create any sort of gesture, any quality of line that your irregular one can. It's more to do with how the mind sees the function of drawing. If your mind insists on producing a drawing that is neat and tightly controlled, then that is where you are heading. If you have a mindset that is a little more adventurous then the brain will allow the hand to wander.

LEFT *Boulevard Traffic*
Charcoal (P)
ABOVE *London Eye* Pencil (P)

X FACTOR

While, given time, most of your work will reach a level of competency or understanding and you'll become aware of your own strengths and weaknesses as an artist, there will from time to time be works that stand out and make you think, 'Wow – did I do that?' These works will have the X Factor. Sadly, there's no formula you can learn to get you there time after time. Chances are that if you go all out to create a masterpiece you just won't, as you'll be working under a weight of expectation. By all means have ambition, but just focus on forming good working habits without obsessing about what is or isn't allowed, and that will allow certain works to emerge that will surprise and inspire you.

XL

I have always found drawing small difficult. I can, of course, work in a sketchbook, but when I sketch outside I often use an A2 board. Some people find holding a board difficult, but I generally sketch standing up and try to find something to lean against. Beware of the wind though – I have been hit in the face when it's caught under the board!

I love working on large drawings at the studio using the information gathered on location. I staple a piece of paper from a Fabriano roll on the wall, and when I begin my large drawings I tie a piece of charcoal to a long stick so I can reach everywhere on my paper and create a big overall sketch. You can't be too detailed with this method as it's too unwieldy, but it allows you to have distance away from the surface so you can see the progress. After this initial part of the drawing I normally use either charcoal or compressed charcoal and stand on small steps or a decorator's bench.

Shanghai in the studio.

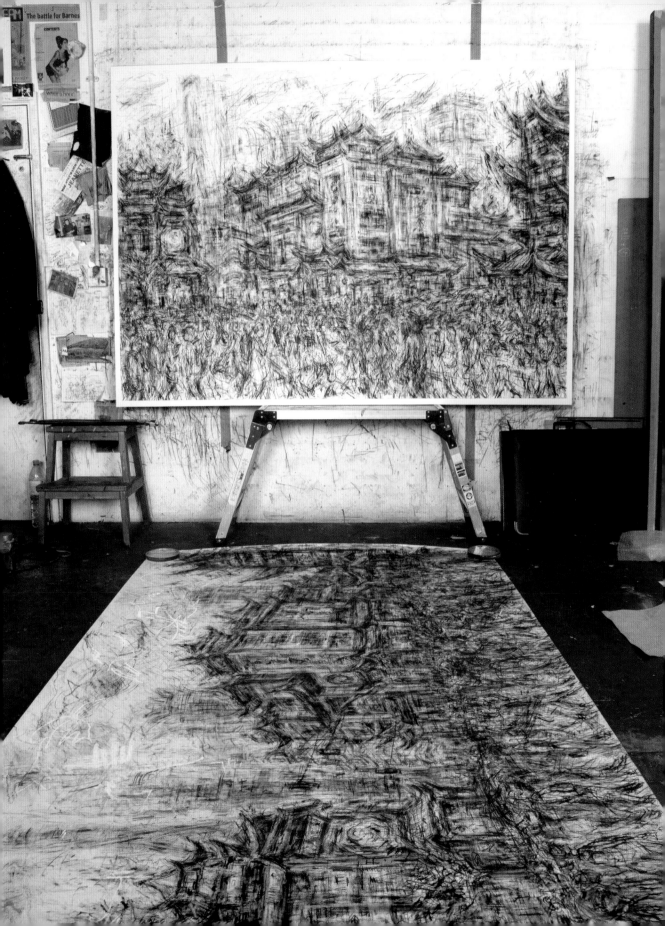

YESTERDAY

If you're struggling for subject matter or wondering what materials might be your cup of tea (especially if you're fairly new to all of this), think back to the sort of things that inspired you when you were younger. Most artists, in a funny sort of way, are after the same goals throughout their careers but develop different means of expressing that as they get older. If you are drawing something that you somehow have a connection to or a history with it will mean a little more, but also spur you on, without you even being that aware of it.

YOU CAN'T BE TOO CAREFUL

Drawing in urban locations isn't in itself dangerous. The people who might come up to you are almost certainly going to be curious rather than malevolent, so don't be overly scared. Having said that, it's good to keep your wits about you. If you don't want people coming up behind you then lean against a wall. Only take out the valuables that you need, and if you have a bad feeling about a place then don't hang around. Cities are cities at the end of the day but, to put risks into perspective, Jeanette has drawn all over London and other cities for over 30 years without a hint of trouble. (She has lost her phone on the way home a few times though!)

Haslingden, Lancashire Pencil (J)

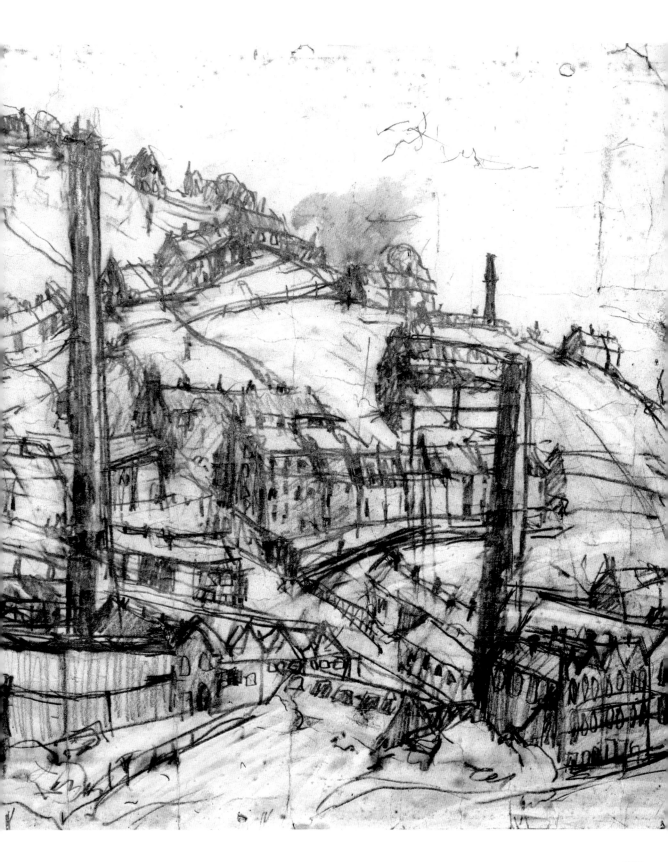

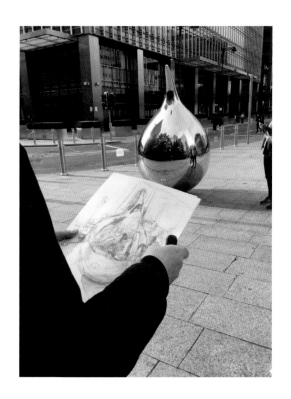

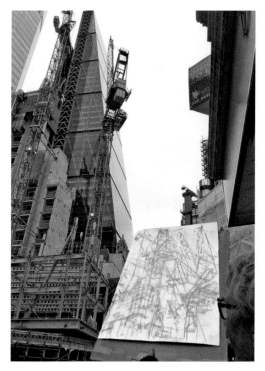

ZERO TO HERO

Well, here you are, almost at
the end of the book. Hopefully
it's encouraged you somewhat
and given you one or two
ideas about what you might
like to do with your own
drawing. Sadly, it's not going
to turn you into your favourite
artist, the best artist or even
the richest one. With any
luck it will point to how you
can be yourself as you draw
and enjoy the experience
along the way.

Q & A

JEANETTE ASKS PAUL:

Jeanette: *So, Paul, are you actually an urban sketcher?*
Paul: Not in any way. I have been out and about to create illustrations for this book but no, I'm much more at home in the studio. Having said that, the challenge of capturing things as they happen was a lot of fun. Many of my efforts were lost during the editing process!

J: *Were you any good at art at school?*
P: My A level grade for art was the lowest grade I got, I've got a much better A level in maths. There wasn't a lot of teaching going on back then, and the art teacher spent his time praising the work of my sister, who could get a really convincing highlight on a red pepper when she painted those.

J: *Do you have an exercise regime?*
P: Being middle-aged, it's important to look after my body. Art can be quite a physical activity, but if that's not enough, our studio is on the top floor of a three-storey building. Your big-framed drawings can only just be lifted down the twists and turns of the staircase, burning off thousands of calories in the process.

J: *Where are you most well-known?*
Paul: Having exhibited far and wide over three decades, the scene of my greatest triumph isn't London or Paris, but Stockport. The War Memorial Art Gallery there is a fantastic venue that has hosted two of my largest exhibitions. Special mention to the Scotch Egg Café who very kindly took in a huge roll of bubble wrap for me when the gallery was closed.

J: *Which of my drawing trips have you been on?*
P: I haven't been with you to Tokyo, Shanghai, Las Vegas, Dubai, Singapore or Hong Kong, so that leaves New York. I didn't do any drawing there but I did manage to secure us those seats at the bar in Grand Central Station by putting on a very rough-sounding London accent when the locals were hovering.

Q & A

PAUL ASKS JEANETTE:

Paul: *Where are your top three cocktail bars with a view?*
Jeanette: In third place: the Peace Hotel roof bar in Shanghai looking across from the Bund to Pudong. Second: any of the bars in Grand Central Station that overlook the main concourse. First: Burj Al Arab hotel, Dubai. It's the sail-shaped seven-star hotel serving a divine Cosmopolitan – but, as you can imagine, it has a price tag to match.

P: *Which subject have you found the hardest to realize?*
J: I never got a satisfying drawing finished looking down on the Shibuya Crossing in Tokyo, which has always really annoyed me. I like the large drawing I did of being in the throng of commuters surrounded by traffic, and all the advertisements from ground level, but I would love to go back and gather more information about looking down on the crossing itself.

P: *Which cities are at the top of your bucket list?*
J: I would love to go back to a few places: Tokyo for the Shibuya Crossing, Venice because I only briefly sketched St Mark's Square, and also Hong Kong. I'm obsessed with wanting to draw the Happy Valley Racecourse, where you can see the skyscrapers surrounding the track. I only managed a few days there last time, so that would be at the very top of my list. I'd also love to draw in Chicago, Moscow and some of China's newer cities that have vast construction sites – me and my sketchbook can't wait.

P: *Has any of your work ever been run over by a bus?*
J: It wasn't funny! When I was a student at the Royal Academy Schools I got a print into the RA Summer Exhibition and only sold one in the edition. It took me absolutely ages to produce a perfectly clean print. Anyway, I did manage it, I was taking it home, accidentally dropped the roll it was in on the road, where it subsequently got run over by an oncoming bus. It made me cry.

INDEX

ABOUT THE AUTHORS

Jeanette Barnes and Paul Brandford have taught drawing for three decades. During that time, they have worked for a range of art institutions between them including the Royal Academy of Arts, the Royal Drawing School, Somerset House and the National Society for Education in Art and Design. As practising artists they have exhibited widely and won major prizes in the field of drawing. Although their own works are particularly distinct from one another's, they share a similar grounding to drawing that can be traced back to their art educations in the 1980s.

www.weexploredrawing.co.uk

First published in the United Kingdom in 2022 by
B. T. Batsford Ltd
43 Great Ormond Street
London
WC1N 3HZ

An imprint of B. T. Batsford Holdings Limited

ISBN 978-1-84994-690-2

A CIP catalogue record for this book is available from the British Library.

10 9 8 7 6 5 4 3 2 1

Reproduction by Rival Colour Ltd, UK
Printed and bound by Toppan Leefung Ltd, China